Master of Light

Ansel Adams and His Influences

Therese Lichtenstein

TODTRI

For Stanley

A Note on the Photographs by Ansel Adams

Ansel Adams' National Park Service photographs are held by The National Archives in Washington, D.C. While the original prints prepared by Adams himself can still be seen, the master negatives disappeared some years ago. Therefore, the images seen in this book have been reproduced from copy negatives or photographs of the original prints.

The editors and author are grateful to Lynn Radeka, who acted as photography consultant for this project. Himself a student of Ansel Adams, he supervised the making of prints from the copy negatives, eliminating damage and imperfections that had developed over the years, and producing images that faithfully capture the spirit and flavor of the originals. Mr. Radeka was greatly aided in his work by John Haug and Photomation Photo Lab, in Anaheim, California, who put in long hours of careful and diligent work to provide strong, high-quality prints within a short period of time.

This book was designed and produced by Todtri Productions Limited P.O. Box 572, New York, NY 10116-0572 FAX: (212) 695-6688

Printed and bound in Singapore

ISBN 0-7651-9150-4

Author: Therese Lichtenstein

Publisher: Robert M. Tod
Editorial Director: Elizabeth Loonan
Senior Editor: Cynthia Sternau
Project Editor: Ann Kirby
Photo Editor: Edward Douglas
Picture Researcher: Laura Wyss
Production Coordinator: Jay Weiser
Designer: Anthia Papadopoulos

Photo Credits:
All photographs by Ansel Adams were supplied through the courtesy of The National Archives, Washington, D.C.

This book has been published without the assistance or endorsement of The Ansel Adams Publishing Rights Trust.

Richard Albertine 37
Ellen Brooks and Vicki Alexander 55
Corbis-Bettmann, New York 5, 7, 10 (inset), 25 (inset), 43 (inset), 49, 50
The Imogen Cunningham Trust 16, 30, 41
Mark Klett 54
Sue Davidson Lowe 31
Richard Misrach 56–57
The Museum of Modern Art, New York18, 28, 32, 33, 34
The National Archives, Washington, D.C. 4, 6, 10, 13, 14–15, 20, 21, 22, 23, 25, 40, 43, 45, 46–47, 53, 59, and all photographs on pages 60 to 143
PaceWildersteinMacGill, New York 38
Paul Strand Archive 27
The Minor White Archive, Princeton University 39

CONTENTS

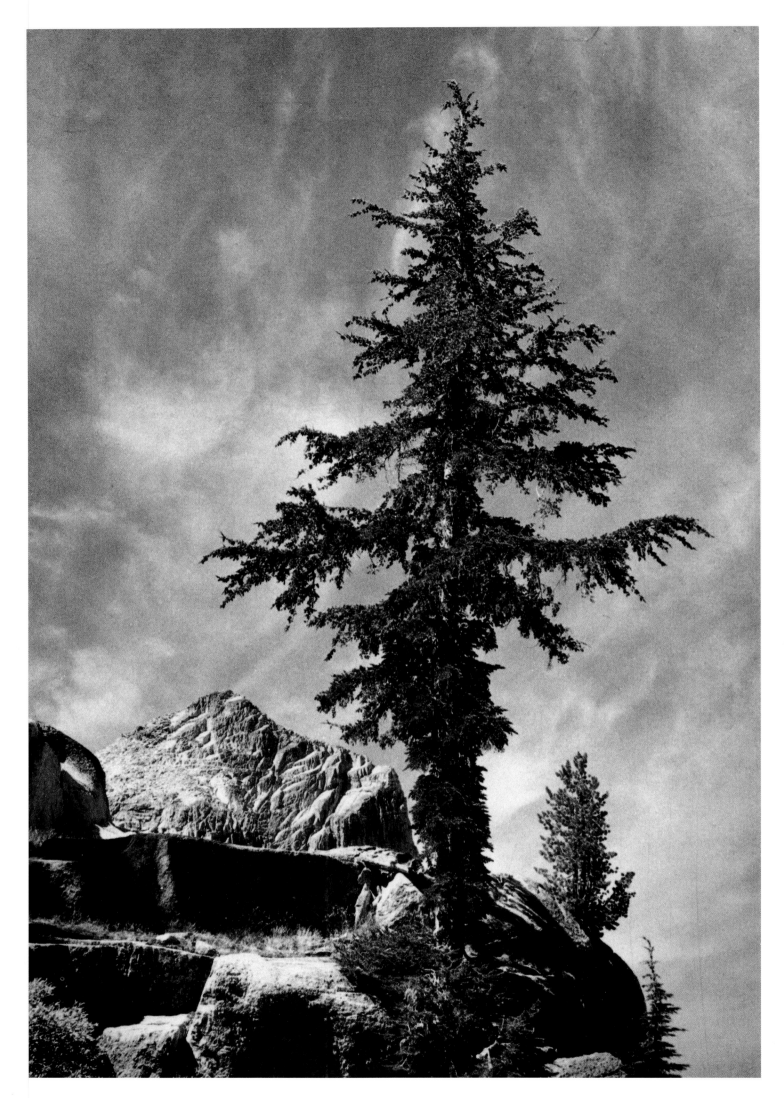

Unnamed Peak, Kings River Canyon by Ansel Adams.

Introduction
The Range of Light

When devastating flood waters from the Merced River wreaked havoc in the Yosemite Valley in early 1997, one of the leading cover stories in *The New York Times* of February 2 read, "In Yosemite Nature May Have Its Way Yet." Photographs of this area revealed huge rock and mud debris covering and blocking off parts of one of the park's main entrances on Highway 140. Such powerful images of natural destruction offer a shocking visual contrast to Ansel Adams' photographs of Yosemite taken many years earlier, depicting it as a pristine, timeless, and indestructible paradise.

The jarring juxtaposition of these images invites us to think about the different kinds and functions of landscape photography, and in particular, its meaning for Ansel Adams. Adams' work operated in a number of different contexts: in the Modernist fine-art world of beautiful unique prints; in the mass media, frequently reproduced in Sierra Club calendars and magazines; and in his lobbying for conservationist and environmentalist concerns. Environmentalist, author, technical innovator, storyteller, classical pianist, and teacher, Ansel Adams was primarily known for his landscape photography. The man and his work cannot be reduced and pigeonholed into limiting categories. Like the subtle zones of light in his photographs, our own interpretations should be nuanced and diverse.

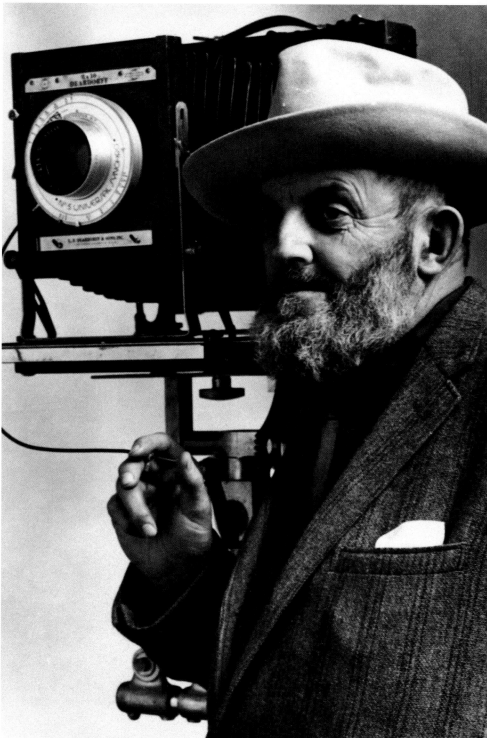

Ansel Adams. Corbis-Bettmann, New York.

His photographs not only serve as visual documents of a particular place eternalized in bountiful splendor, but are re-presentations of the landscape through his personal vision. Similar to an interpretation of a musical score, his subjective approach to nature is orchestrated by his feelings and experience of a particular place. The camera for Adams is a vehicle to convey his deeply spiritual vision, and the creative act for him combines the relationship between photographer, camera, and object photographed. He manipulates and calculates the end result through the selection of a particular lens to negotiate spatial relationships between objects, angle of vision, filters that can produce various tones in order to effect certain moods, and specific film for spectral ranges that control the quality of light. Dawn, late afternoon, or inclement weather were his favorite kinds of light.

Yet light for Adams goes beyond its literal effect—it is a metaphor for spiritual sight, and photography is an art of revelation. Although, at first glance, one can admire the exquisitely austere and glittering snowcapped mountains in his photographs, their physical

Ansel Adams with President and Mrs. Ford in the White House Rose Garden in 1975. Corbis-Bettmann, New York.

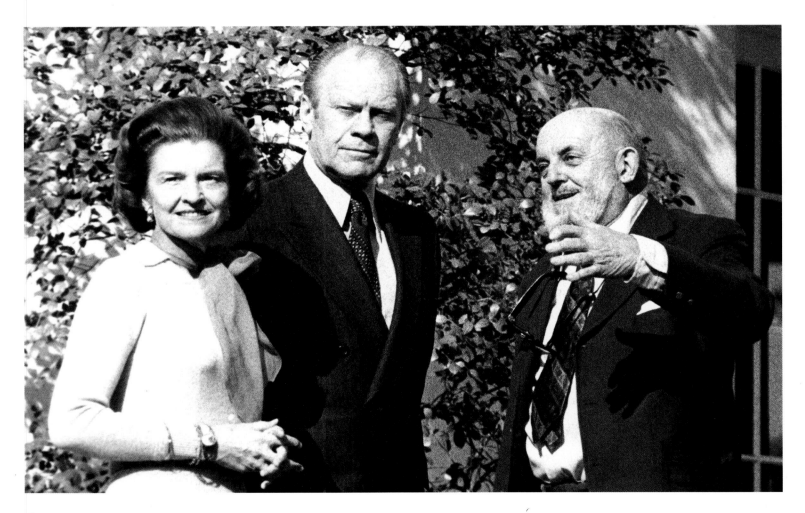

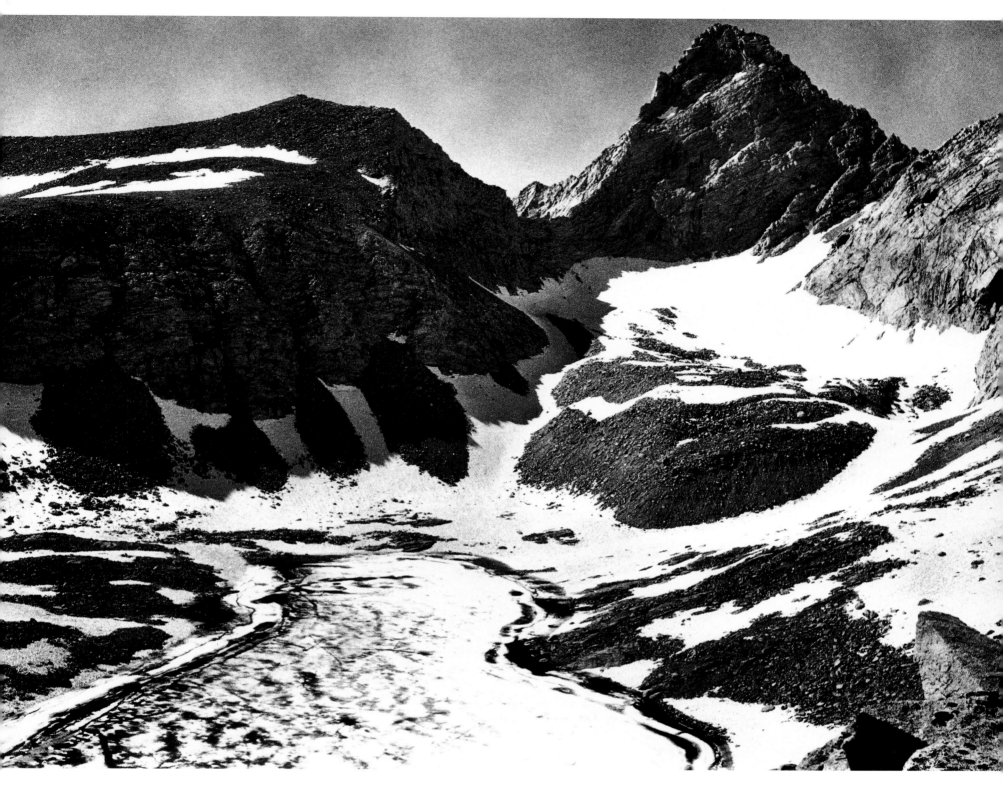

 Junction Peak by Ansel Adams.

beauty radiates beyond the surface—into a metaphysical realm of essences. Although Adams' landscapes are typically characterized as distanced from the subject and heroicized, many of them are immediate and intimate close-ups of flowers, trees, and mountain paths. At the same time that his photographs inspire the awe and terror of the sublime, they can also produce a tame and cultivated pastoral lyricism. For example, in *Junction Peak*, a dazzling light dapples the surfaces of powdery snow and rock. We are invited to enter the scene through a path that moves us through the soothing and dreamy patterns of rock, snow, light, and shadow.

In order to appreciate the inner workings

of Adams' photographs we must spend a long time looking at them, and the closer we look, the more we want to observe them. We become insatiable viewers, and the images, like the actual landscapes that inspired them, become inexhaustible—metaphors for physical, emotional, and spiritual desire. Adams' photographs invite us to pause and examine closely the visible and at times inaccessible details of nature that we might easily overlook with a sweep of our eyes. In this way his vision is a utopian one, pushing the limits of the viewer's consciousness to a higher level of reality. When we pay close attention to the sharp details that Adams carefully emphasizes, including the surface textures of rocks, mountains, flowers, grainy rock crevices, lakes, water, sugary snow, the quality of light, and the freshness and clarity of the air, our senses become awakened. The tactile quality of substances is so palpable that we can almost feel and taste them. We hear the silence, and notice the way sunlight reveals the crunchy surface of snow and suggests its squeaky sounds. Light has a life of its own—as it reveals objects in moments of startling change.

In Adams' photographs the aesthetic of light is a transformative experience that leaves emotional traces by creating the sensation of having been present. A quality of intangibility is "literally" conveyed in a self-portrait of Adams' own semi-transparent shadow that stretches across etched mountains and sky—a ghostly electrified presence that is also a powerful, looming absence. The photograph functions like a souvenir, a memory cherished, a moment eternalized.

Many people who have visited the same areas that Adams photographed are often disappointed by the actual views. They don't conjure up the same magical effects evoked by the photographs. Adams' images possess a fairy-tale quality, capturing and creating the mystery and aura of light as it plays across different surfaces. The commonplace in nature becomes spectacular, producing feelings of wonder. Many of Adams' landscapes are vast panoramas of sublime mountain ranges in front of which the viewer is suspended.

The viewer is both psychologically distanced from and close to these landscapes, poised in a position of anticipation and desire. Although one's focus alternates between near and far, from the detail to the general view, there exists a harmony among the various elements of the photograph that provides another way for both the artist and the viewer to merge with nature. Adams' approach to pho-

tography is both scientific and poetic, with his love of nature omnipresent. Carrying his fragile glass negatives and viewfinder camera into the mountains was such a difficult feat in itself that the very act of photographing became an heroic gesture. Adams also photographed from a platform placed on top of his Cadillac station wagon.

Throughout his long life, the spiritual importance of the mountains for Adams inspired urgent and growing environmentalist concerns, from the conservation and preservation of wilderness areas to larger global ecological interests. Adams' work—and his legacy to the world—brings together art and conservation creatively. His images create both nostalgia for a lost paradise and hope for the future. At the same time that they are transcendent visions of nature, they may be seen as a source of inspiration for future generations interested in promoting conservation and preservation practices. Just as *The New York Times'* photographs of the natural disasters in Yosemite might encourage further conservation efforts, Ansel Adams' images of that same region may also stimulate conservation and preservation awareness and practices. The legacy of Ansel Adams will not let us forget that the land we live on is precious, and that we must work collectively to maintain it for bodily and spiritual sustenance.

Chapter One

BETWEEN EDEN AND TECHNOLOGY

Ansel Adams was born in San Francisco in 1902, a time when burgeoning progressive movements in America cultivated liberal politics, poetic beliefs, and back-to-nature ideals. The progressive democratic tradition of social reform with its return to nature was a response to the complex effects of technological industrialization. The nostalgia for the simpler good old frontier days in the urban West created a trend among the middle and upper classes to leave the big city for suburbia. It was during this time that Adams' prosperous family moved from San Francisco to the outskirts of town.

The Formative Years

Adams' family originally migrated from Northern Ireland to New England in the 1700s. Adams was well versed in the middle-class Puritan values of prudence, enterprise, and hard work. His father, Charles Adams, stimulated and encouraged a love of nature and a frontier style of social ethics. He introduced Adams to the writings and ideas of Ralph Waldo Emerson. Emerson's form of transcendental philosophy celebrated the idea that every living being was connected to a higher Universal spirit, and that religion was a very personal expression. Emerson wrote in *Nature* (1836): "Standing on the bare ground—my head bathed in the blithe air, and uplifted into infinite space—my mean egotism vanishes. I become a transparent eyeball; I am nothing; I see all; the currents of the Universal Being circulate through me; I am part and parcel of God." Nature was regarded as a powerful primordial place that must be regarded with awe and respect. It provided a sanctuary—a haven that brought solace to the people who entered it, countering the threatening, destructive aspects of urbanization.

Adams was also deeply moved by Henry David Thoreau's belief that nature was healing and redemptive for society. Adams' love of and respect for nature and his close attention to detail in his photographs is reminiscent of Thoreau's scrupulous depictions of nature in his writings from *Walden* (1854):

The scenery of Walden is on a humble scale . . . this pond is so remarkable for its depth and purity as to merit a particular description. It is a clear and deep green well, half a mile long and a mile and three quarters in circumference, and contains about sixty-one and a half acres; a perennial spring in the midst of pine and oak woods, without any visible inlet or outlet except by the clouds and evaporation. The surrounding hills rise abruptly from the water to the height of forty to eighty feet . . . They are exclusively woodland. All our Concord waters have two colors at least; one when viewed at a distance, and another, more proper, close at hand. The first depends more on the light, and follows the sky. . . . The sea, however, is said to be blue one day and green another . . . I have seen our river, when the landscape being covered with snow, both water and ice were almost as green as grass . . . But, looking directly down into our waters from a boat, they are seen to be of very different colors. Walden is blue at one time and green, even from the same point of view. Lying between the earth and the heavens, it partakes of the color of both.

"The firmament inlaid with suns is the real cathedral. The interpreters of nature are the true and only priests . . . let us flood the world with intellectual light."

—Robert Green Ingersoll

The Romantic myth of America as an innocent, rural paradise was also fostered by the scenic and panoramic views of the painters of America's nineteenth-century Hudson River School. The primeval landscapes represented in their paintings come very close in tone to the moral and religious sentiment associated with nature that is found in the transcendental writings of Emerson and Thoreau. Such painters as Thomas Cole and Asher B. Durand portrayed the intimate, sheltered, and uncultivated region of the Hudson River Valley as an idyllic mythical Eden, strongly emphasizing the glory and majesty of light.

Light is a beacon and a metaphor for revelation and mystery, and Adams' photographs capture a similar effect of light. For example, in *Peak Above Woody Lake,* shadows approach the creviced rocky terrain covering them like so many transparent veils. The snow forms pockets of caressing light. From the dense, roughly textured trees in the foreground, the viewer moves across and up toward daunting mountain peaks dappled with light.

Cedric Wright, the son of Adams' father's attorney, introduced Adams to the democratic ideas of Walt Whitman and to the writings of Edward Carpenter, a late nineteenth-century social reformer, who believed that industrial progress destroyed poetic and aesthetic values. Adams read Carpenter's book of poems, *Toward Democracy* (1883) on his trip to Kings Canyon in 1925, and was moved by his direct approach to nature. In one poem, "After Civilization," Carpenter writes:

In the first soft winds of spring, while snow yet lay
* on the ground—*
Forth from the city into the great woods wandering,
Into the great silent white woods where they waited
* in their beauty and majesty*
For man their companion to come:
There, in vision, out of the wreck of cities and
* civilizations . . .*
I saw a new life, a new society arise.
Man I saw arising once more to dwell with Nature.

Another important early influence on Adams was John Muir, a Scotch immigrant, naturalist, and writer with a strong passion for the American wilderness. Muir wrote many books about the Sierra Nevada and was one of the first conservationists in the United States. By the middle of the nineteenth century, Yosemite was becoming well known. By 1869, the first Yosemite guide book was published. In 1871, Muir wrote articles for *The New York Daily Tribune* and for the *Overland Monthly*, a major magazine on the West Coast, about the wonders of Yosemite in order to stimulate a love of nature and the preservation of the

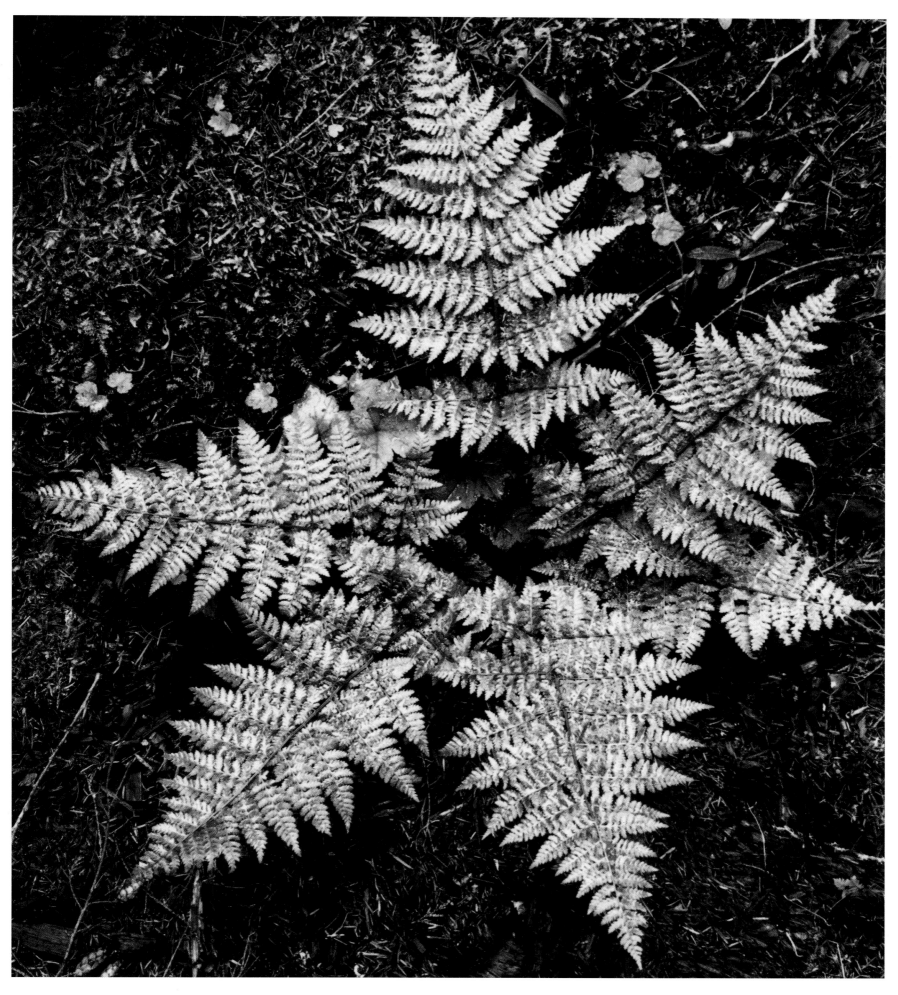

In Glacier National Park by Ansel Adams.

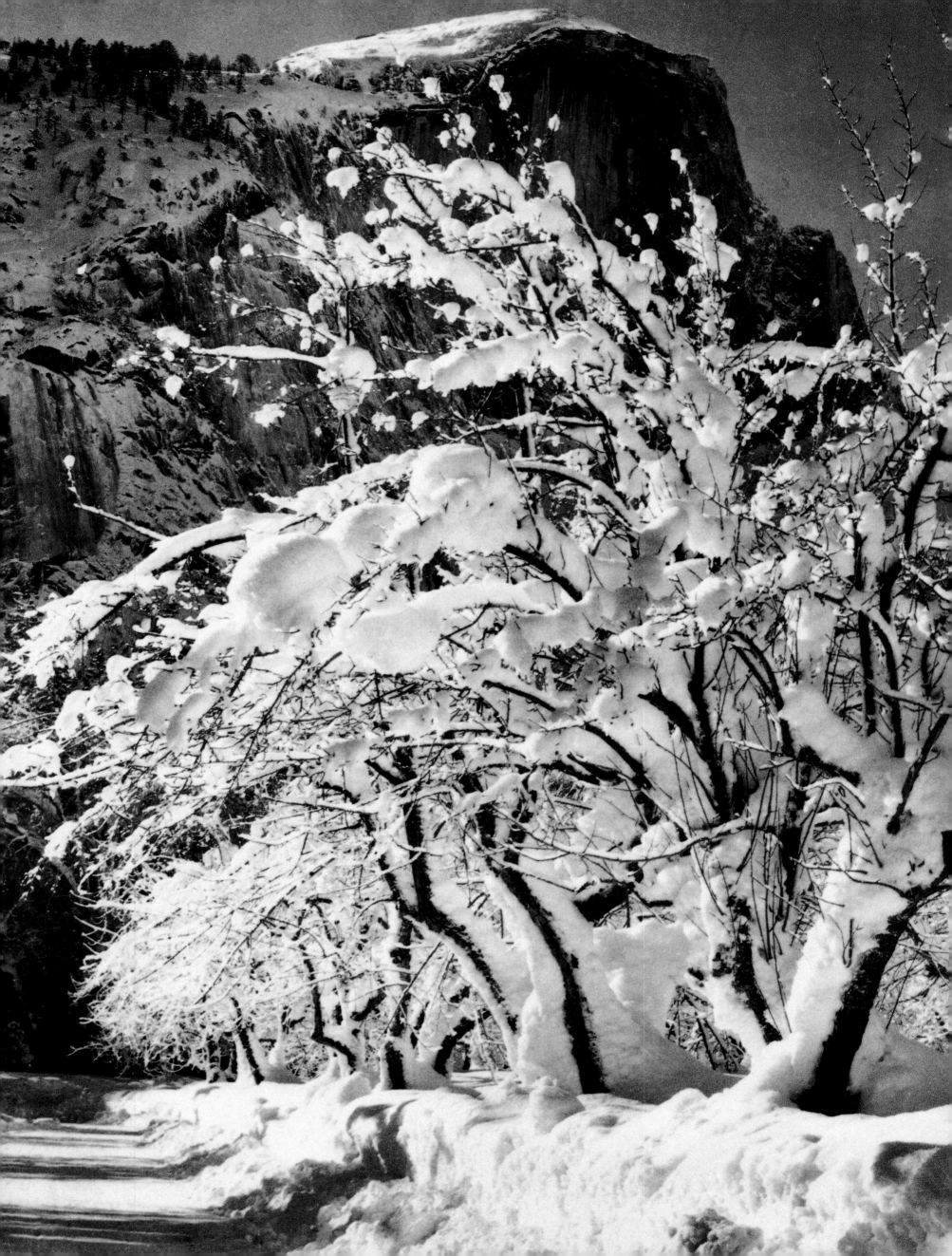

"*Alone in the mountains or some solitary wilderness . . . Divine glory seemed to appear in everything; in the sun, the grass, in the water and all nature. I felt God, if I may so speak, at the first appearance of a thunderstorm.*"
—Jonathan Edwards

Half Dome, Apple Orchard, Yosemite National Park by Ansel Adams.

"A place is not fully a place until it has had its poet. Yosemite and the Sierra Nevada have had two great poets, Muir and Adams."

—Wallace Stegner

forests. He called the Sierra Nevada the "Range of Light." He also wrote a letter from Yosemite Valley to Asa Gray, a well-known botanist, ". . . I ran home in the moonlight with your sack of roses slung on my shoulder by a buckskin string—down through the junipers, down through the furs, now in black shadow, now in white light, past great South Dome white as the moon . . . star crystals sparkling above, frost crystals beneath, and rays of spirit beaming everywhere." Although Adams felt that Muir's writing was too elaborate, he nonetheless shared his love of the wilderness and his conservationist ethics.

Yosemite National Park was born on Oct. 1, 1890, as a result of Muir's impassioned writings about turning the state reserve into a national park. Yosemite became the second national park in America following Yellowstone in 1872. The Sierra Club was formed with John Muir as President on June 4, 1892. It was legally incorporated as the Yosemite Defense Association, in order to protect the park from being stripped by logging and from overgrazing by flocks of sheep. Since that time, the Sierra Club has developed into a major world-wide conservation organization.

After reading J. M. Hutching's book *In The Heart of the Sierras* (1886), which thrilled him, and seeing the diorama of Yosemite at the Panama-Pacific International Exposition in 1915, Adams convinced his family to go to Yosemite for a vacation. Adams brought his first camera, the Kodak Box Brownie, on the trip, and returned to Yosemite every year for the rest of his life.

In 1916, Adams joined the Sierra Club, and by 1919 he had taken extensive trips into Yosemite and the High Sierra. In 1929, after numerous trips with the Sierra Club, he became assistant manager on these mountain outings. Following Muir's conservation and environmental initiatives, Adams became one of the Sierra Club's most prominent leaders. While his early photographs were more visual recordings connected to the spirituality of the Yosemite wilderness, his later work expressed a more personal vision of his experience, and can be compared to a poem or musical score.

Monolith, The Face of Half Dome (Yosemite, 1927) is Adams' first visualization. According to Adams, the visualization process captures the artist's feelings and ideas about a place or object. Through this extremely personal and subjective process, Adams visualized what the final print would look like before the exposure and printing. The photograph is a poetic equivalent of his emotional response to a particular place at a particular time. In *Monolith, The Face of Half Dome*, Adams is not interested in duplicating the realistic light on the mountain, but in capturing the mood and quality of the place. Therefore, although the huge granite rock is visually accurate, he manipulates and harmonizes its tonal values to create a quality of mood that derives from his emotional sensations. Yet Adams also captures the complex geologic history of this region over and over again in his images. Adams thought of the Sierras "as sculptures in stone, rather delicate and gentle, yet not small." He believed that the Sierra range was particularly appealing to travelers because every mountain peak was accessible to the climber.

Land Surveys

The nineteenth-century landscape tradition in photography greatly inspired Adams. Photographers accompanied geological surveys to document various sites, were employed by railroad companies, or had studios in California. The purpose of the land surveys was to create historical documents that explored the Western wilderness and examined its potential for development. These surveys, associated with a liberal tradition, were used to domesticate the wilderness for human consumption.

Lt. George Montague Wheeler was famous for his geological and geographical surveys and explorations west of the 100th meridian. The photographers who participated in these surveys struggled with the unwieldy wet-plate process, and had to set up their cameras at abrupt angles in order to capture the vastness and power of the area. The photographic surveys were primarily "scientific," documentary records of a place, mapping access to new territory. They were not intended to be artistic, personal, or intimate images of ephemeral light or timeless visions like the ones created by Adams. Their aesthetic worth was secondary. Yet it is not surprising that Adams was inspired by the aesthetic merits of many of the images.

Adams admired many of the photographers of the American West, including Frank J. Haynes, whose magnificent *Geyser, Yellowstone Wyoming* (c. 1885), an albumen print, suggests an upside-down world of pouring rain falling from the sky, and William Henry Jackson, whose photographs of the Yellowstone area of the Rocky Mountains geysers and hot springs helped provide support for the establishment of Yellowstone as a national park in 1872. In order to capture the immensity of scale, Jackson was the first photographer, in 1875, to use 20 x 29 inch (50.8 x 73.6 cm) plates. Mule packs were used to carry the heavy equipment. Jackson also brought numerous cameras along with him to make a variety of negative sizes. Carleton E. Watkins was another photographer Adams respected. In *Multnomah Falls Cascade, Columbia River* (1867), the viewer can almost feel the spray as the waterfall of light tumbles over trees and rocks. Although these photographs were commissioned and used for documentary purposes, many were breathtaking images of the western wilderness.

"The question is not what you look at, but what you see."

—Henry David Thoreau

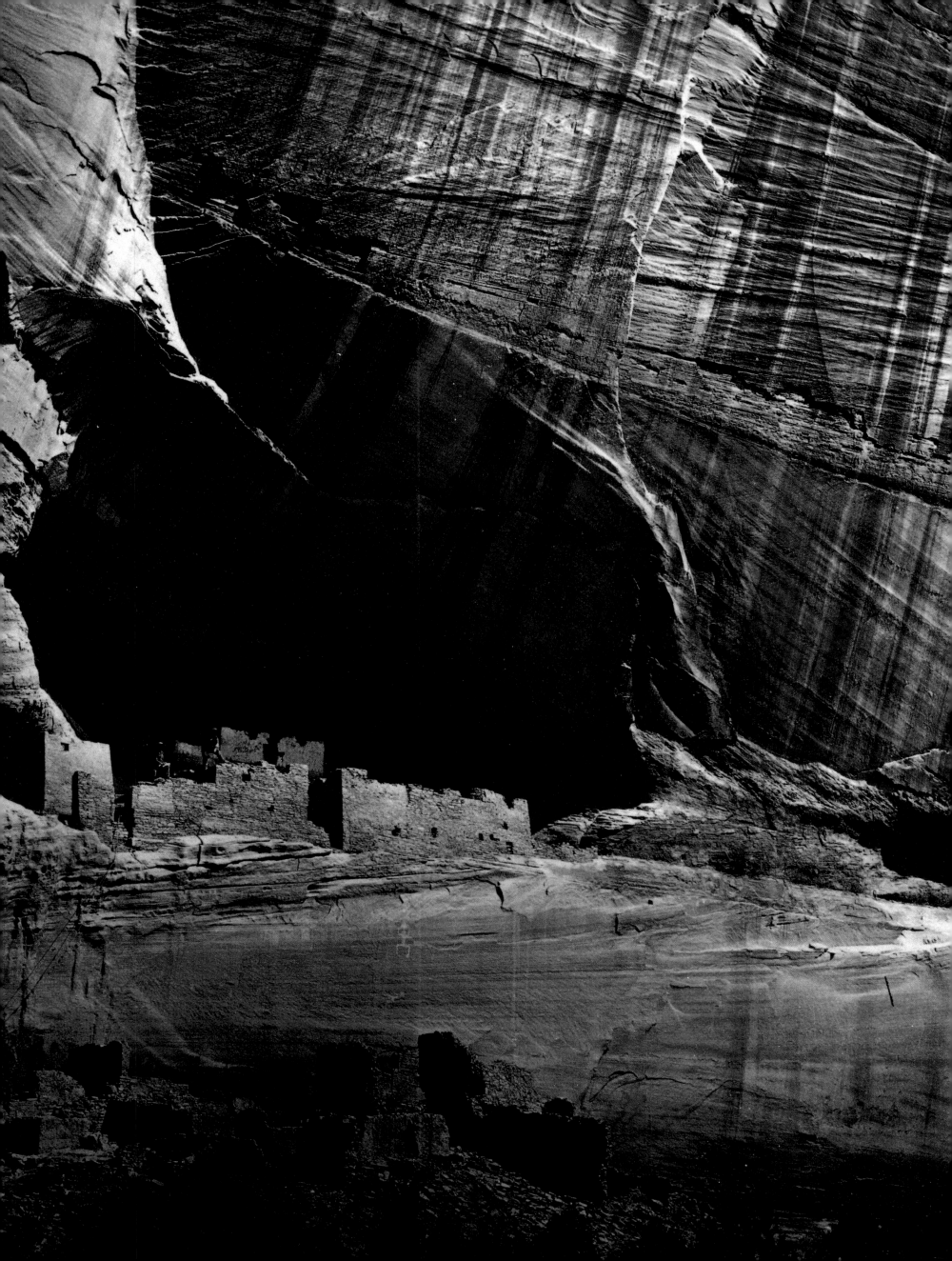

Timothy O'Sullivan was another one of the well-known nineteenth-century photographers who participated in the survey expeditions. He accompanied the United States Army's geographical surveys and explorations of the 100th meridian in 1871. In 1873, the Wheeler Survey mapped out vast tracts of land and collected scientific data. O'Sullivan documented Canyon de Chelly, Arizona. O'Sullivan's albumen print *Ancient Ruins* (Canyon de Chelly, Arizona, 1873) shows the vast wall of mountain rock as light illuminates its weather-streaked surface. The view has a depth of field that includes a foreground of trees and other vegetation, and the viewer is gradually eased into the scene by a diffused and uniform light. Like a ghost town emerging out of a deep niche in the mountain, the remains of an old Native American civilization lie almost camouflaged against the mountain rock.

Photography and Music
Throughout his creative life Ansel Adams made analogies between photography and music. He compared the photographic negative to the musical score and the print to the musical performance.

Adams took numerous photographs of Canyon de Chelly, Arizona. In some of his views, spatial depth is reduced to the point that the rock is in such close proximity to the viewer that its steep verticality is emphasized. In his image of Canyon de Chelly (very similar to O'Sullivan's, which is shown at the left), Adams' use of a strident and dramatic light makes the mountain rock the focal point of the image. A sense of exhilarating grandeur is created as light majestically sweeps across the rock's weathered surface. Their ancient grooved lines appear to be made of light, becoming somewhat abstract upon prolonged viewing. Like skeletal ruins of a lost culture, the dwellings are starkly set against a cavernous niche.

Some nineteenth-century photographers were also involved with documentary projects in the urban centers. For example, Eadweard Muybridge took a fascinating thirteen-plate panorama of San Francisco from California Street Hill, in 1878. The camera in the nineteenth century was used to celebrate the power of technology at the same time that it wanted to protect the purity of the wilderness being threatened by industrialization.

Ancient Ruins in the Canyon de Chelly, New Mexico, 1873 by T. H. O'Sullivan. Gift of David H. McAlpin, The Museum of Modern Art, New York.

Images of the Sublime

Many of Adams' images reveal nature's most sublime aspects—its infinite and complex dimensions appear miraculous. The poignant contrast of near and far objects, specific and general areas in his photographs are metaphors for the earthly and spiritual domains. The viewer is placed over and over again on the precipice of a mountain looking out onto infinite views. The feelings and visual projections the viewer experiences are reminiscent of the sublime feelings felt when looking at paintings by the nineteenth-century German Romantic painter Casper David Friedrich (1774–1840). For example, *Bridal Veil Fall Yosemite National Park, California* (1927) is similar in effect to a Friedrich painting. The viewer stands in front of a scene of rushing white clouds of waterfalls that evaporate into misty veils of fog in the sky. The trees in the foreground both shelter and invite the viewer in. This is indeed a marriage between the viewer and nature.

In another photograph, *Grand Canyon National Park*, a harmony exists between the earth and sky, as the evanescent light and moisture of the enveloping clouds dramatically play

 Canyon de Chelly by Ansel Adams.

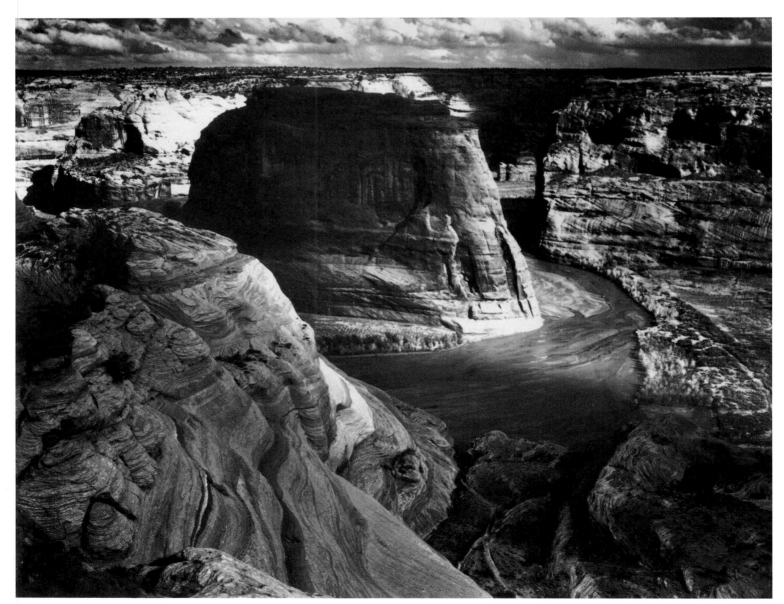

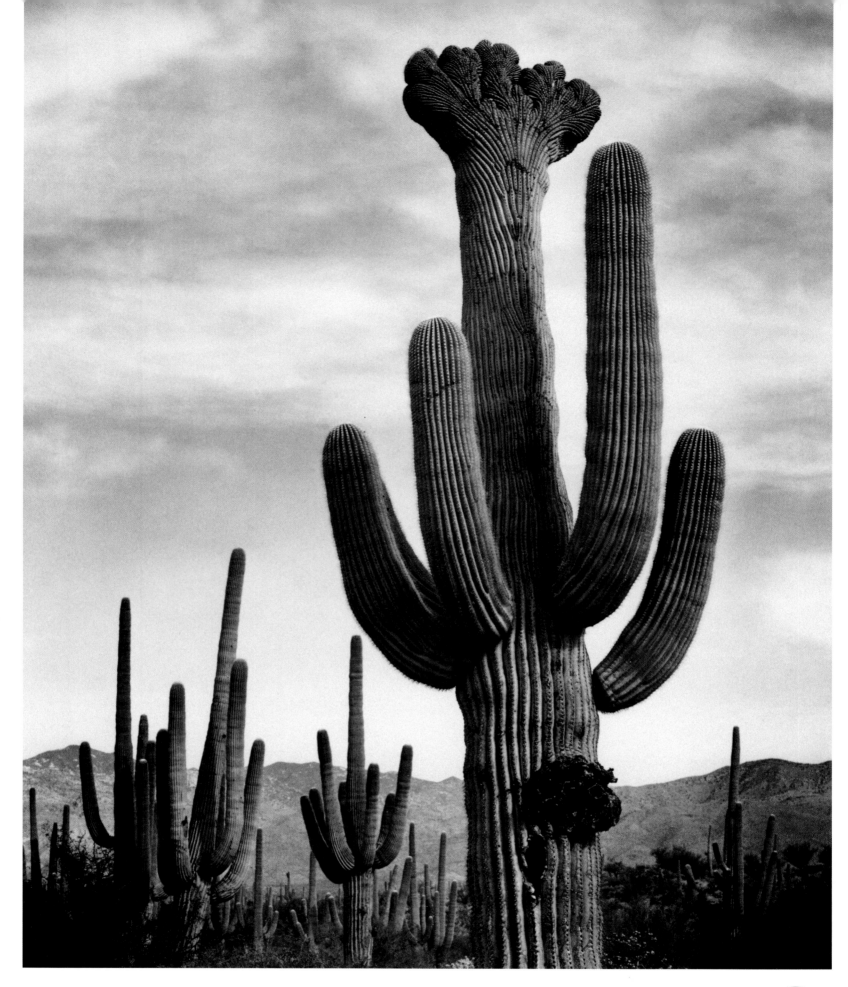

Saguaro, Saguaro National Monument by Ansel Adams.

"Beauty, grandeur, impressiveness in any way, from scenery, is not often to be found in a few prominent, distinguishable features, but in the manner and the unobserved materials with which these are connected and combined."

—Frederick Law Olmsted

against the thick layers of dark mountains. The wondrous complexity of nature is further revealed in *Paradise Valley* and *Grand Sentinel*, where light illuminates crevices, blades of grass, and trees. The mountains take on an almost incomprehensible grandeur, expressing the wonders of nature. When the viewer shifts back and forth between the general areas and the specific details, the mountain becomes an image of abstract forms and textures. This effect is repeated in many of Adams' images. In other images the mountains look like elephant skins—rough, thick, and deeply wrinkled, with creviced folds and lines that carve out their surfaces.

> *"It is a blessed thing to go free in the light of this beautiful world, to see God playing upon everything, as a man would play on his instrument. His fingers upon the lightning and the torrent, on every wave of sea and sky, and every living thing, making all together sing and shine in sweet accord, the one love-harmony of the universe."*
>
> —John Muir

 Paradise Valley by Ansel Adams.

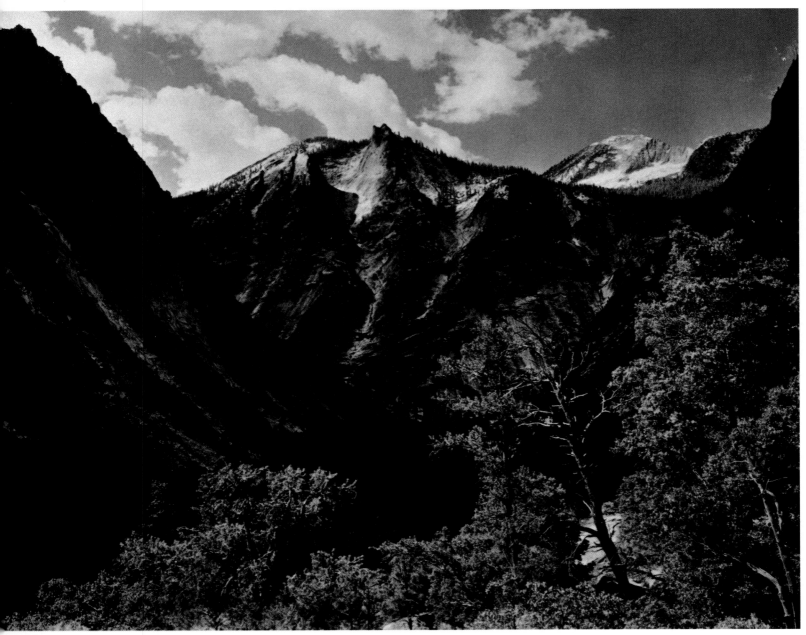

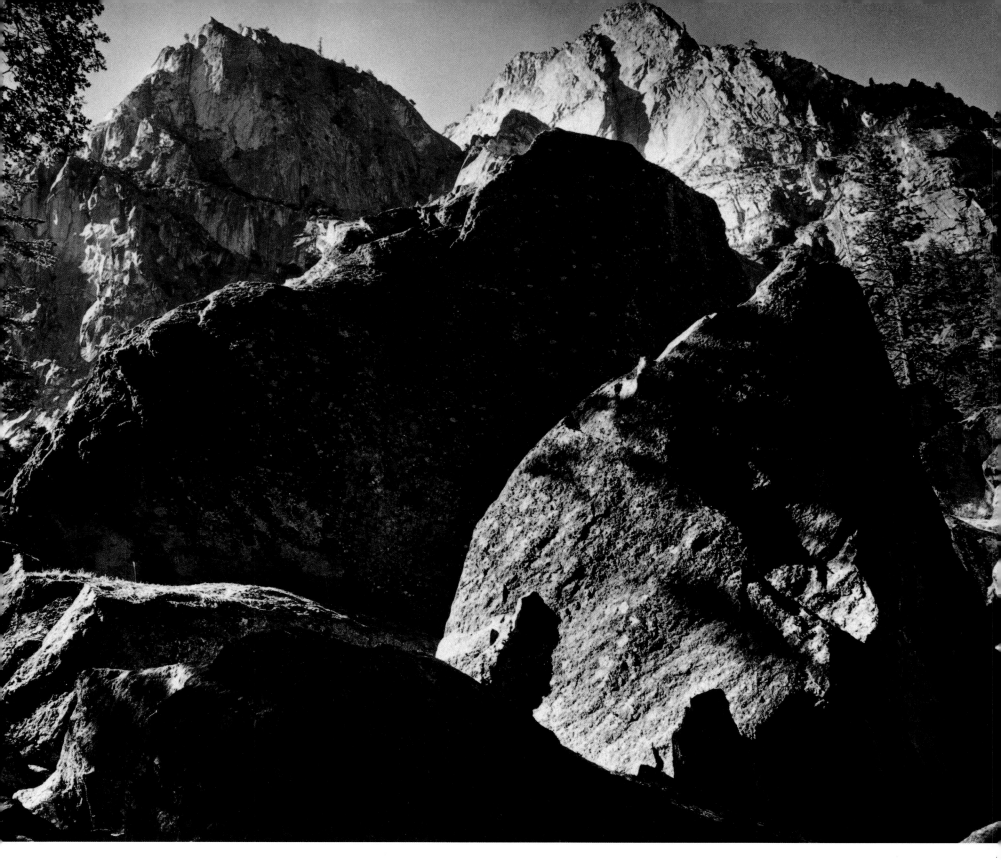

Grand Sentinel by Ansel Adams.

Adams combines different levels of reality in his photographs, balancing elements of light, space, and texture. Glacial lakes, forests, meadows, mountains, canyons, and streams combine to produce a potpourri of pleasures and visual sensations. By allowing the viewer to see an entire scene in its complexity, through a balance of light and framing, Adams represents a non-hierarchical and democratic view of nature. Some of these panoramic views suggest a vision of democracy and the desire for freedom associated with nineteenth-century American ideals of Manifest

"These mountains have a quality of majesty and craggy exaltation that suggest Beethoven to me."
—Leonard Bernstein

23

Coloramas

Ansel Adams had a number of corporate clients throughout his life including *Fortune* and *Life* magazines, and the Eastman Kodak Company. During the 1950s and '60s Adams made over fourteen coloramas of images taken from Yosemite, Death Valley, and Bryce Canyon. These images were 18 x 60 ft. transparencies. He used many cameras for the coloramas, including 35 mm, 21¼ in. square, 4 x 5 in., 8 x 10 in., and a 7 x 17 in. banquet camera. From 1950 until 1990, more than five hundred Kodak Coloramas were installed in Grand Central Station in New York City. The colorama consisted of either a single image or sometimes a composite image divided into three or more sections. They were designed for a general public and promoted photography, and, in particular, Kodak color products. Scenes of Americana—picturesque landscapes or close-ups of people—were frequently depicted as nostalgic ideals, and are connected to the American tradition of the panoramic sublime landscape.

"If conceptual photography concerns ideas and not feelings I wonder how it relates to art. Art should create some feelings or emotions."

—Ansel Adams

Destiny, with its moral obligation to move West and expand areas of land as a sign of freedom from the ruling monarchies overseas. Ironically, one of the unfortunate results of moving westward and acquiring access to Yosemite was the internal colonization of Native Americans, for the American government threw these people off their lands and relocated them.

Adams' work was influenced by a combination of factors: the nineteenth-century American vision of nature as an unspoiled wilderness; the progressive liberal ideas of reform that also saw nature as a source of spiritual revitalization; as well as twentieth-century technological developments. In many respects, all these ideas are identified with the purist aesthetic of modernist photography that celebrates a utopian, transcendent spiritualism.

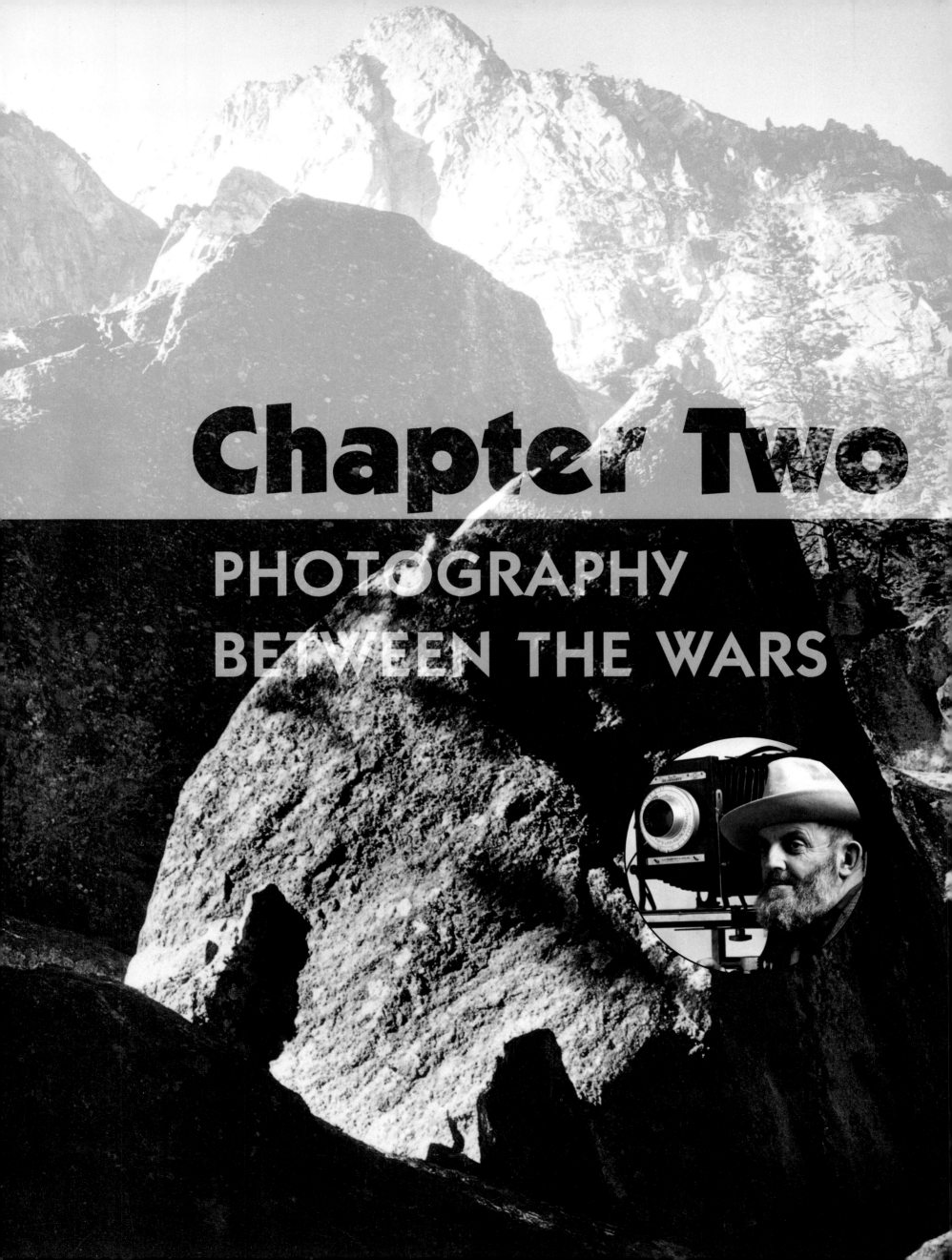

Chapter Two

PHOTOGRAPHY BETWEEN THE WARS

At a party in 1926, Cedric Wright introduced Adams to Albert Bender, a supporter of the arts, who became Adams' patron and sponsored his first portfolio, "Parmelian Prints of the High Sierra," published in 1927. Adams met numerous avant-garde artists from the Bay Area through Bender. During their travels together in California, Arizona, and New Mexico in 1927, Bender introduced him to the literary critic and writer Mary Austin, from Santa Fe. Since Austin and Adams shared similar attitudes toward nature, Bender encouraged them to collaborate on a book about the Taos Pueblo. Mabel Dodge Luhan, a friend of Austin's who lived nearby, helped them obtain access to the restricted Taos Pueblo through her husband Tony Lujan, who was a member of the Pueblo. Their book, *Taos Pueblo*, was published in 1930, and included twelve photographs by Adams and a text by Austin.

Pioneers of Modernism

Artistic Bohemian circles flourished in Santa Fe and Taos during the 1920s. Luhan became famous as "hostess" to important people in the radical political and artistic avant-garde in Europe and America. Many of her guests were artists from Alfred Stieglitz's modern-art circle, who would constantly frequent her large adobe home in Taos. It was at Luhan's that Adams met a number of people who would greatly influence his life and career, including the painters John Marin and Georgia O'Keeffe. A close, lifelong friendship was initiated there between the photographer Edward Weston and Ansel Adams when they met in 1928.

"He [Adams] is perhaps among the last of those romantic artists who have seen the great spaces of the wilderness as a metaphor for freedom and heroic aspirations."

—John Szarkowski

Edward Weston at Point Lobos, 1945, by Imogen Cunningham. © 1945 The Imogen Cunningham Trust.

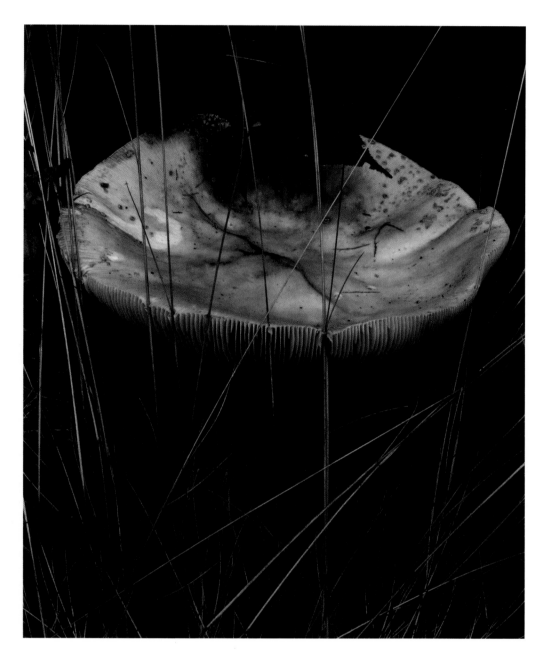

Toadstool and Grasses, Maine, 1928 by Paul Strand. Copyright © 1950, Aperture Foundation, Inc., Paul Strand Archive.

Weston believed that the camera sees more than the naked eye and has the potential to reveal the wonders of the world. His ability to capture close-up, clear details of common objects appealed to Adams' aesthetic sensibility. In Weston's *White Dunes, Oceano, California* (1936), a wall of dunes, stacked at horizontal angles, appears both realistic and abstract, as their wind-streaked surfaces create rhythmic patterns of light and shadow. In Adams' photograph *In Glacier Park*, a star-shaped textured fern rests upon a darker ground of plants, leaves, and evergreen branches. Although Adams' overhead, close-up view creates a tension between two-and three-dimensionality, it is not as abstract as Weston's. Weston looked for the essential form in the structure of nature, and his photographs, in general, appear more abstract than Adams'. Adams wrote a celebratory review of one of Weston's exhibitions in 1931, for a local San Francisco magazine called *The Fortnightly*. Adams and Weston both taught the First Yosemite Workshop, the U.S. Camera Forum, in Yosemite in 1940.

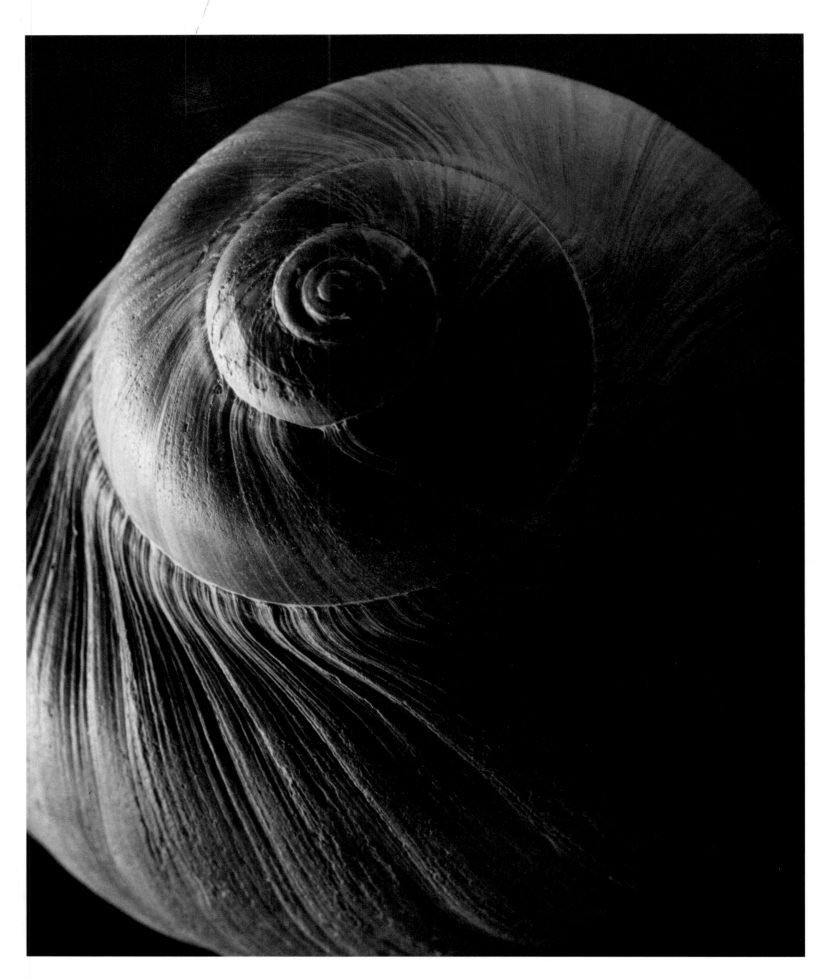

The Spiral Shell, 1921, by Edward Steichen. Gift of the photographer, The Museum of Modern Art, New York. Reprinted with permission of Joanna T. Steichen.

The year 1930 marks an extremely important juncture in Adams' life. When the guest cottages were filled at Mabel Luhan's, the photographer Paul Strand and his wife invited Adams to share their cottage with them. Adams soon discovered Strand's formal and emotional commitment to photography when looking at a group of his negatives. The sharp, clear images, enhanced by subtle tonal gradations, glowing shadows, and unusual vantage points, enthralled Adams. These photographs were diametrically opposed to the blurred edge and moody romanticism of Edward Steichen's pictorialism, and gave the viewer a new way to observe everyday life.

Strand's commitment to photography as an art form had such a powerful impact on Adams that he decided to become a professional photographer. He abandoned his career as a concert pianist, opened a photography studio in San Francisco, and started his own commercial business. He photographed catalogs and industrial reports for various companies, including Gumps, the San Francisco Specialty Store, and Yosemite Park and Curry Company, which ran public concessions in Yosemite. Adams' commercial career existed alongside his artistic one well into the 1970s.

Group f/64

In 1931, Adams got together with a number of other photographers, including Imogen Cunningham, Willard Van Dyke, Sonya Noskowiak, Henry Swift, and John Paul Edwards, and with the help of Weston, formed the Group f/64. They had their first exhibition on November 15, 1932, at the M. H. de Young Museum in San Francisco. Focusing on formal issues and personal exploration rather than on social or political agendas, the Group f/64 believed that photography should be faithful to the qualities inherent in the medium without manipulating the image. They favored the sharp, clear details of pure or straight photography over the painterly, soft-edged pictorialism that concentrated on the similarities between painting and photography.

Their name, f/64, refers to the smallest aperture stop on the camera lens, which provides the greatest depth of field and clarity of focus. Using smooth, glossy paper to bring out every detail and to emphasize a full range of values from pure white to deepest black, a large-format view-camera, and printing by contact sheet rather than by enlargement, the Group f/64 celebrated simple, everyday subjects from nature and technology

Excerpt from Group F/64 Manifesto

"The members of Group f/64 believe that photography, as an art form, must develop along lines defined by the actualities and limitations of the photographic medium, and must always remain independent of ideological conventions of art and aesthetics that are reminiscent of a period and culture antedating the growth of the medium itself."

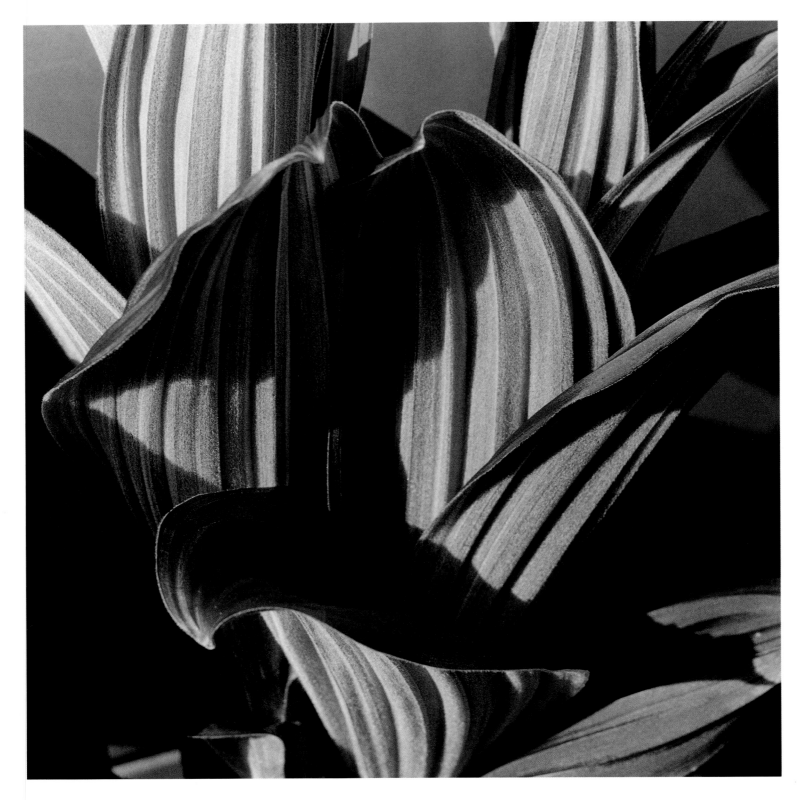

False Hellebore, 1926, by Imogen Cunningham. © 1926 The Imogen Cunningham Trust.

photographed in natural light. Balancing both form and structure, and near and far objects with explicit clarity, their visual images reflect the precision and directness of the American Imagist poets Ezra Pound, H.D. (Hilda Doolittle), and T.S. Eliot.

But Alfred Stieglitz, who earlier in the century established photography as a legitimate high-art form at his gallery, the Little Galleries of the Photo Secession at 291 Fifth Ave, New York, exercised the most vital impact on them. Similar to the modernist painting exhibited in his gallery, the photographic fine print was also intended to inspire contemplation and a transcendent spiritualism. For Stieglitz, it was important that photography engage with issues of self-referentiality, and focus on the formal qualities of the medium. This is evident in his own famous series of sun and clouds from the 1920s called *Equivalents,* taken with a 4 x 5 inch (10.1 x 12.7 cm) graflex camera. In this series, the sky, composed of a combination of intense blacks

"When the photograph is a mirror of the man and the man is a mirror of the world then spirit might take over."

—Minor White

and luminescent whites and grays, oscillates between realism and abstraction, spatial depth and flatness. These unsentimental images were equivalent to his feelings, thoughts, and emotions.

In 1933, Adams met Stieglitz at his New York gallery, An American Place, a gathering spot for various avant-garde musicians, writers, and artists in the '30s. That same year, Adams opened his own creative photography center in San Francisco, called the Ansel Adams Gallery. In 1936, Stieglitz gave Adams a solo exhibition at An American Place, which was recreated at the Center for Creative Photography in San Francisco in 1982, and called "Ansel Adams at an American Place."

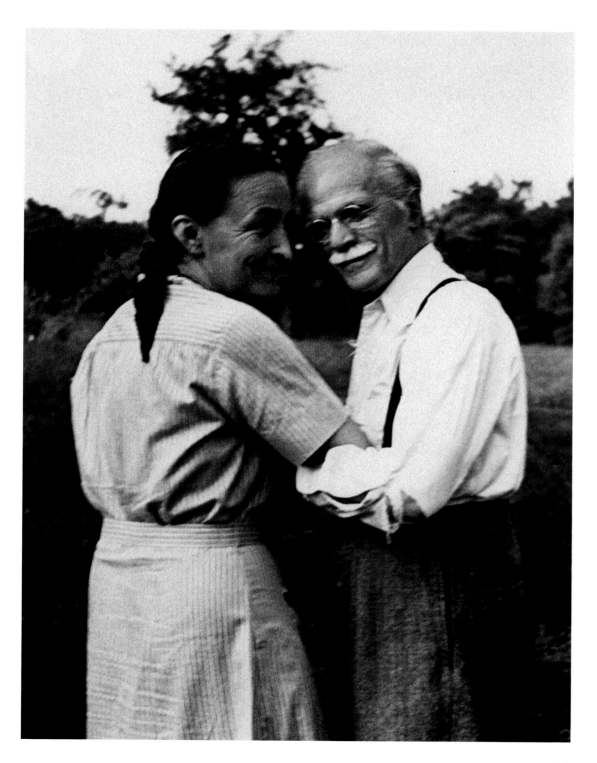

Georgia O'Keeffe and Alfred Stieglitz, 1930s, by Josephine Marks. Courtesy of Sue Davidson Lowe.

The European Avant-Garde

The Group f/64 was one of many diverse international modern art movements that reshaped the world of photography during the 1920s and '30s. At this time European photographers used formalist, social, political, and psychological approaches to alter the viewer's vision and transform consciousness. They desired to change society in a positive way. They used various techniques to accomplish their utopian goals: the close-up, unusual angles, solarization (the re-exposure to light of negatives or film in the developing emulsion), brulage (burning the edges of a negative), and rayographs (exposing the object on light-sensitive paper to light), also referred to as photograms, collage and montaged images that were cut, cropped, and combined in new ways.

After World War I, the Dadaists, disillusioned with what they considered ineffectual transcendent and spiritual art, made art or "anti-art" using visual and verbal puns to attack the bourgeoisie and the fascist movements. Some of their social and political commentaries can be seen in the ironic and critical photomontages of the German avant-garde artists Hannah Hoch and John Heartfield.

The New Vision in Europe was another group cultivated by a complex and diverse artistic and social community. The German Bauhaus, with its analysis and reconstruction of industrial society, desired to improve ordinary lives by rediscovering their own surroundings. Breaking down distinctions between high and low art and culture by

"The painters have no copyright on modern art! . . . I believe in, and make no apologies for, photography: it is the most important graphic medium of our day. It does not have to be, indeed cannot be—compared to painting—it has different means and aims."

—Edward Weston

The Street, 1929, by László Moholy-Nagy. Anonymous gift, The Museum of Modern Art, New York. © 1997 Artists Rights Society (ARS), New York/VG Bild Kunst, Bonn.

Reflection, 1932, by Man Ray. Gift of James Thrall Soby, The Museum of Modern Art, New York. © 1997 Artists Rights Society (ARS), New York/ADAGP/Man Ray Trust, Paris.

"The photographer's problem is to see clearly the limitations and at the same time the potential qualities of his medium . . . The fullest realization of this is accomplished without tricks of process or manipulation through the use of straight photographic methods."

—Paul Strand

attempting to merge the worlds of art and science was for them a positive response to the machine age. The Hungarian artist, László Moholy-Nagy, a painter, sculptor, designer of light machines, and teacher, a major figure of New Vision Photography at the German Bauhaus, used unusual camera angles and experimented with light and form to produce new ways of seeing things. By imbuing industrial life with a creative spirit, he saw photography as an aid in social reform, writing in "From Pigment to Light" (1936): ". . . the clear recogni-

tion that apart from all individual emotion, apart from the purely subjective attitude of the spectator, objective factors determine the effectiveness of an optical work of art: factors conditioned by the material qualities of the optical medium of expression." Moholy-Nagy's objective attitude contrasted with Adams' more personal and emotional approach to photography.

The "New Vision" sensibility can be seen in Albert Renger-Patzsch's photographs. His book *The World is Beautiful* (1928), includes close-up

views of machine and plant forms that are transformed into beautiful aestheticized abstractions. Karl Blossfeldt, another German artist, photographed images of individual plants at close range against a neutral background. He compiled many of these images for his book *Plant Forms in Nature* (1930). Their scientific names appear as captions next to each image. It is difficult to believe that these images are plants, for, amazingly transformed, each plant looks like an industrial or anthropomorphic form. Although here the camera is used to deceive the eye, the actual "reality" of the object has not been altered—only the viewer's perception of it. Thus photography is not only a transparent medium, but a manipulative and constructive one.

The American photographer Man Ray participated in both the Dada and Surrealist movements, shifting back and forth between commercial and fine-art photography. He experimented with various techniques that altered vision and the viewer's perception of reality. His rayographs expose the optical unconscious of the viewer by revealing the commonplace in new, strange, disturbing, and pleasurable ways.

Cotton Picker, San Joaquin, California, 1938, by Dorothea Lange. Purchase, The Museum of Modern Art, New York.

Ansel Adams' Favorite Photographers

Some of Ansel Adams' favorite photographers were Ernst Haas, Joel Meyerowitz, George Tice, Jim Alinder, Olivia Parker, Jean Dieuzaide, Chris Rainer, John Sexton, Don Worth, Paul Caponigro, Jerry Uelsmann, Wynn Bullock, Minor White, Bill Brandt, Andre Kertesz, Josef Sudek, Lucien Clergue, Brassai, Eugene Smith, Eliot Porter, Philip Hyde, Mary Ellen Mark, Nicholas Nixon, Bill Clift, Roy DeCarava, Brett Weston, Wright Morris, and Arnold Newman.

In Russia, the desire to expose contemporary social existence was accomplished through experimental photography that created strange angles of vision that would disorient and destabilize the viewer in order to change their perception of reality. Most of the European movements engaged in radical, manipulated approaches to photography that differed greatly from the Group f/64's straight, pure photography.

Documentary Photography in America

During the Depression in America in the 1930s, documentary photography was extremely popular and played an important social and economic role. Many photographers were hired to work for the Historic Section of the Resettlement Administration, under Franklin Delano Roosevelt's New Deal, later called the FSA (Farm Security Administration). The director of this program was Roy E. Stryker. More than 270,000 images were taken by photographers between the years 1935 and 1942 that documented the work and life of displaced farmers, drought, and economic depression. They also attempted to capture the more positive facets of rural life. These images were to be used to help provide jobs and to record the effects of relief and reconstructive programs. The photographs that were submitted to the government were often cropped and edited. (The negatives are on file in Washington, D.C., at the Library of Congress.) The FSA photographs raised a lot of questions about the legitimacy of social documentation. Some people saw them as images of reality, while others saw them as pure propaganda.

Dorothea Lange, one of the FSA photographers, stimulated and encouraged Adams' interest in documentary photography in the 1930s and

"People are always trying to put photographers in a niche and categorize them. Now, everyone—I don't argue the point—everyone calls me a documentary photographer. I'm not. I did that for ten years and enjoyed it immensely."

—Dorothea Lange

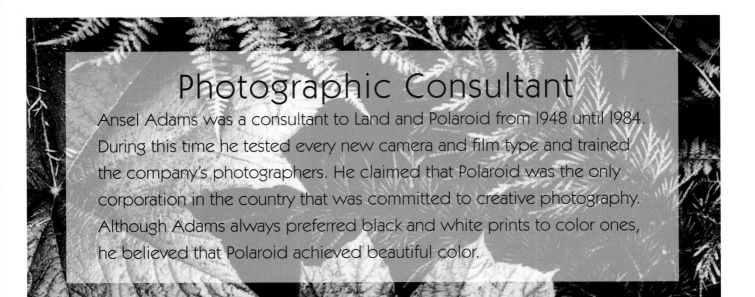

Photographic Consultant

Ansel Adams was a consultant to Land and Polaroid from 1948 until 1984. During this time he tested every new camera and film type and trained the company's photographers. He claimed that Polaroid was the only corporation in the country that was committed to creative photography. Although Adams always preferred black and white prints to color ones, he believed that Polaroid achieved beautiful color.

'40s. He valued their friendship and admired her work. Although he strove to combine art, social commitment, and a growing conservation activism, he had doubt about the documentary mode. He believed that too often, reportage was separated from emotional, personal, and creative expression. Lange raised issues for Adams about his own work, and the importance of the documentary for communicating important social messages and realities. Lange's compassionate images of migrant workers instigated action from the government toward helping to relieve their suffering. During World War II, Adams and Lange made photographs of the Japanese-Americans interned at the Manzanar Relocation Camp, in the Owens Valley of the High Sierra. His project culminated in the book *Born Free and Equal* (1944), which gave him a new understanding about documentary photography. Over 110,000 Japanese-Americans were interned, and Adams wanted to represent them in a dignified, positive, and sympathetic way. He claimed he didn't want to create sentimental or propagandistic pictures, but ones that revealed hope, pride, strength, and accomplishments under difficult conditions. Adams depicted the internees as powerful and courageous survivors, often idealized, photographing them from upward angles

against the sky and integrating them with the landscape. He believed that the natural beautiful landscape of the Owens Valley nurtured them. In 1944, he exhibited sixty-one photographs of Manzanar at the Museum of Modern Art in New York. Yet critics attacked him for creating propaganda, claiming that by showing one-dimensional, homogeneous images that were not psychologically complex, he neglected to show the "reality" of the Japanese-Americans' suffering and victimization.

Photography as a Fine Art

In 1940, the first Department of Photography was established at the Museum of Modern Art, with Beaumont Newhall as its director. Newhall, previously a librarian at MoMA, organized a history of photography exhibition in 1937, "Photography: 1839–1937." Adams was included in the exhibition. Newhall, influenced by Moholy-Nagy, provided less of an historical context for the photographs, and focused more on the aesthetic, eternal, and transcendent moments. Photography was seen as revelatory. Newhall, with the help of Adams (who met him and his wife Nancy Newhall in 1939), and David H. McAlpin, a wealthy stockbroker (related to the Rockefellers, and whom

Minor White in Vermont, 1971, by Richard Chase Albertine.

Adams recommended to Newhall) turned photography into a fine art. They constructed an "art history" of photography at MoMA, and changed the entire way in which photography was received at the institutional level. It became a Museum Art and part of the Modernist canon. Adams and Stieglitz helped assemble the collection, and McAlpin contributed funds for MoMA to purchase the photographs. He joined the MoMA board as founding chairman of the committee on photography. McAlpin brought Adams into MoMA as Vice Chairman of the new department to help Newhall organize exhibitions. The first exhibition, "60 Photos: A Survey of Camera Aesthetics,"

emphasized the creative potential of photography and utilized the vocabulary of uniqueness, authenticity, and personal expression.

The Zone System

In 1941, Adams popularized and codified the ten-step Zone System. This system calculated the exposure and development of film to precise modulations of grays that would reveal nature's details in sharp clarity. The Zone System was not simply intended to create a beautiful picture but was used to evoke deeper emotions. Adams used the Zone System to produce his famous image *Moonrise,*

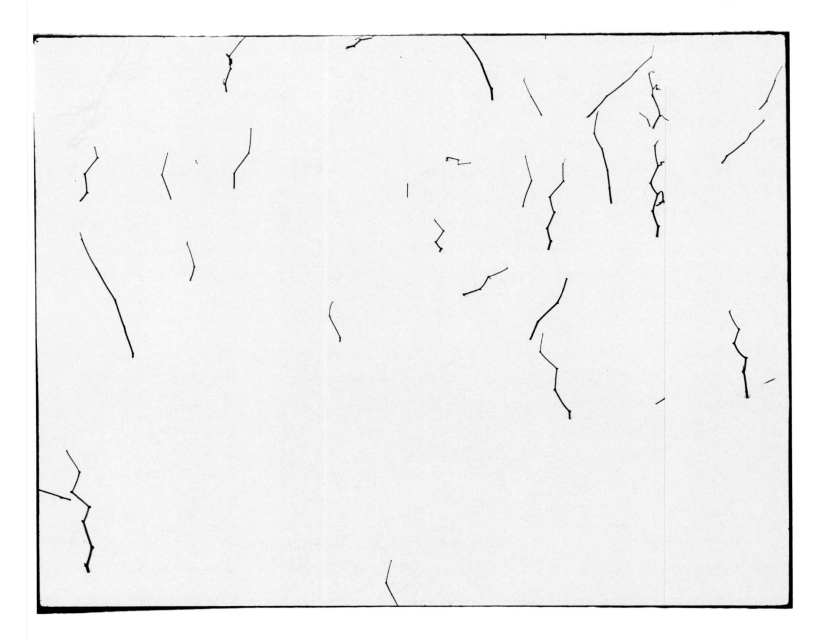

Grasses in Snow, n.d., by Harry Callahan. Copyright Harry Callahan.
Courtesy of PaceWildensteinMacGill, New York.

Hernandez, New Mexico (October 31, 4:05 P.M., 1941) while he was on commercial assignment for the United States Potash Co. in Carlsbad, New Mexico. The Zone System consisted of ten zones of tonal scale that extended from pure white, zone IX, to pure black, zone O. The range of light was measured in each part of a scene and related to specific zones of tone in the final print.

Although Adams and the Zone System influenced many photographers with formalist leanings, it was Harry Callahan and Minor White, two American photographers, who were deeply affected by Adams' evocation of the personal, mysterious, and emotional aspects of photography through technical precision. While Callahan

"We can reprint our negatives from a real place in ourselves all our lives and expect to find new insights."

—Minor White

"Photography began for me with people and no matter what interest I have given plant life, I have never totally deserted the bigger significance in human life. As document or record of personality I feel that photography isn't surpassed by any other graphic medium."

—Imogen Cunningham

attended a workshop for amateur photographers in Detroit in 1941, Adams traveled there to give a demonstration and a talk on straight, unmanipulated photography. Most of the camera clubs during this time were interested in pure photography, believing in the expressive use of formal and technical experimentation. Callahan, who later taught at the Rhode Island School of Design and the Institute of Design in Chicago, was especially influenced by Adams' photographs made along the ground. In many ways, his work is more abstract and technically experimental than Adams'. For

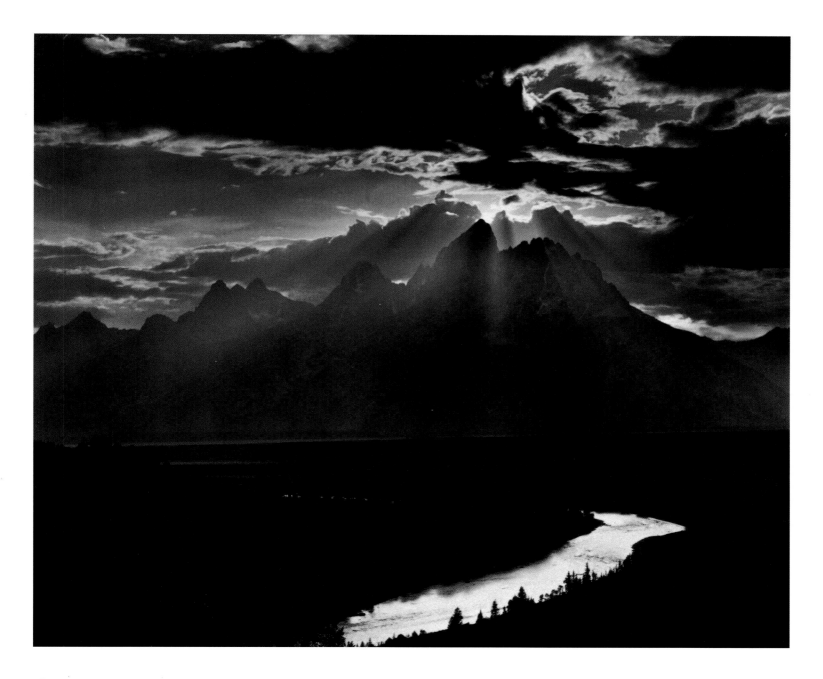

Grand Teton National Park, Wyoming, 1959, by Minor White. Reproduction courtesy of The Minor White Archive, Princeton University. Copyright © 1982 by The Trustees of Princeton University. All rights reserved.

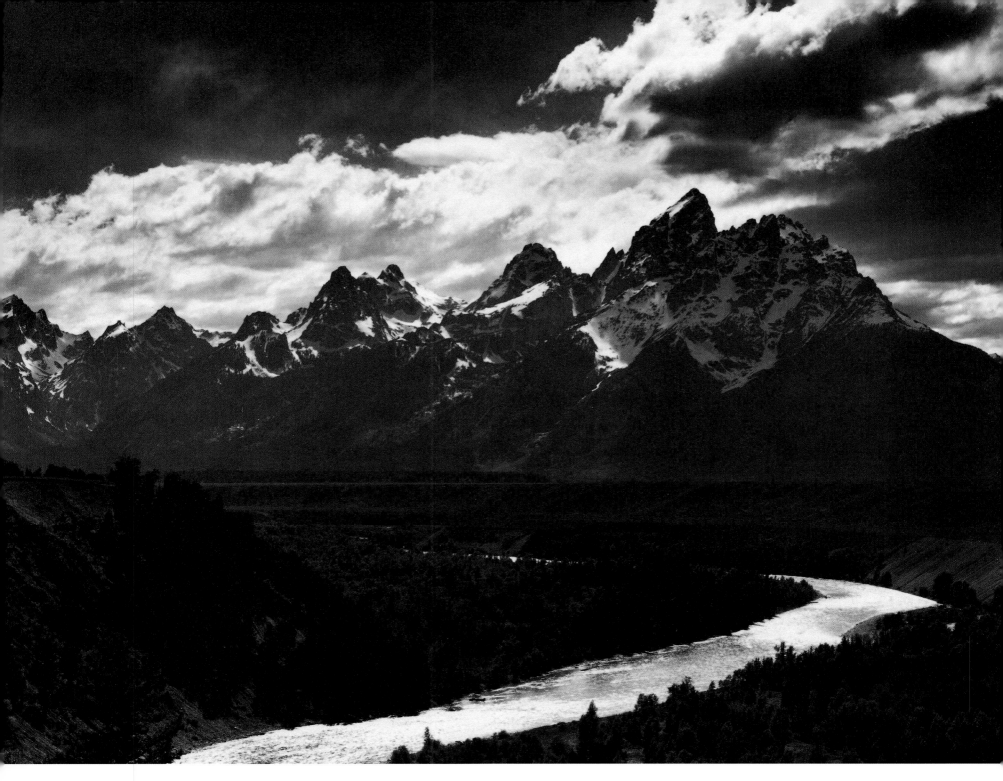

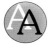 *The Tetons and the Snake River* by Ansel Adams.

"The Term f/64 is a technical one: it is the measure of the effective diameter, or aperture, of a photographic lens in terms of its focal length."

—Beaumont Newhall

example, Callahan's *Grasses in Snow* (1943), which Adams purchased, does not use a full range of tone but a high contrasting light. The viewer is mesmerized by the otherworldly, mystical quality of the weeds which borders on abstraction, creating a delicate pattern of black lines against the white ground.

In 1946, when Adams founded the Department of Photography at the California School of Fine Arts in San Francisco, later named the San Francisco Art Institute, he hired Minor White to teach with him. The photographs of Minor White powerfully convey a mysterious, personal, and mystical quality. White's photograph, *Grand Teton National Park* (1959), reveals a vista of mountains, sky, land, and river as it snakes through the landscape. Beams of sunlight break through storm clouds, illuminating the silver-grey

Self-Portrait on Geary Street, 1958, by Imogen Cunningham. © 1958 The Imogen Cunningham Trust.

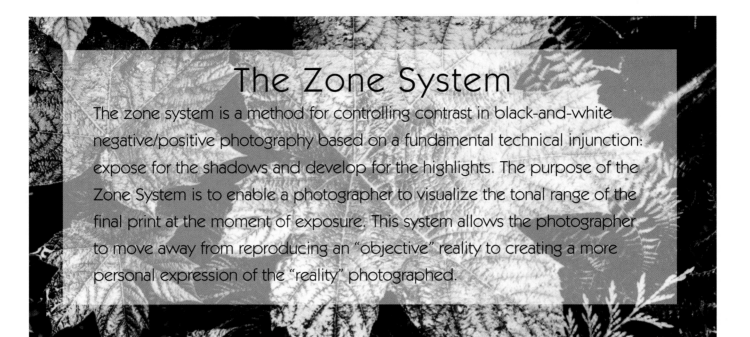

The Zone System

The zone system is a method for controlling contrast in black-and-white negative/positive photography based on a fundamental technical injunction: expose for the shadows and develop for the highlights. The purpose of the Zone System is to enable a photographer to visualize the tonal range of the final print at the moment of exposure. This system allows the photographer to move away from reproducing an "objective" reality to creating a more personal expression of the "reality" photographed.

river, surrounded by a darkened landscape. The scene creates a moody, mysterious sublime symphony of light and form. Although Adams' *The Tetons and the Snake River* (Grand Teton National Park, Wyoming, 1942) is less lyrical and dramatic, it is also powerful in its own way. The viewer is suspended in front of a similar landscape. The Snake River moves the viewer both forward and back toward the majestic mountain peaks. The tumultuous clouds allow light to break through and brighten the river. Adams reveals more texture and detail of the landscape, while White creates more mood through the heightened contrast of darks and lights.

In 1952, Adams, Lange, and White founded *Aperture* magazine, a creative photo-journal, with support from the Polaroid Corporation, thus opening new doors for their own work, as well as for the photographers who would follow them.

"I want a picture to reflect not only the forms but what I had seen and felt at the moment of exposure."

—Ansel Adams

Chapter Three

BETWEEN ART AND CONSERVATION

Ansel Adams' work exists between modernist art practices that glorify the landscape and conservation interests that focus on the ruinous effects of technology on the land. Yet how can conservation policies best be influenced by photography and by what kinds? According to Adams, he never intentionally made a creative photograph that related *directly* to environmental issues, but allowed his works to be used for conservation concerns. He believed that beautiful images of the wilderness could inspire and promote conservation activism on the part of the viewer. In many ways his photographs are a nostalgic reminder of the grandeur of the earth. Both nostalgic and utopian, these exhilarating images have shaped the viewer's notion of the wilderness as a place of liberation and freedom, and express a desire for harmony and higher spiritual awareness.

Traces of Eden

The wilderness for Adams was always a place of spiritual renewal. As a young man, he encouraged people to visit it regularly as a respite from the stresses of daily urban life. Earlier in the twentieth century, trails and roads were built to make the national parks more accessible to travelers so they could appreciate the natural beauty of the land. But with increasing exploitation of the national parks, overrun by tourists, marketing, advertising, consumer goods, and outdoor recreation areas, including ice-skating rinks and bowling alleys, Adams revised his attitudes on conservation, and advocated conservation laws that would limit access to the wilderness areas. His concerns with environmental issues and land preservation continued to evolve throughout his life.

By the 1930s, Adams had rallied against the Curry Company's commercialized marketing approach in Yosemite. He didn't want his photographs to attract tourist money alone, but wanted them used to further the public's appreciation of the park's natural beauty, and to preserve nature as a wilderness sanctuary. Although he believed in science and technology for social improvement, he also considered their negative effects on the earth—their potential for destroying the planet.

Wilderness conservation began earlier in the Sierra's history, with the creation of Yosemite and Sequoia national parks. A year after the establishment of Sequoia National Park in 1890, John Muir proposed an extension to include the Kings Canyon area in California. He began writing about the natural history of these forests, commenting

Boulder Dam, 1941 by Ansel Adams.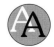

*"Only that people can thrive that loves its land
and swears to make it beautiful."*

—Edward Carpenter

on how hydraulic mining led to environmental degradation, observing that hoses washed away mountainsides and delivered sediment into rivers in northern California, obliterating plant and animal life. During the gold rush of 1849, giant sequoias were cut down. In 1891, the creation of the first forest reserves led to the establishment of federally regulated national forests.

Muir also advocated that the wilderness be used for human renewal. He wrote in *Our National Parks* (1901): "Thousands of tired, nerve-shaken, over-civilized people are beginning to find out that going to the mountains is going home; that wilderness is necessary; and that mountain parks and reservations are useful not only as fountains of timber and irrigating rivers, but as fountains of life."

Even earlier in the nineteenth century, William Henry Jackson's photographs of the Yellowstone area of the Rocky Mountain's geysers and hot springs, and Carleton Watkin's photographs of Yosemite contributed to the history of conservation legislation. In his autobiography *Time Exposure* (1940), Jackson recalled that his photographs "helped to do a fine piece of work: without a dissenting vote, Congress established Yellowstone as a national park, to be forever set aside for the people. And on March 1, 1872 with the signature of President Grant, the bill became law." By 1916, Congress created a National Park Service to govern the sixteen national parks and twenty-one national monuments under the National Parks Act—a mandate to conserve scenery and natural history for the future.

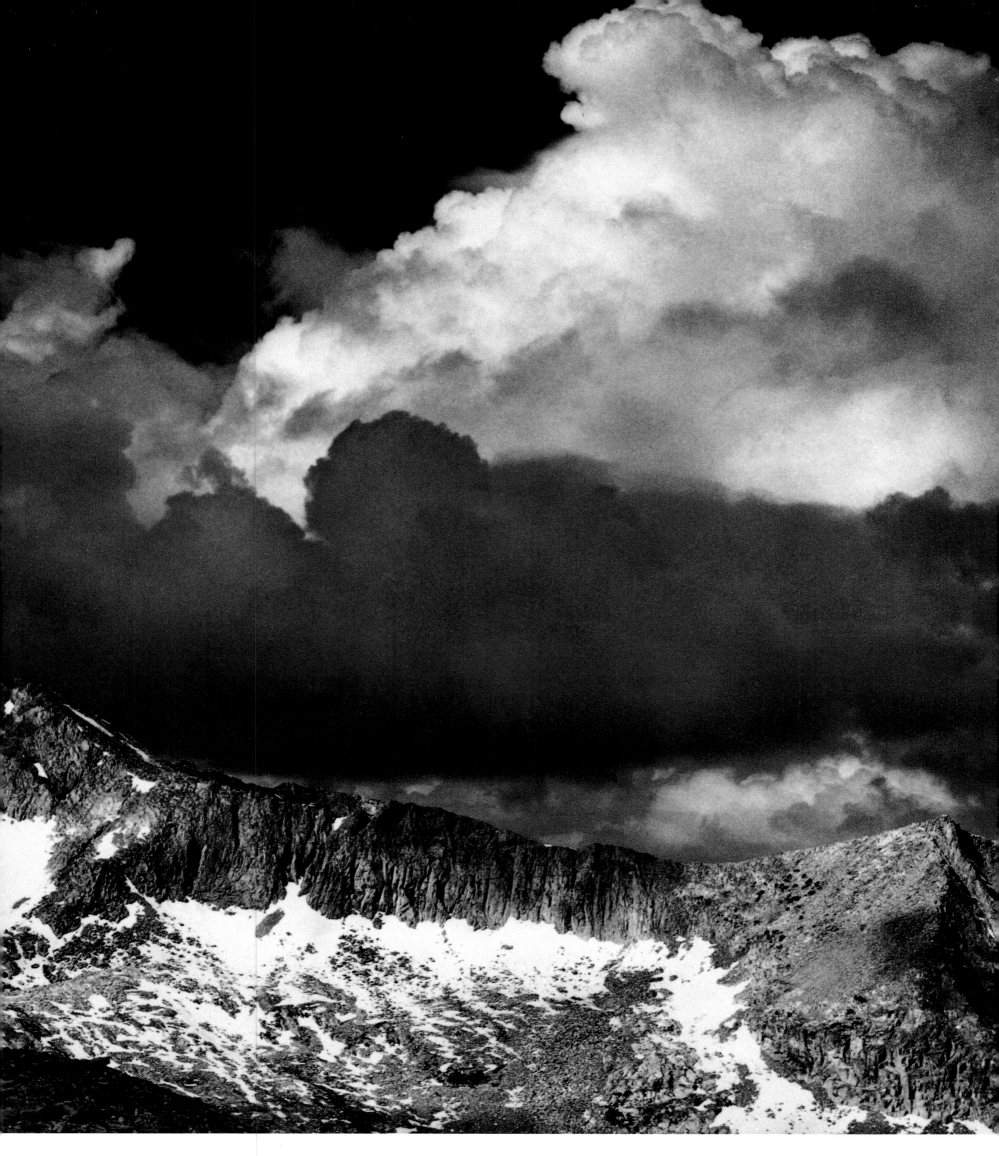

 Clouds-White Pass by Ansel Adams.

Kings Canyon National Park

The 1930s were important years in the history of conservation in America. Franklin Delano Roosevelt, in the tradition of his cousin Theodore Roosevelt, was a champion of conservation. He appointed Harold Ickes, director of the Department of the Interior, in charge of the National Park Service. In 1935 Ickes organized the Conservation Forum, also called the Wildflower Forum, in Yosemite for various organizations, institutions, and individuals to gather together to build a united strategy for the preservation of scenic resources. Harold Ickes went to Washington to convince Congress and the federal agencies that Kings River Canyon, California, should be made into a wilderness park.

In 1935, the Sierra Club asked Adams, who was elected to the Sierra Club's Board of Directors in 1934, to be a representative to a conference of National Parks in Washington, D.C., in 1936. Adams lobbied Congress in Washington, D.C., on behalf of the Sierra Club for the establishment of the Kings River Canyon National Park, using *Half*

"The lesson I have taken from Ansel Adams is if you love something and want to protect it, you must first point it out and argue for its value."

—Gregory Conniff

Dome, Apple Orchard, 1930, a close-up view of snow-laden trees drenched in bright sunlight, and other photographs to defend his claims. In another photograph of the region, *Clouds White Pass, Kings River Canyon*, snow gathers in mountain pockets, illuminated by majestic areas of light and shadow. The soft snow caresses the rock as the clouds that surround the peaks look like mountain ranges against the sky.

The Kings Canyon Bill was re-introduced to Congress in 1937. By 1938, Secretary Ickes lobbied again for the bill. Adams sent his recent book, *The Sierra Nevada and the John Muir Trail*, to Arthur Demaray, director of the National Park

The Center for Creative Photography

In 1975, Ansel Adams helped found the Center for Creative Photography at the University of Arizona. His archive is housed there, for he wanted his negatives to be printed by advanced photography students. He fantasized about the expressive potential the development of new technologies might bring for his images, comparing these new possibilities with musical scores that can be intensified and interpreted and reinterpreted by new sounds. By the end of his life Adams believed that he could not make a print of the same quality as laser-scan printing.

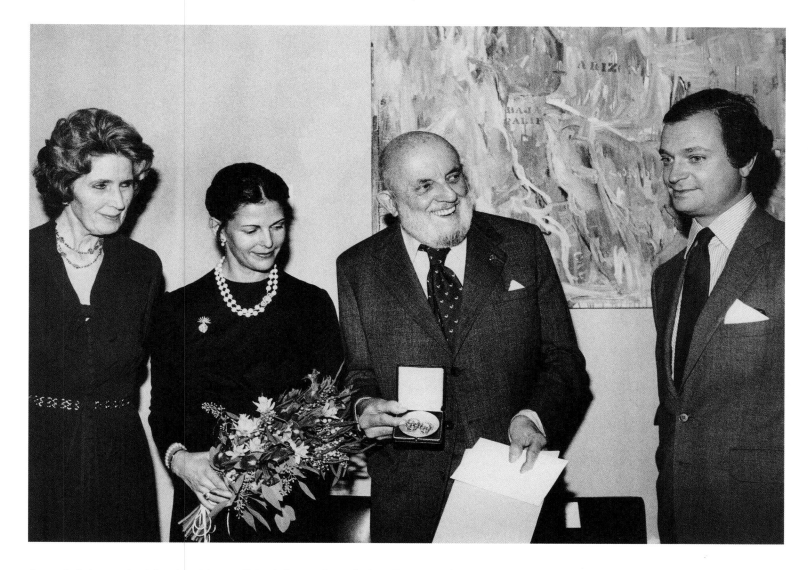

Ansel Adams holds the Hasselblad Award and the Erna and Victor Hasselblad Gold Medal presented to him by Sweden's King Carl XVI Gustaf and Queen Silvia at The Museum of Modern Art in New York, November 18, 1981. Corbis-Bettmann, New York.

"What impressed me the most about Ansel was his statement that he was as proud of his work for the environment as he was about his photography."

—Robert Dawson

Service. Secretary Ickes took the book to President Roosevelt. With the aid of Adams' influential photographs, the bill was signed by Roosevelt on March 4, 1940, declaring Kings River Canyon a national park.

By the time Adams was hired by the United States Department of the Interior to produce a series of photographic murals for offices in Washington, D.C., in 1941, he had developed broader ideas about the conservation movement, separating "personal euphoria from impersonal appraisals of the rights of man to participate in the bounties of his environment." The problem of conservation, as Adams perceived it, was not "*whether* we must save the natural scene, but *how* we may accomplish it."

In 1946, he received a Guggenheim for his work on the national parks and monuments, which resulted in the book *My Camera in the National Parks*, a direct expression of his conservation ethics and ideals. Yet Adams' life and work continued to be filled with contradictions. On the one hand, he wanted to focus less on marketing the wilderness for resort amusement, and tried to

reduce the development of public access to the Sierra. By depicting the Sierra as a place for spiritual renewal, he hoped to reorient people's attitude about the area. On the other hand, he still promoted tourism for his clients, Standard Oil and Eastman Kodak.

This Is the American Earth

By the late 1940s, Adams was a respected leader and spokesperson for photography as a fine art, and for the environment. His idea of celebrating America involved leaving the land in its natural state to be protected by the government. He saw nature as perfection in contrast to the world constructed around it. By 1951, preserving the true

wilderness by protecting the now-overrun natural areas that were littered with overcrowding and trash was a major concern of conservation legislation.

In 1955, Adams and the art historian and writer Nancy Newhall, with whom he collaborated on many projects, organized the important exhibition "This Is the American Earth." The exhibition focused on conservation ethics and ideals. It first opened in San Francisco at the Academy of Sciences on May 8, 1955, and had a summer run at the LeConte Lodge in Yosemite National Park. The lodge was a small stone building owned by the Park Service, where Adams did programming for the Sierra Club. The exhibition combined photographs by forty artists, and wall texts and labels

Ansel Adams tells Dick Cavett about his crooked nose during a PBS-TV taping. Adams said his nose was broken during the San Francisco earthquake of 1906, when he was four years old. Corbis-Bettmann, New York.

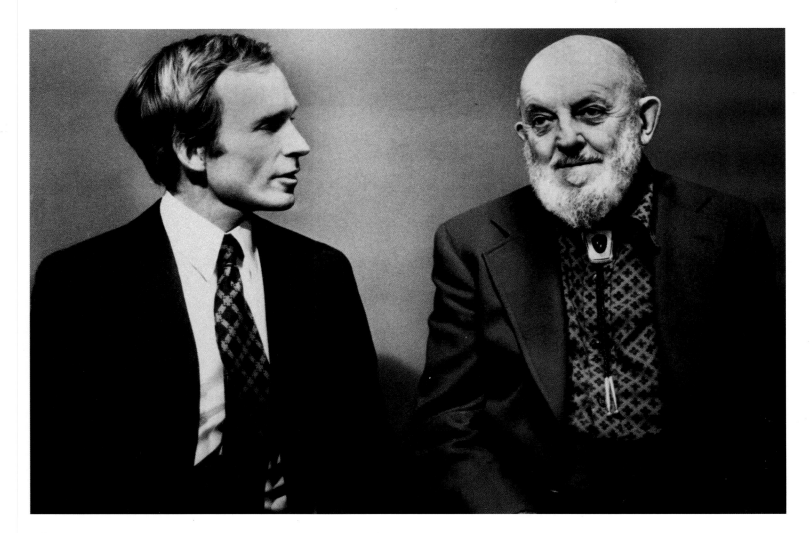

"I have thought about the land while traveling through it and observing its precarious status quo: beautiful, yet on the verge of disaster ..."

—Ansel Adams

by Nancy Newhall on national parks and wilderness concepts. It consisted of fourteen panels, 7 x 4 feet (2.1 x 1.2 meters), one hundred and two photographs, fifty-four photographs by Adams, and forty-eight photographs by thirty-nine other photographers, including Barbara Morgan, Eliot Porter, Margaret Bourke-White, and Edward Weston, to name a few. The importance of this exhibition was to create a mood of nationalism and idealism in order to educate and elevate the viewer.

The immensely popular exhibition developed into a book published by the Sierra Club in 1960, entitled *This Is the American Earth*. Newhall's text for the book was written in poetic free-verse style. The book attempted to rethink myths about

the wilderness and to change public attitudes about conservation. It focused on the development of the preservation of the wilderness in the national parks and on larger issues of global environmentalism. The opening pages contain a two-page spread of Adams' photograph *Winter Sunrise-The Sierra Nevada from Lone Pine, California* (1944), accompanied by a caption by Nancy Newhall.

In 1963, Adams received the Sierra Club's John Muir Award. By 1965, he was participating in President Johnson's environmental task force. His photographs were published in the president's report "A More Beautiful America." In 1968, he received the Conservation Service Award from the United States Department of the Interior, and in 1980, President Carter awarded Adams the Medal

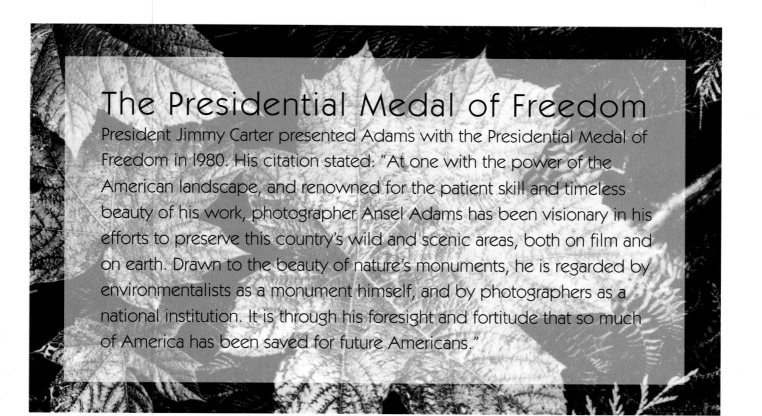

The Presidential Medal of Freedom

President Jimmy Carter presented Adams with the Presidential Medal of Freedom in 1980. His citation stated: "At one with the power of the American landscape, and renowned for the patient skill and timeless beauty of his work, photographer Ansel Adams has been visionary in his efforts to preserve this country's wild and scenic areas, both on film and on earth. Drawn to the beauty of nature's monuments, he is regarded by environmentalists as a monument himself, and by photographers as a national institution. It is through his foresight and fortitude that so much of America has been saved for future Americans."

of Freedom, the nation's highest civilian honor. He secured the first Ansel Adams Award for Conservation given by the Wilderness Society. When he died on April 22, 1984, the Ansel Adams Wilderness Area was declared, covering 100,000 acres between Yosemite National Park and the John Muir Wilderness Area.

The Other Side of Eden

Since Ansel Adams was dedicated to both art and conservation throughout his life and brought them together in creative ways, his influence extends beyond an aesthetic, formal scope. His legacy of conservation ethics has had an important impact on many contemporary landscape photographers who are engaged in environmental issues. Adams' more traditional model of landscape photography celebrates the variety of beauty in nature and inspires a desire for the preservation of the wilderness, rather than depicting the crushing reality of its devastation. His work raises a series of questions for contemporary photographers who are occupied

with redefining the landscape genre. Of course, shifting environmental factors contribute to the different methods and strategies that these photographers use. While some photographers address these issues directly by showing actual environmental hazards and depletion to encourage immediate audience response and activism, others are more conceptual and ironic in their approach. What is the relation between "environmental" landscape images and social change? How are these images used?

Contemporary photographer Robert Dawson was one of thirteen photographers who participated in the "Water in the West Project," begun in 1983. Documenting water issues in the American West and the important role that water has played in effecting all aspects of the landscape, these photographers developed a photographic archive using 8 x 10 inch (20.3 x 25.4 cm) prints instead of precious exhibition ones, in order to educate the public on how to use this essential resource, and to stimulate discourse and political activism for environmental issues. Some of the other photogra-

"What I like about the Water in the West *project is that it offers an alternative to the 'Master Photographer' model that has become so confining in our field. It remains to be seen whether or not a group like ours will be able to match Ansel's ability to further landscape causes, but I think the goals are in the best spirit of his concern for the land. To me that means that as photographers we participate in, and not just witness, the changes of our time."*

—Mark Klett

In Zion National Park by Ansel Adams.

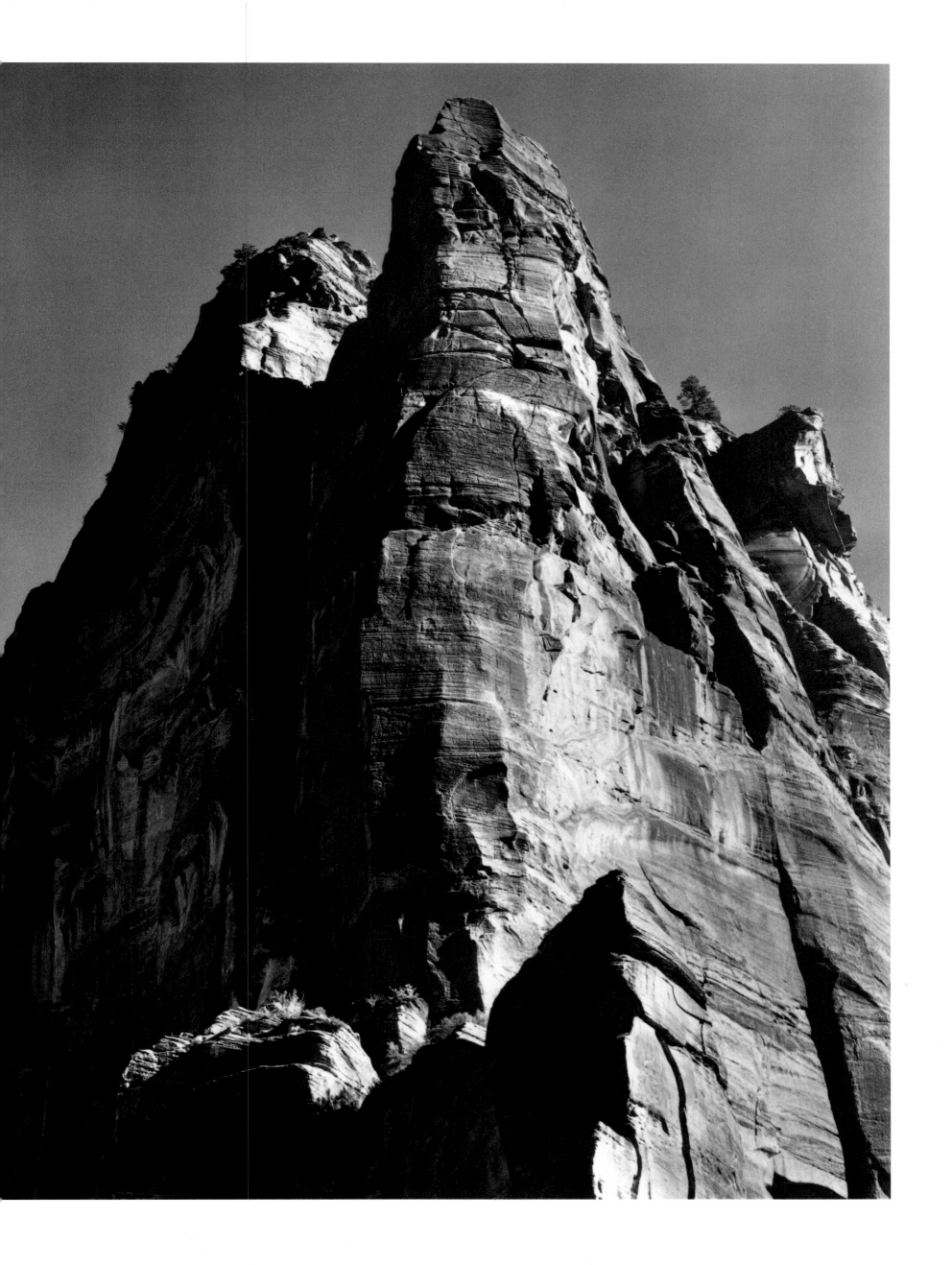

phers in the group included Joseph Bartscherer, Laurie Brown, Gregory Conniff, Terry Evans, Peter Goin, Wanda Hammerbeck, Sant Khalsa, Sharon Stewart, Martin Stupich, and Mark Klett. Through their collaboration they demythologized the concept of the single artist as hero. They also gathered people from various disciplines for public forums and regular exhibitions.

Mark Klett, photographer JoAnn Verburg, and photo-historian Ellen Manchester collaborated on the "Re-photographic Survey Project" (1977–80). This project provided another alternative approach to landscape/conservation photography. Klett re-photographed sites of famous nineteenth-century landscape photographers from the geological surveys, including Timothy O'Sullivan and William Henry Jackson, from the same viewpoint and under the same light and weather conditions, to understand how the earlier photographers had worked, and more important, to see how the sites had changed. Klett's image, *Last Camp of the Season, October, 1979, Bread Loaf Rock, Idaho*, was one of over 122 images of the old views. While Adams' earlier "recreation" of

Last Camp of the Season, October 1979, Bread Loaf Rock, Idaho by Mark Klett.

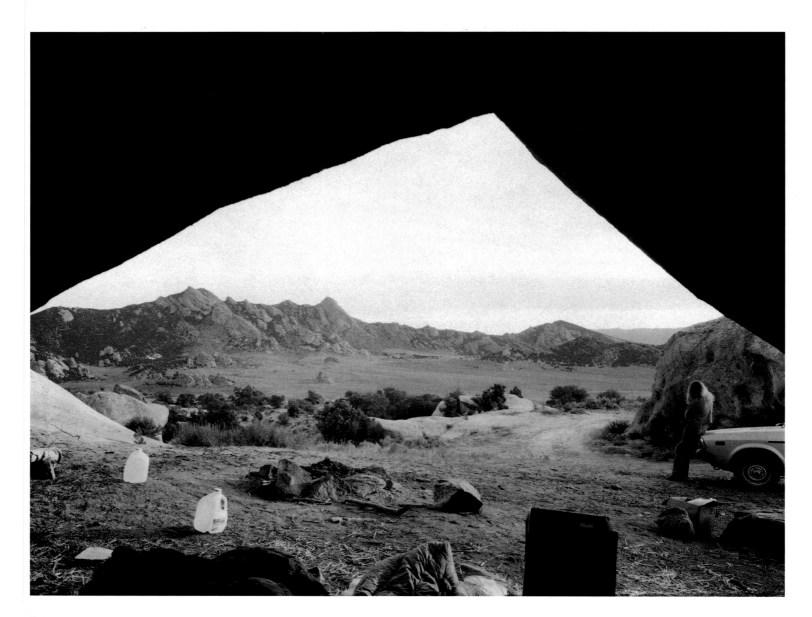

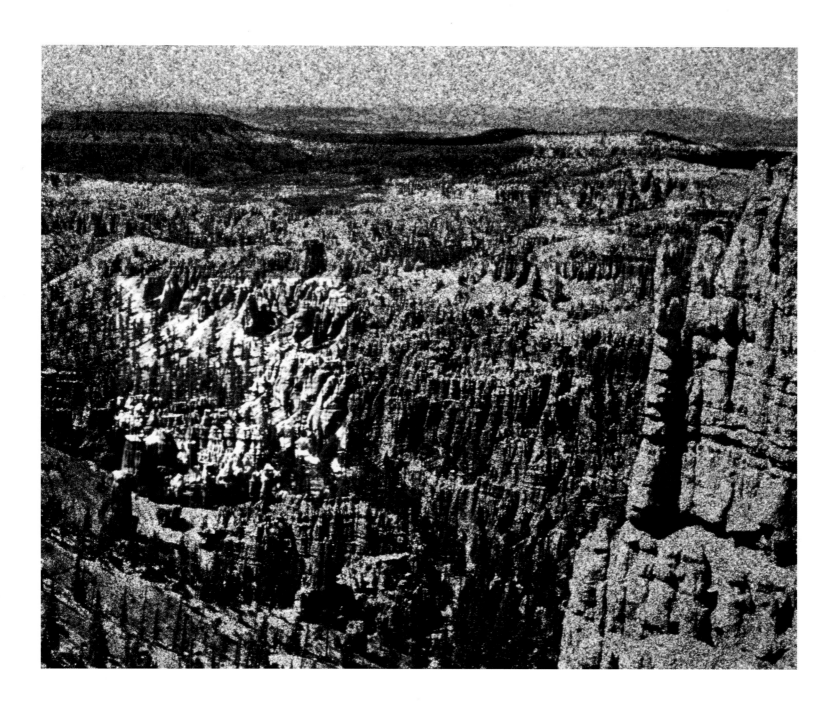

Mt. Ansel Adams

In 1985, a year after Ansel Adams' death, Mt. Ansel Adams, a 11,760-foot peak located at the head of the Lyell Fork of the Merced River on the southeast boundary of Yosemite National Park, was officially named.

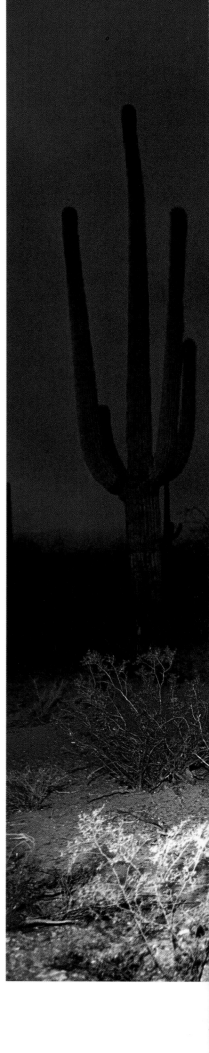

of gardens from magazines, calendars, and brochures through a black plastic mesh that suggests the grid pattern of half-tone screens, or the graininess of an enlarged photograph. The resulting image is an abstracted, veiled, and standardized landscape. A window is cut into a section of the overlay, revealing the reproduction underneath. Because these landscapes are depicted as artificial and denatured, the spectator is placed at a critical distance from them, and becomes acutely aware that ideas about landscape are mediated through cultural frames of reference. These representations produce gaps between the "reality" of the landscape, its formation and manipulation through representation, and the viewer's perception of it.

Another contemporary photographer, John Pfahl, works with codes of the picturesque and the sublime in landscape. In one series, nuclear power plants are photographed in their scenic surroundings, combining idealized landscapes and industry. In another image, he photographs chemical clouds, in saccharine-sweet colors, that emerge from a factory near Niagara Falls (one of the favorite scenic sites of nineteenth-century landscape artists). Ironically, the titles of these images are the bucolic names of the factories and power companies found in the photographs, such as Seabrook or Crystal River. The viewer is attracted and horrified by the beautiful yet disturbing and eerie images of pollution and environmentally hazardous materials that are integrated into relatively natural landscapes. These photographs reveal how seemingly transparent photographs can deceive the eye. The strange beauty of pollution portrayed here also makes the viewer aware of a tradition of landscape painting and photography, and creates a sense of nostalgia for a purer past.

Saguaro #5, 1975 by Richard Misrach. Courtesy of the artist.

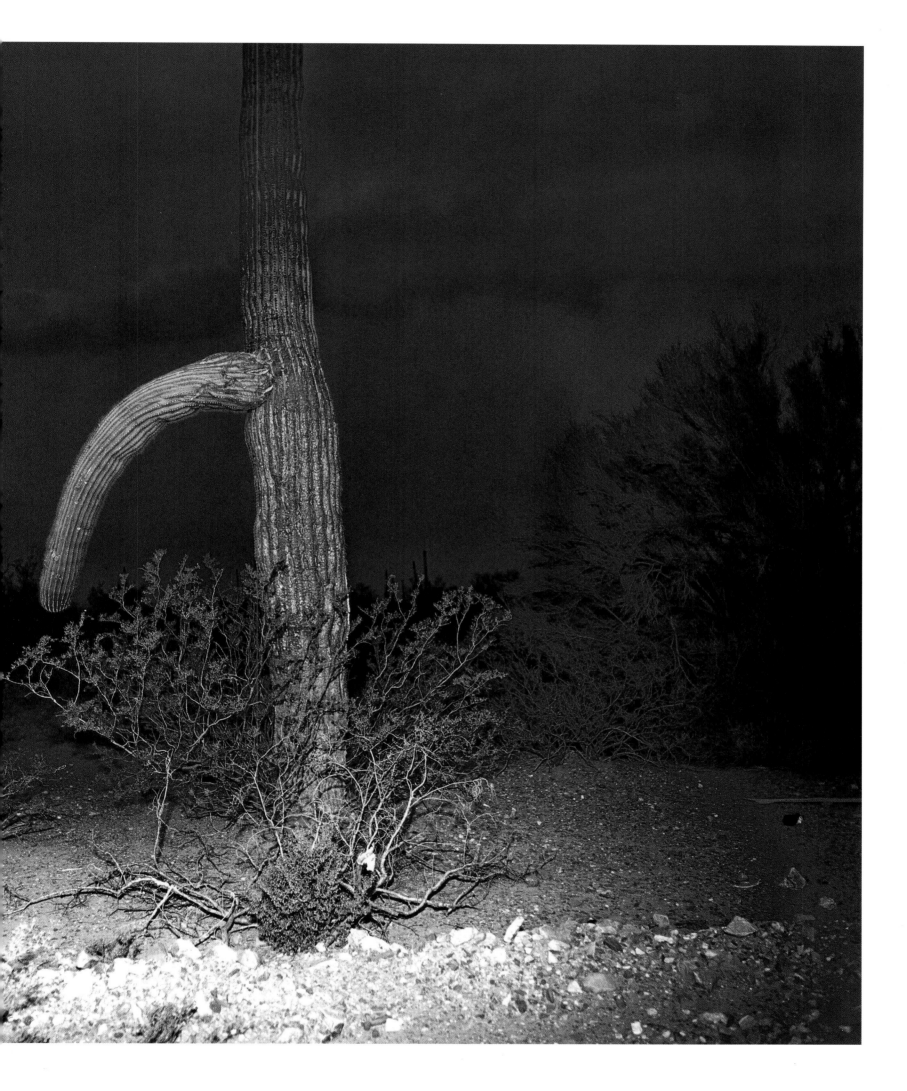

Richard Misrach, a photographer of the desert, transforms the landscape into a beautiful, artificial-looking image as he casts it in a nuclear burst-type light. His ironic-tragic images ask the viewer to bear witness and take collective responsibility for actions and attitudes toward the environment. In a similar vein, Robert Dawson focuses on the moment when a stunning landscape turns into an image of putrefaction and despair, when, for example, a wild-life refuge becomes a toxic dump.

Frank Gohlke's photographic project, *Mt. St. Helens: Work in Progress* began in 1983. When Mt. St. Helens volcano erupted on May 18, 1980, and caused 140 square miles of devastation, it was considered a natural epic disaster. Gohlke represents the destruction in tragic, sublime images. In another project on the Sudbury River, Massachusetts, Gohlke photographs the intrusion of chemicals into the water. *Chemical Brook Enters the Sudbury River* (Ashland, Massachusetts, December 1991) depicts chemical residue polluting the sheltered, peaceful, scenic area. Some other photographers that engage in politicized environmental photography include A. J. Meek, William Clift, Alan Tibbetts, and Philip Hyde.

The ability of art to create pleasure, discomfiture, and social awareness may be accomplished through various means. Adams' work engages both in a modernist art production of harmonious formal images, and in issues of conservation. His photographs are a celebration of the beauty of nature as well as a reminder of the larger ecological problems that the world faces today. Although his images do not reveal the devastation of the landscape, the intrusion of tourists, or power lines, they inspire and remind the viewer that the seemingly timeless, pristine wonders of nature are not indestructible. As the viewer contemplates the refreshing splendor of mountain vistas, lakes, waterfalls, clouds, and the sensual palpability of illuminating light on various surfaces, thoughts about the transience of life are evoked. The noble aura surrounding these images does not make the viewer forget about environmental concerns, but instead, fosters a yearning for a better world. In this light Adams' photographs function as a *memento mori*—a reminder of mortality, causing the viewer to pause and become aware of the transience of nature and human mortality. Adams' images are at once reminders of a paradise desired, and a paradise on the verge of distinction.

Yellowstone Falls by Ansel Adams

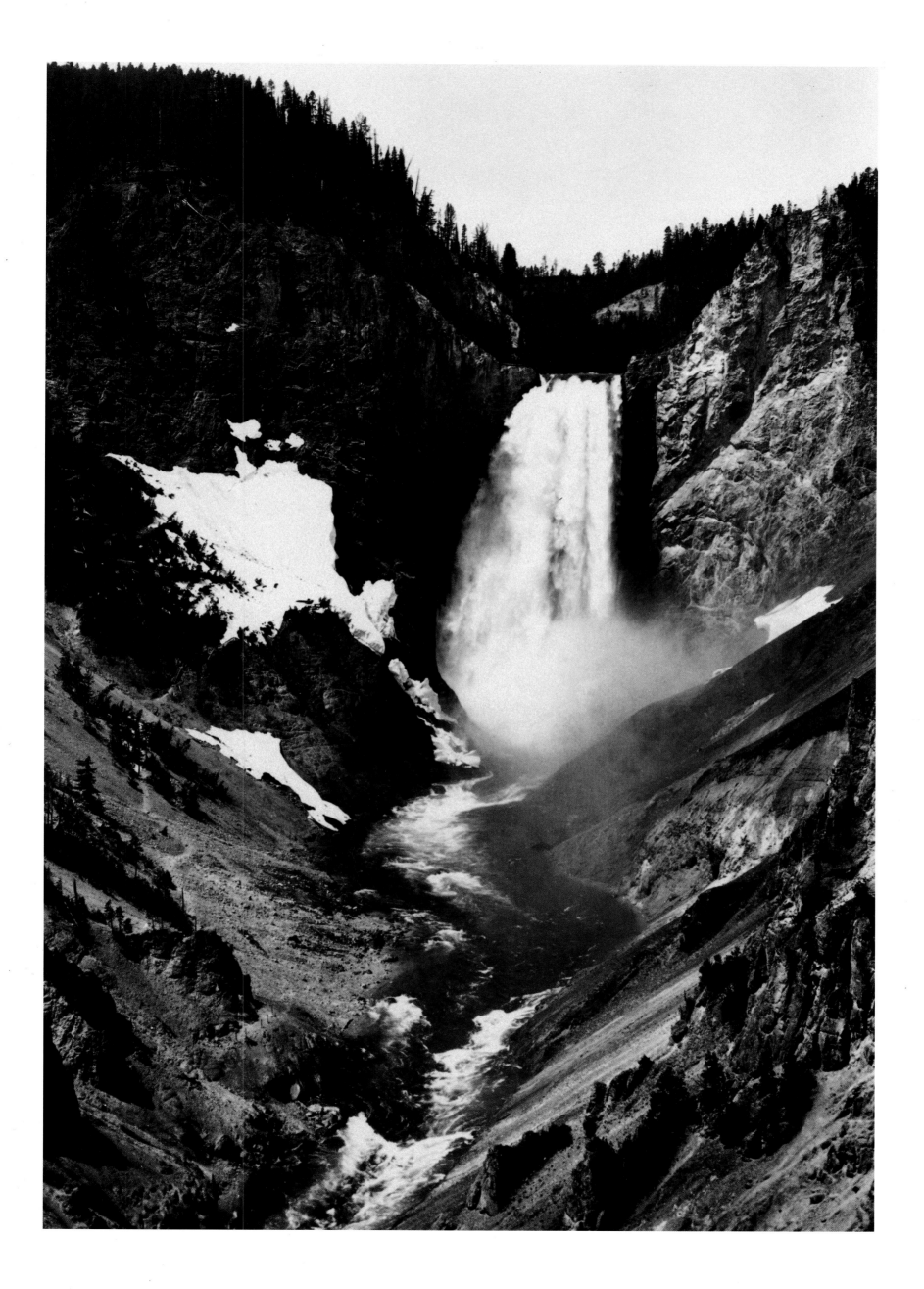

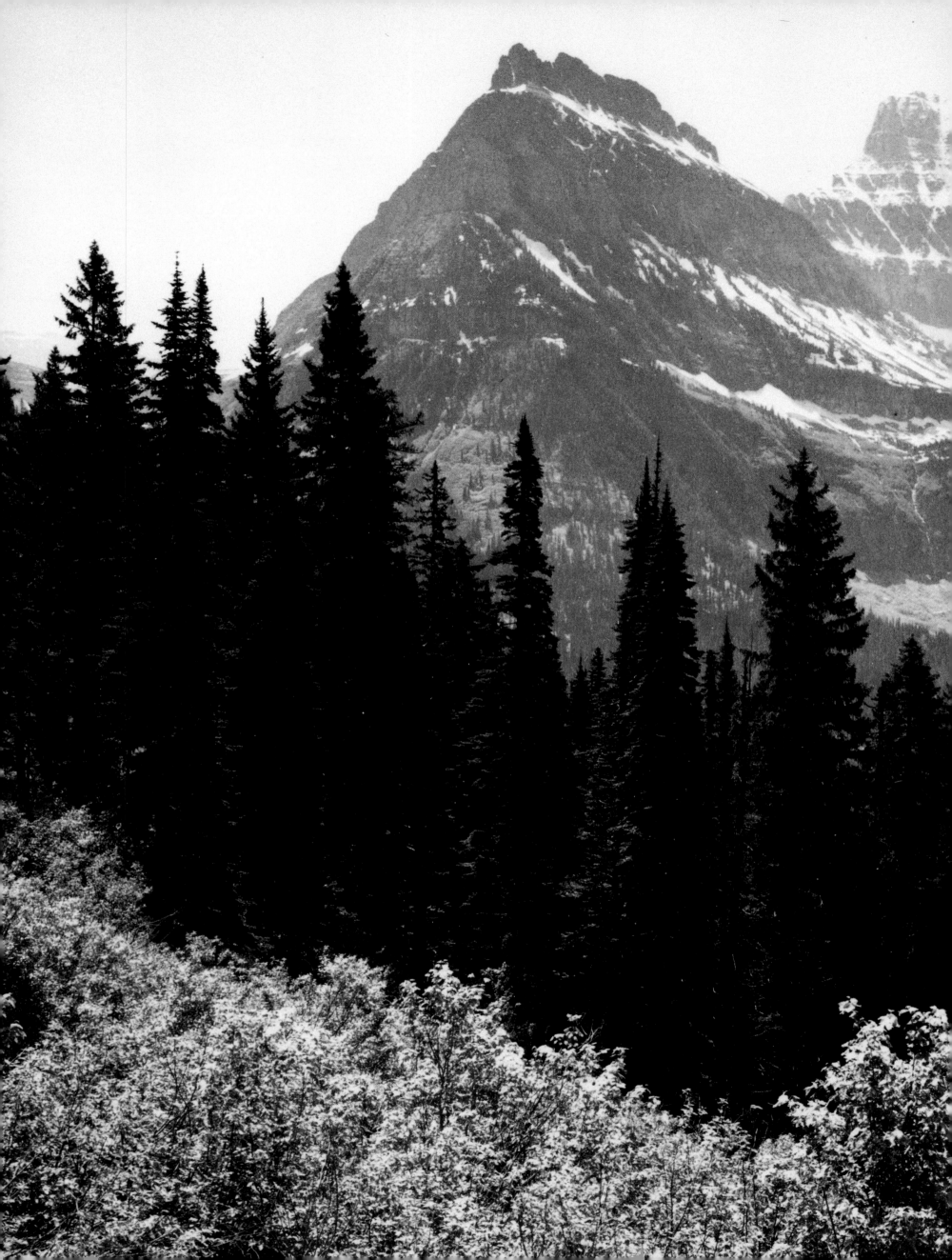

Ansel Adams

The National Park Service Photographs

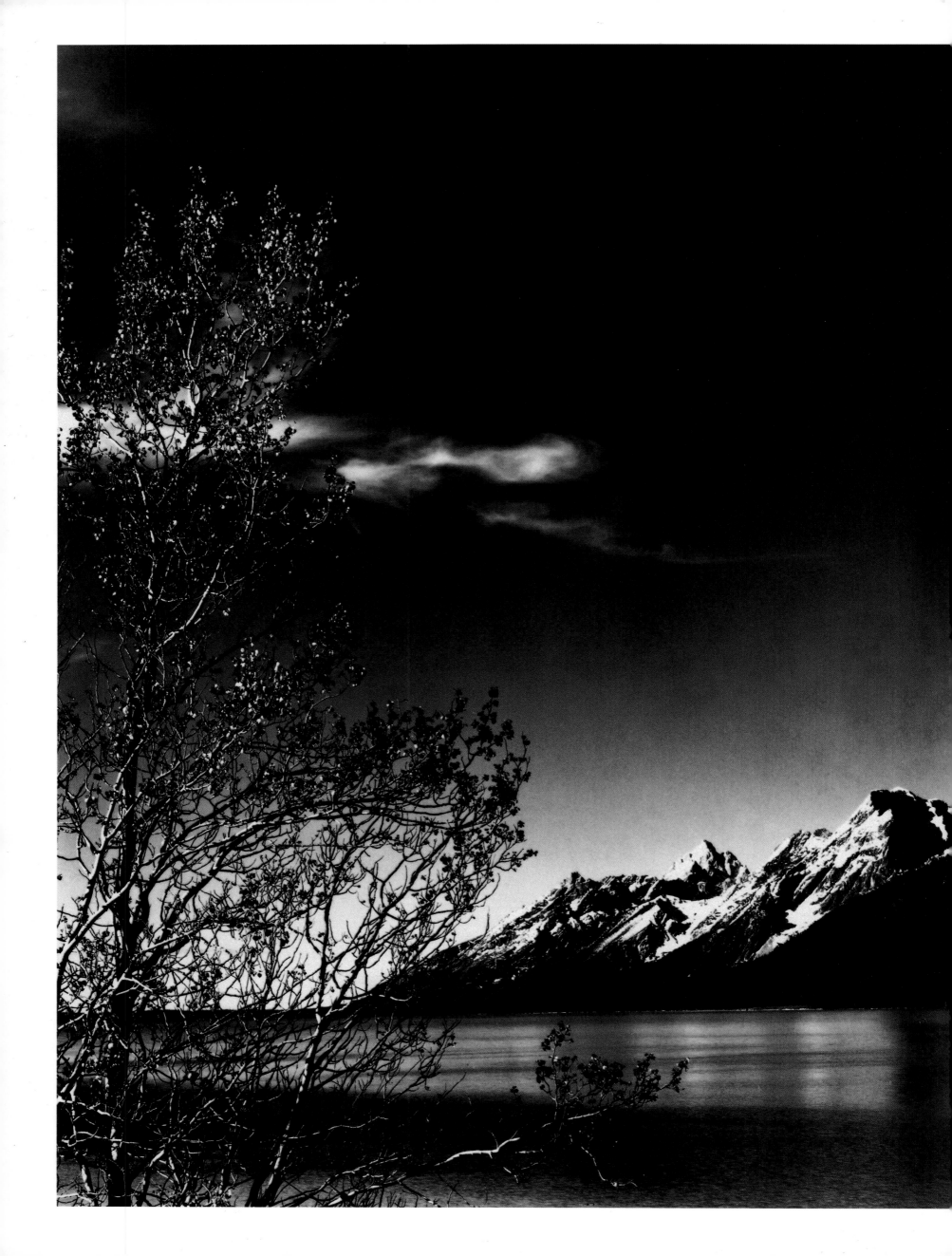

"Grand Teton"

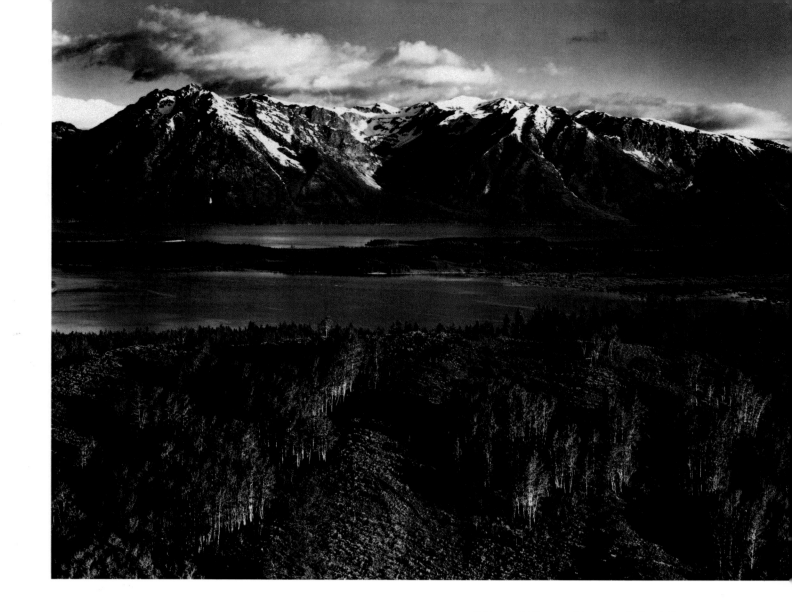

"Grand Teton National Park"

"Long's Pass, Rocky Mountain National Park"

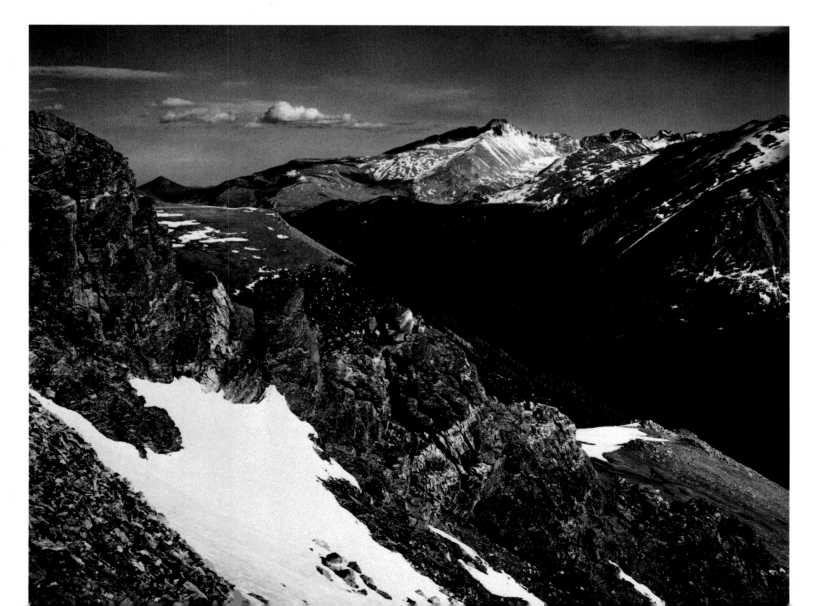

63

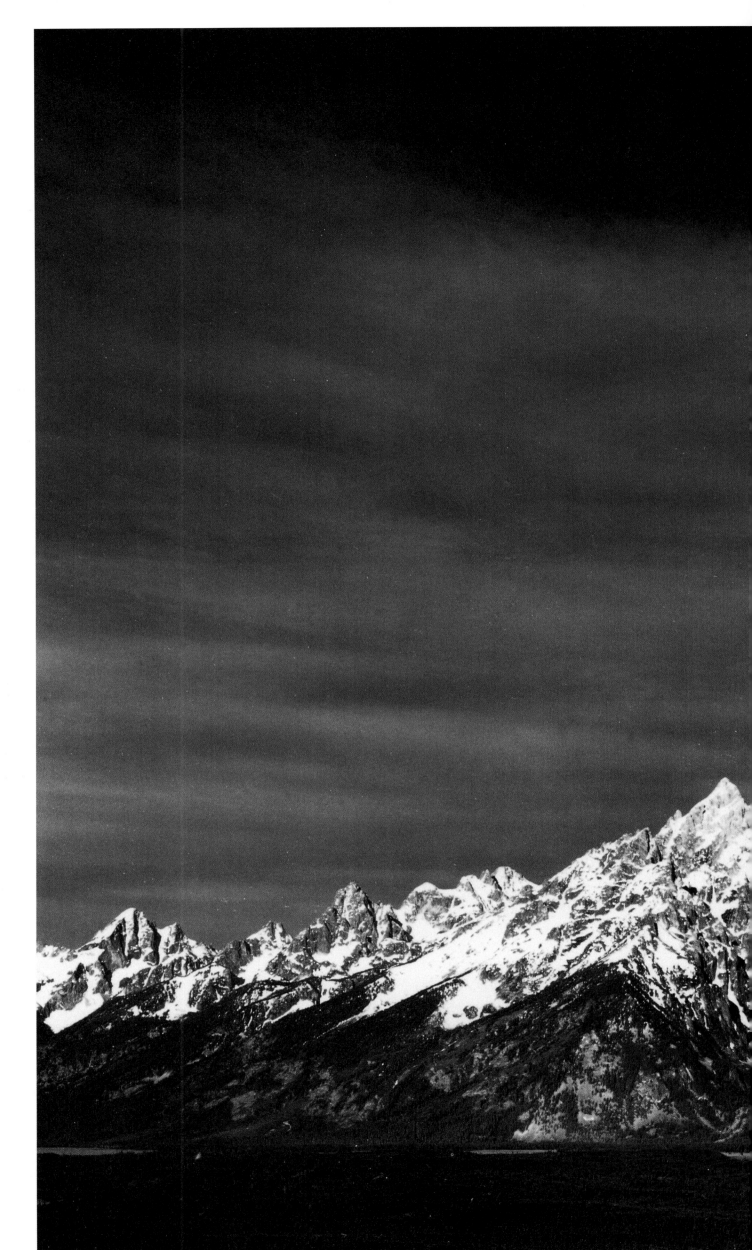

"Tetons
from Signal
Mountain"

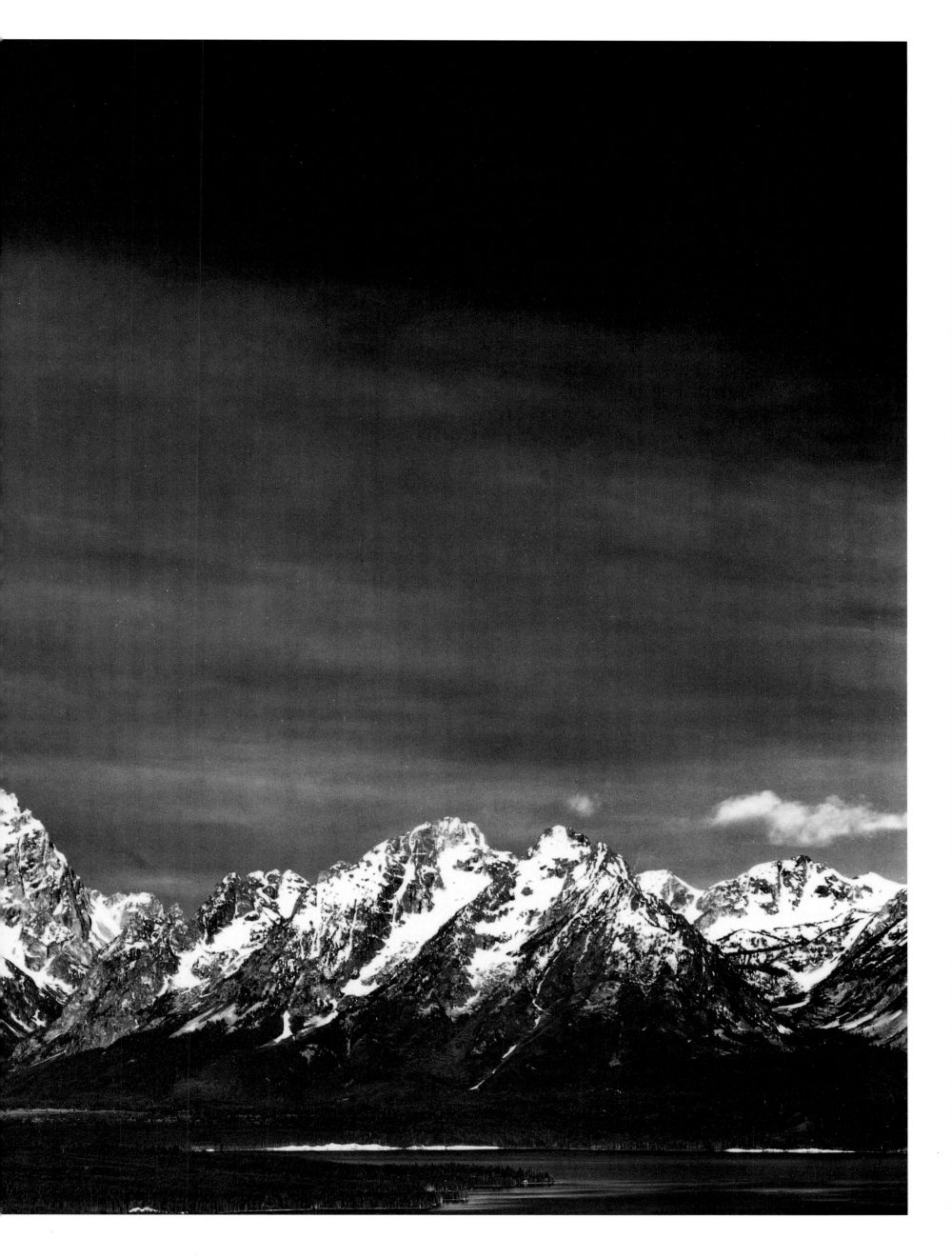

"Rock and Cloud"

"Untitled, Grand Canyon National Park"

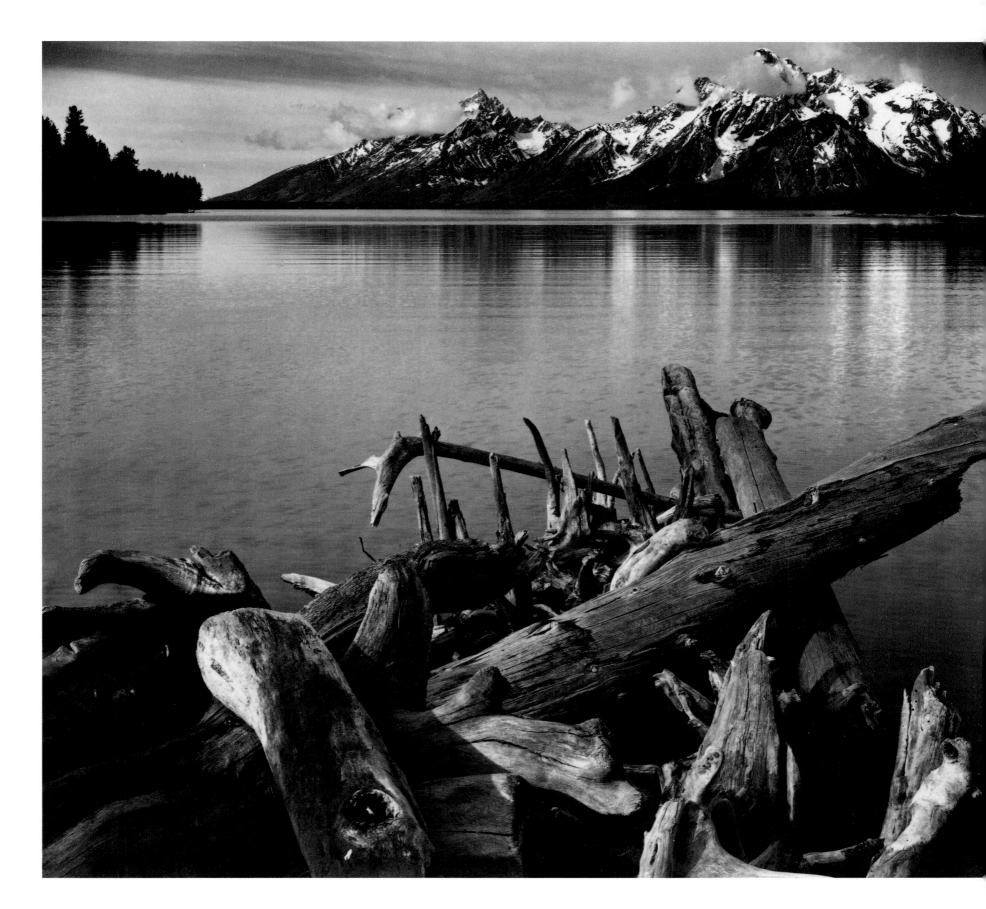

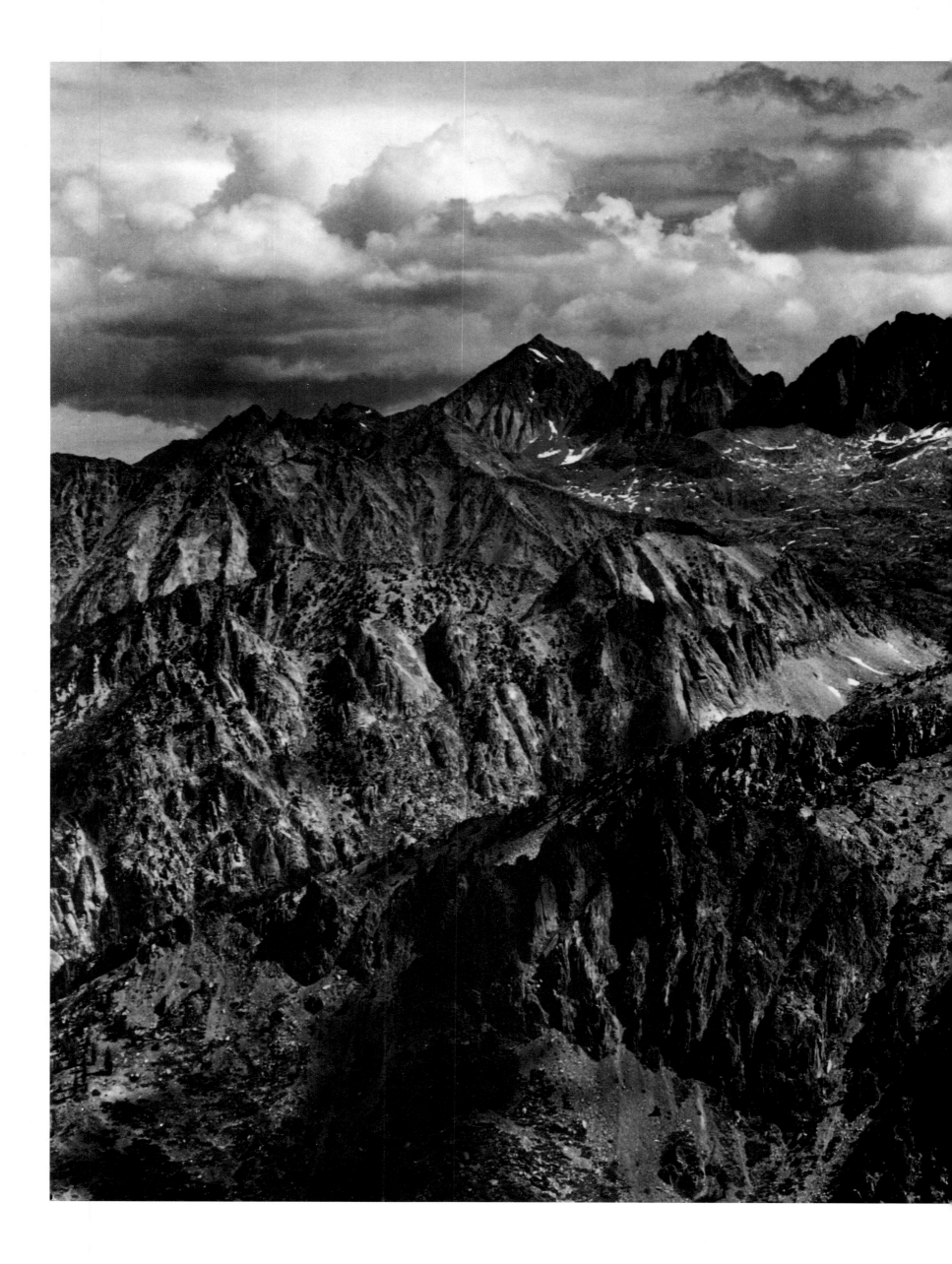

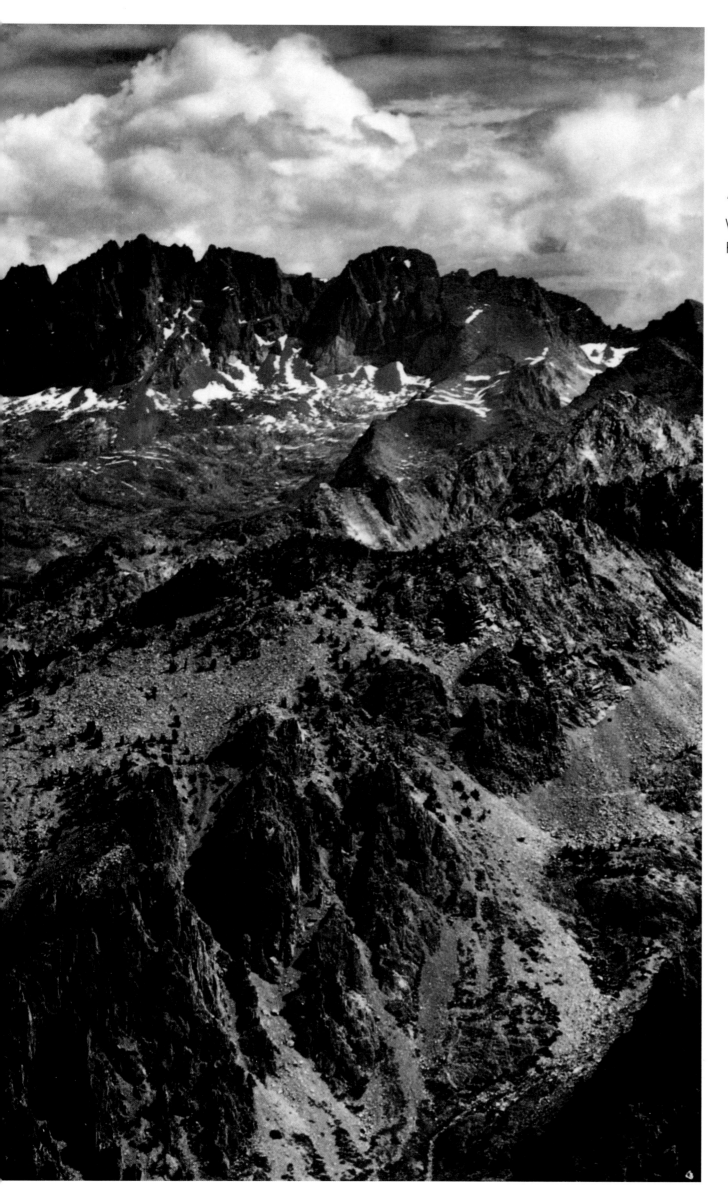

"North Palisade from
Windy Point, Kings
River Canyon"

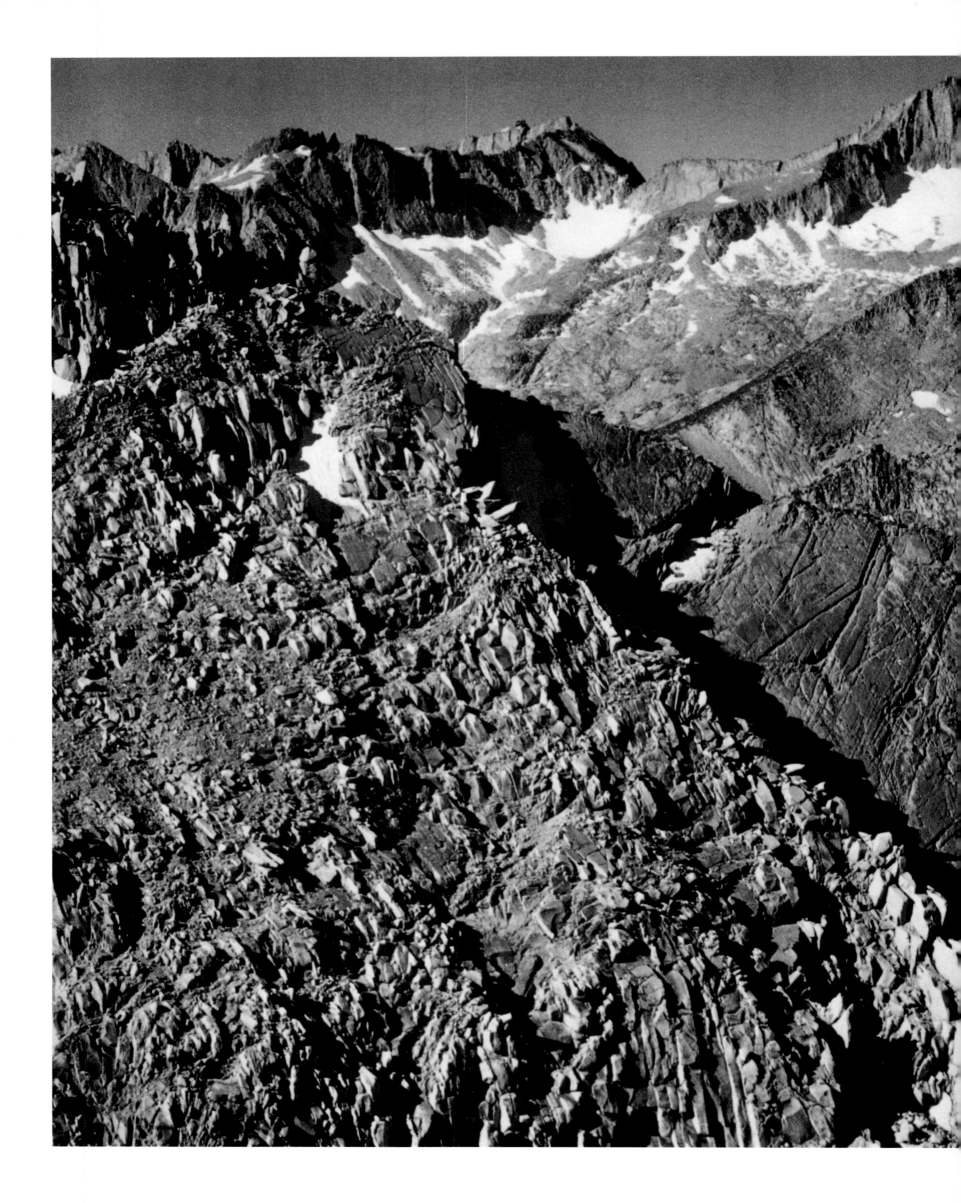

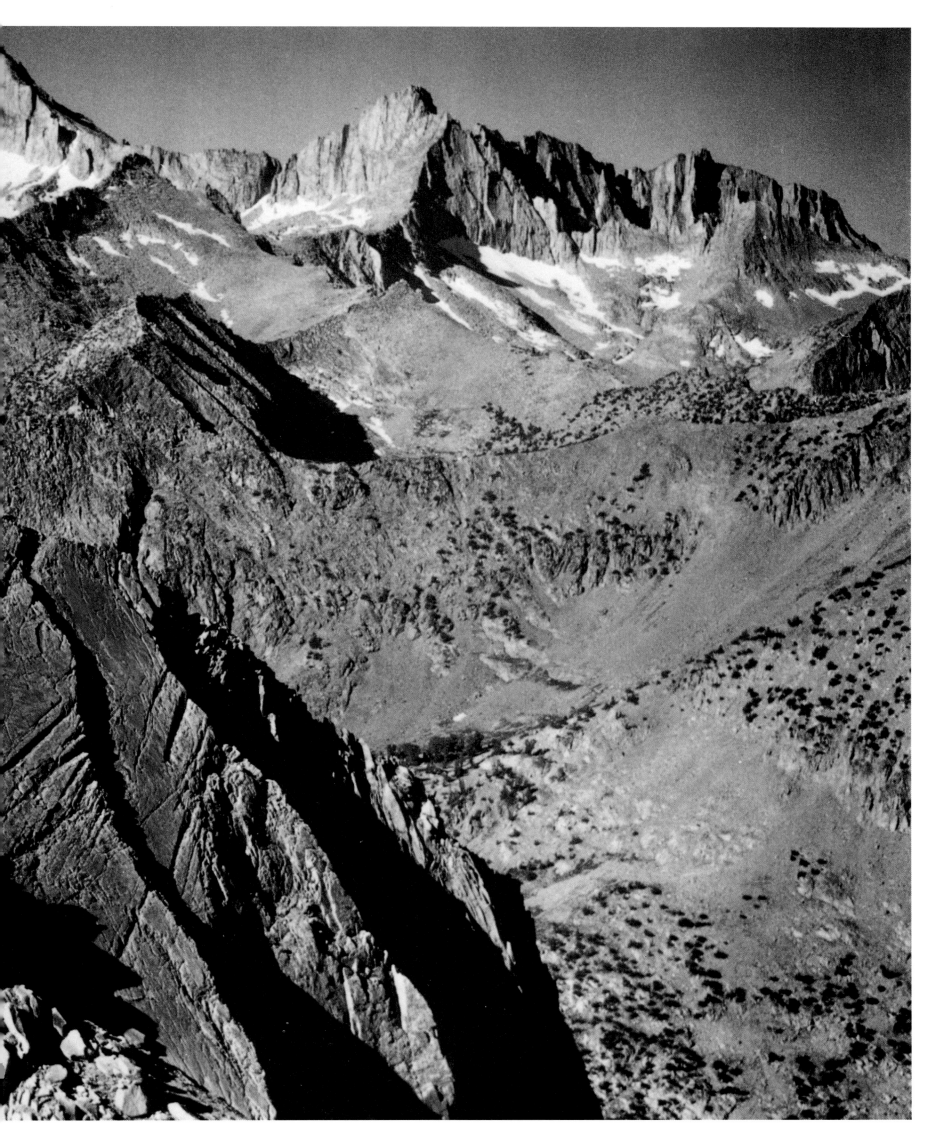

"Mount Brewer, Kings River Canyon"

"North Dome, Kings River Canyon"

"From Going-to-the-Sun Chalet, Glacier National Park"

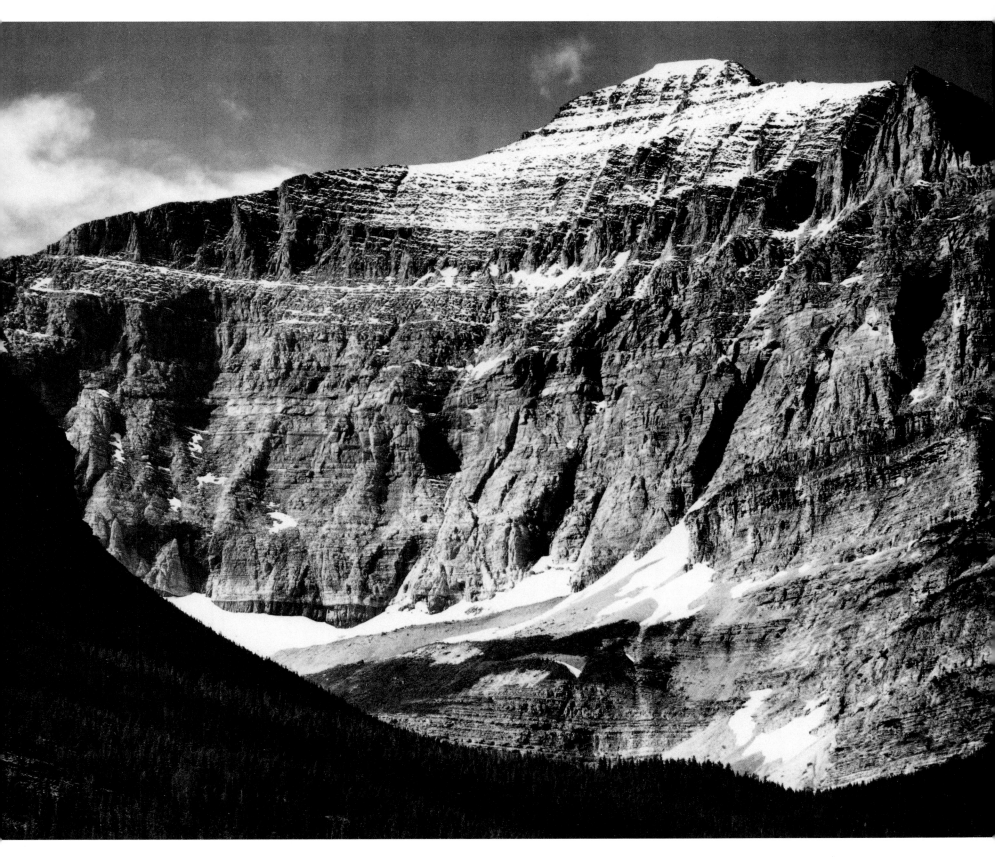

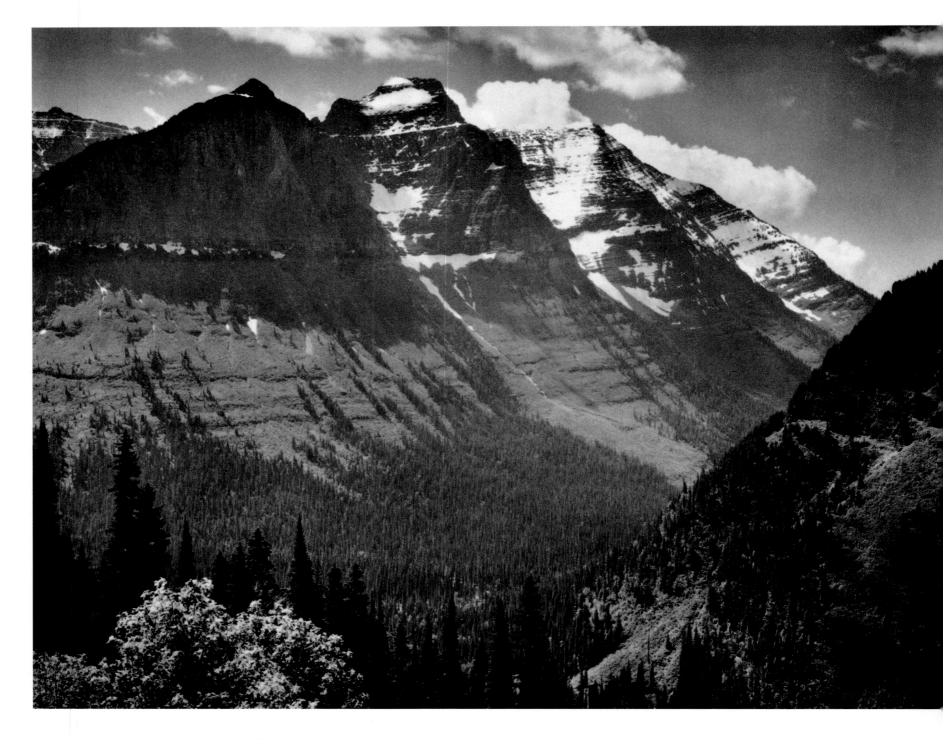

"In Glacier National Park"

"Canyon de Chelly"

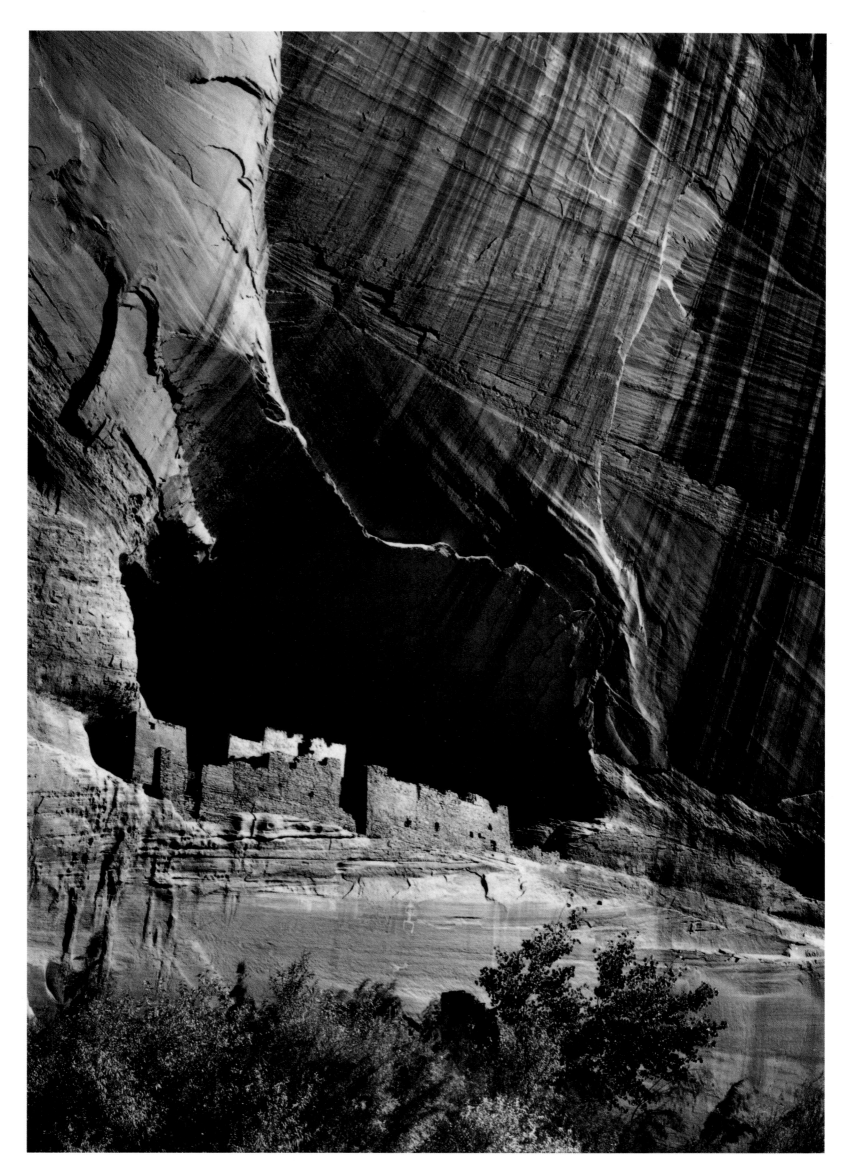

"Cliff Palace, Mesa Verde National Park"

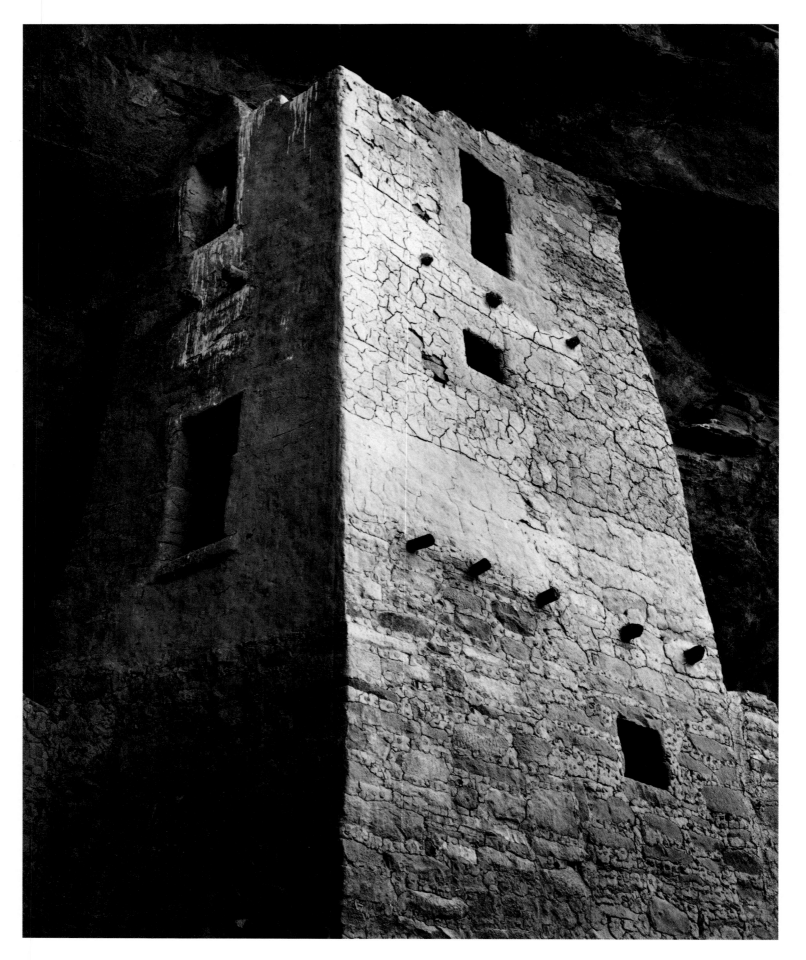

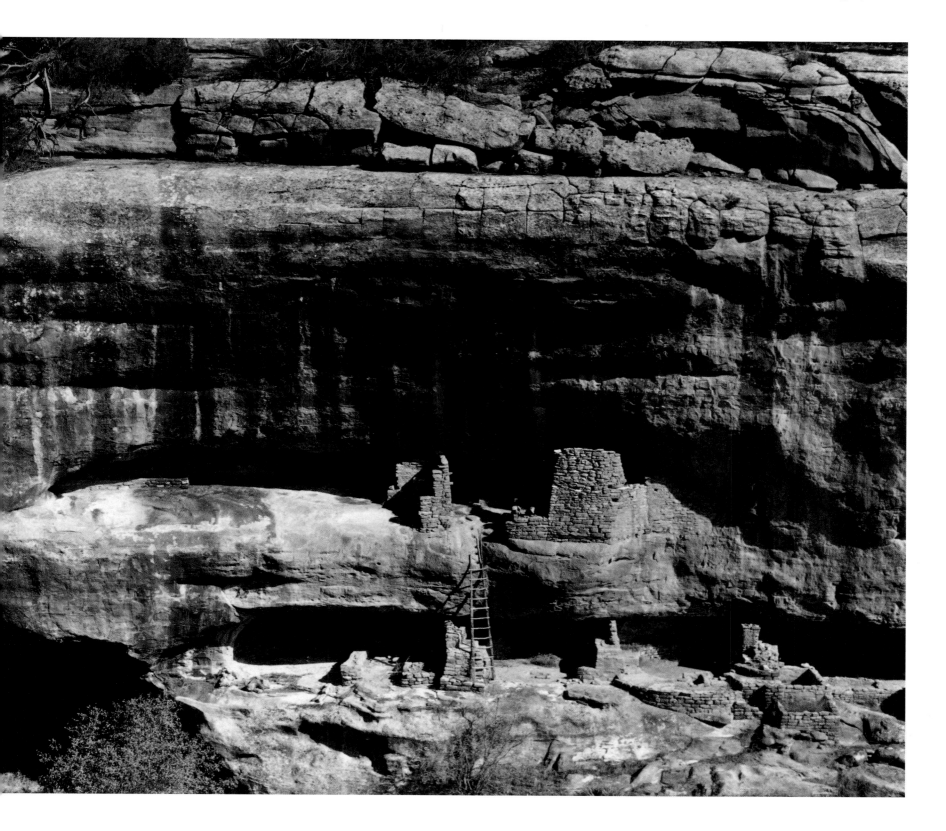

"Mesa Verde National Park"

"İnterior at Cliff Palace, Mesa Verde National Park"

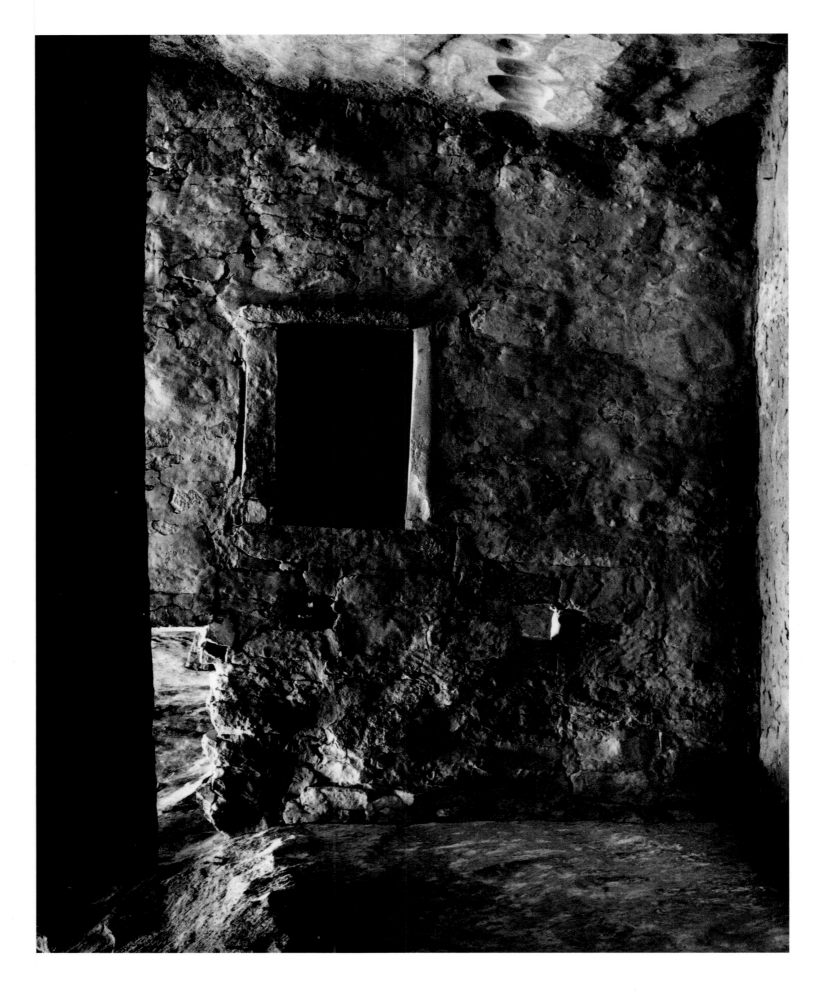

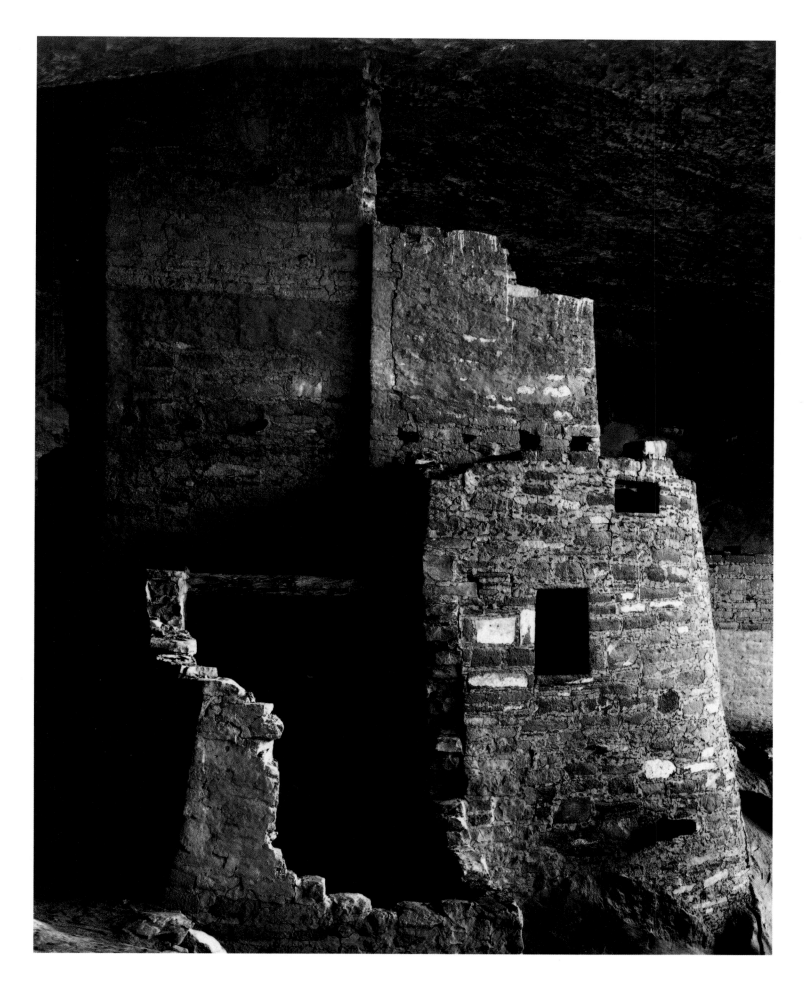

"Cliff Palace, Mesa Verde National Park"

"North Palisade from Windy Point, Kings
River Canyon"

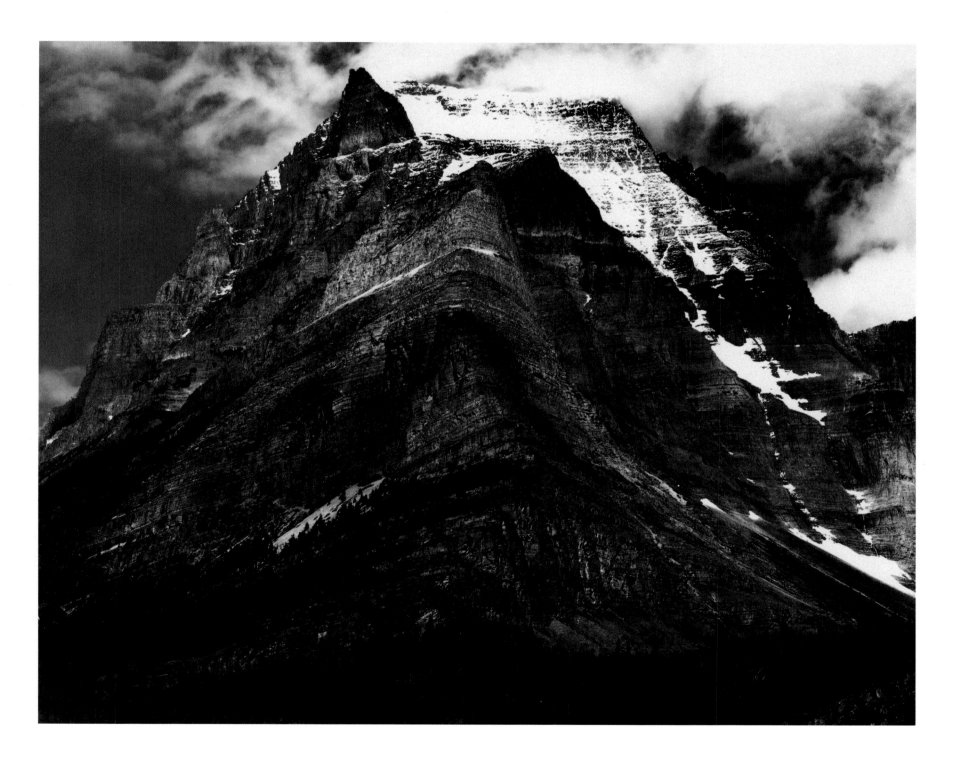

"Going to the Sun Mountain, Glacier National Park"

"Coloseum Mountain, Kings River Canyon"

"Central Peak, Center Basin, Kings River Canyon"

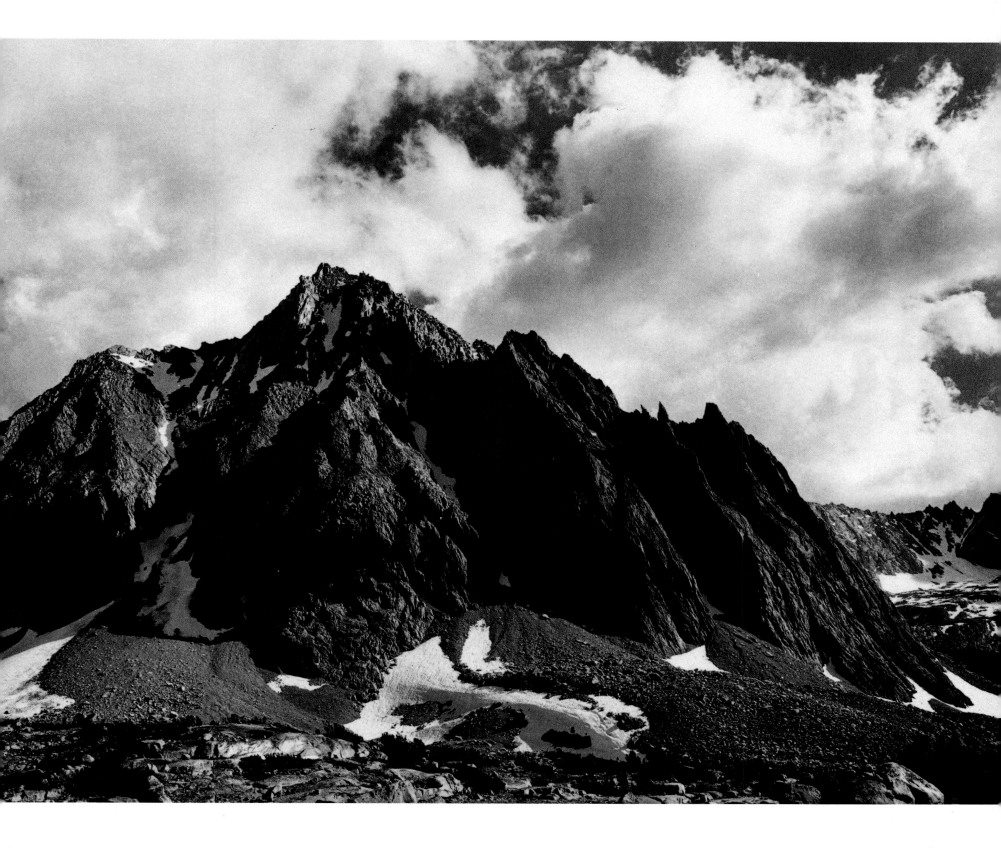

"In Rocky Mountain National Park, Kings River Canyon"

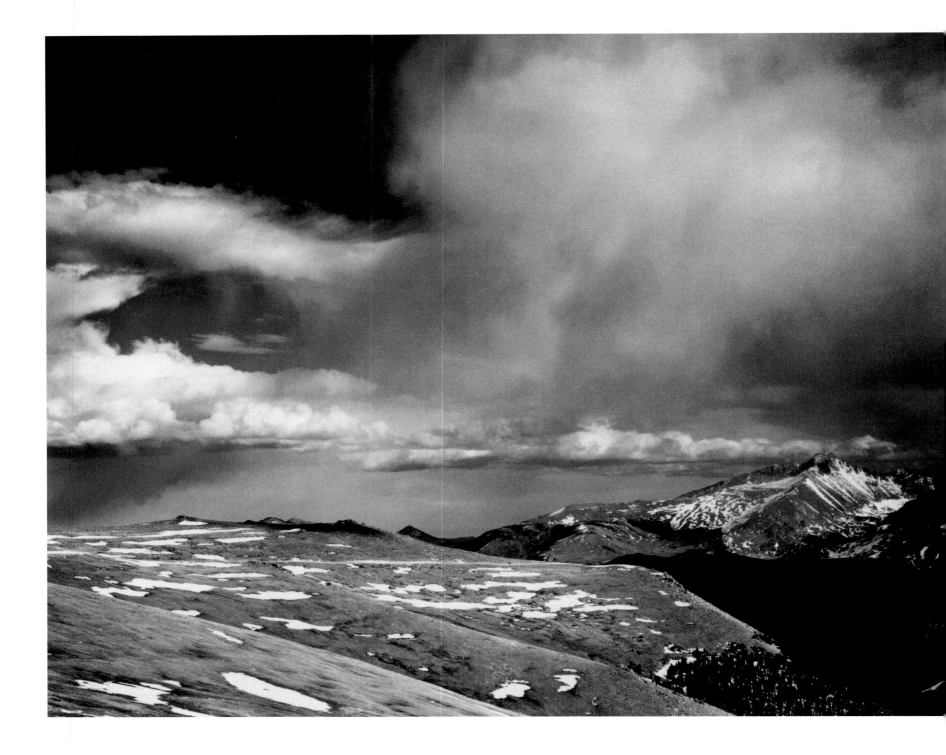

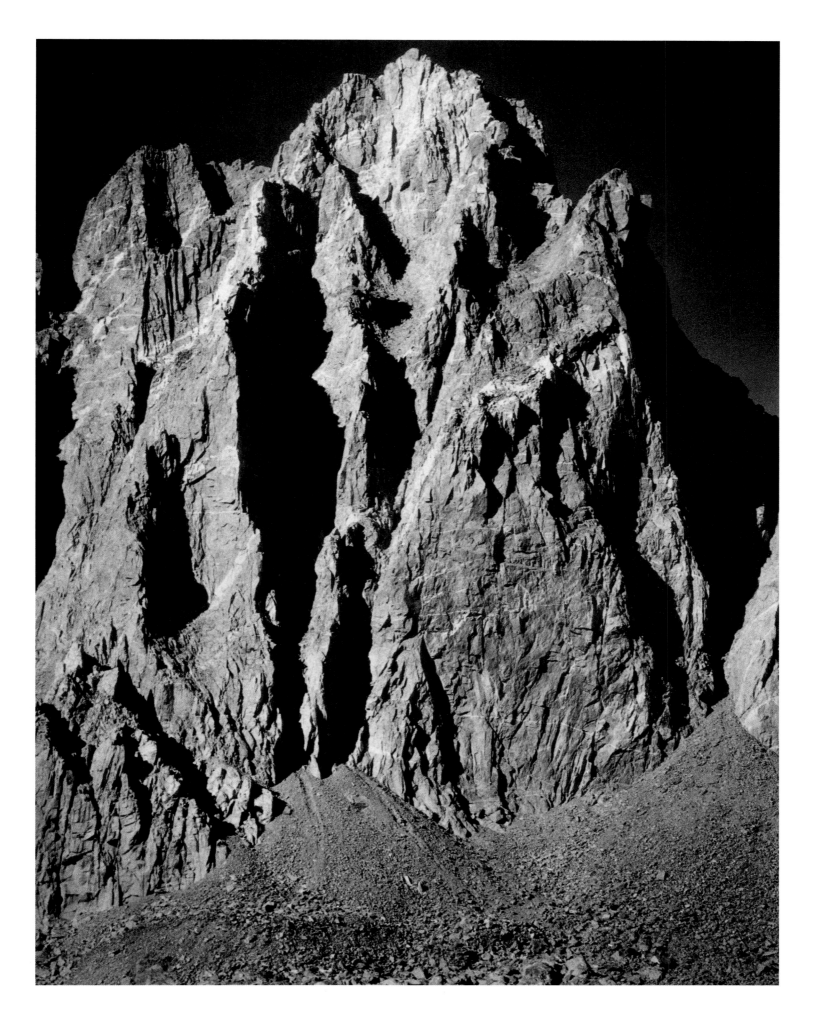

"Mount Winchell, Kings River Canyon"

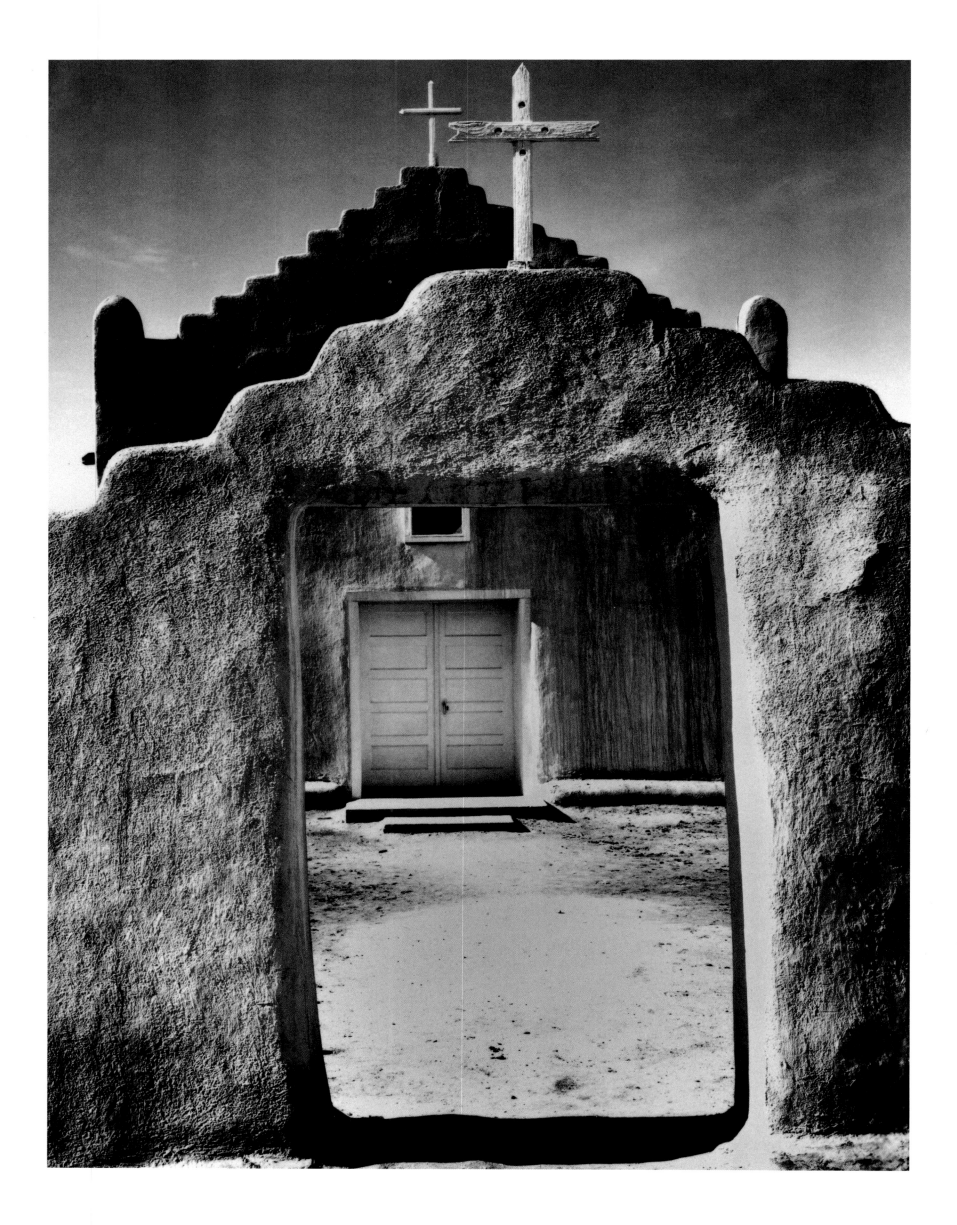

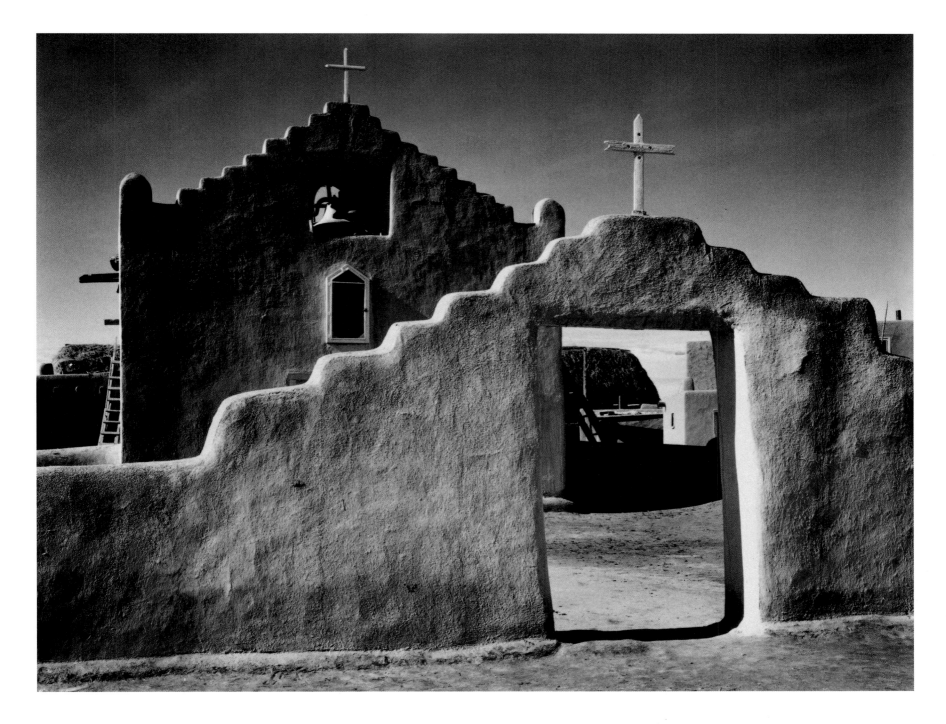

"Church, Taos Pueblo, New Mexico"

"Church, Taos Pueblo, New Mexico"

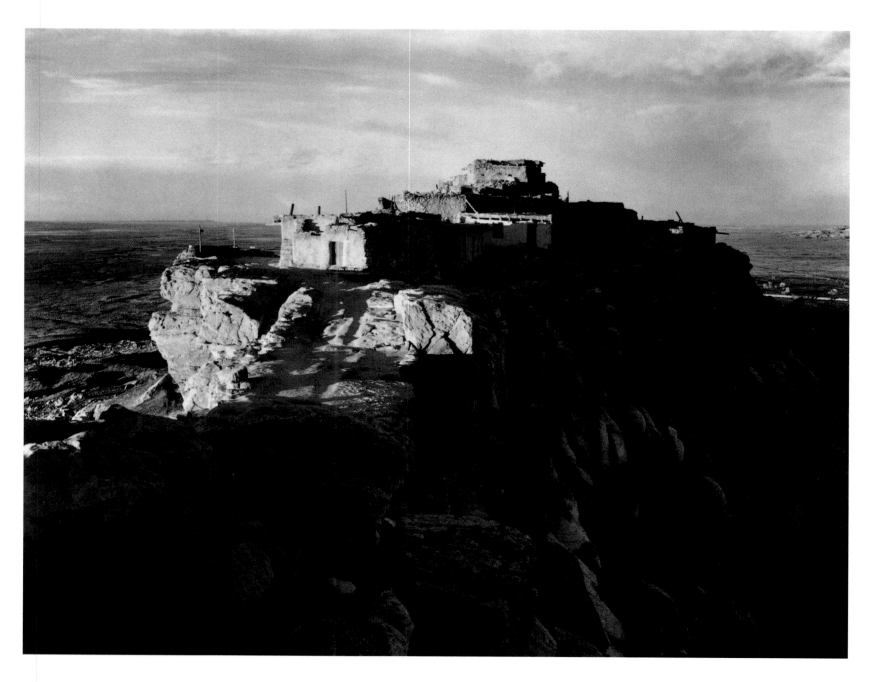

"Walpi, Arizona"

"Navajo Woman
and Child, Canyon
de Chelly, Arizona"

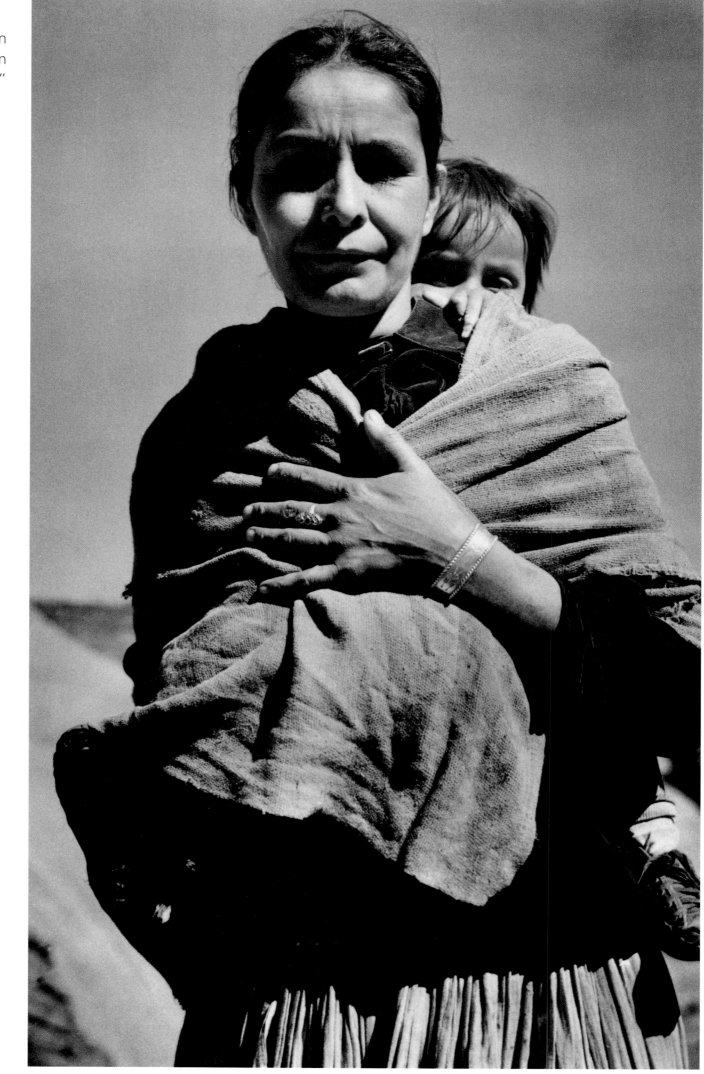

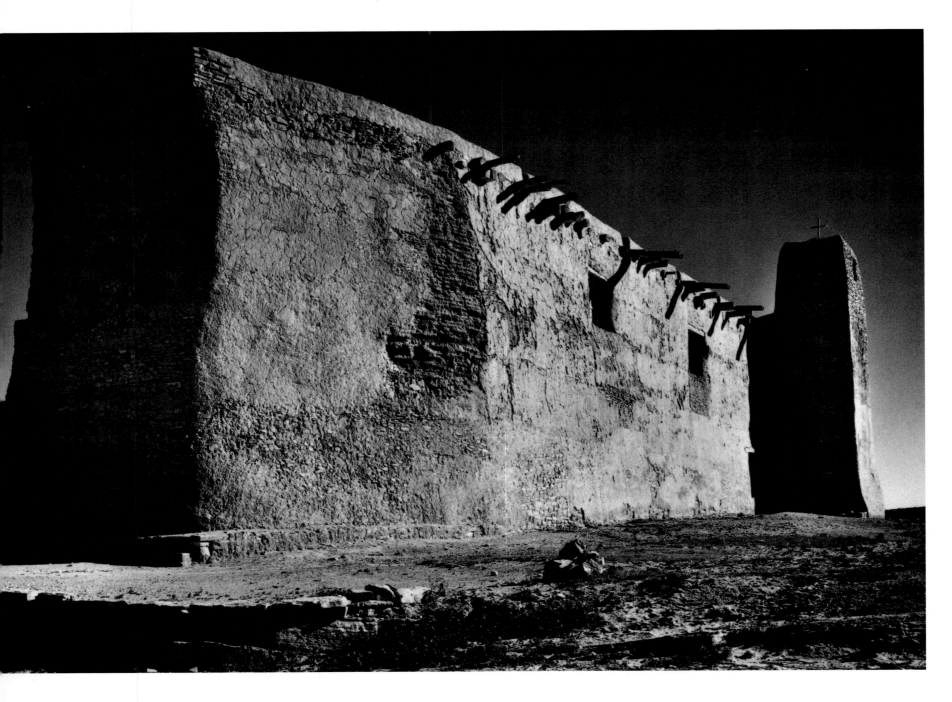

"Church, Acoma Pueblo"

"Flock in Owens Valley, California"

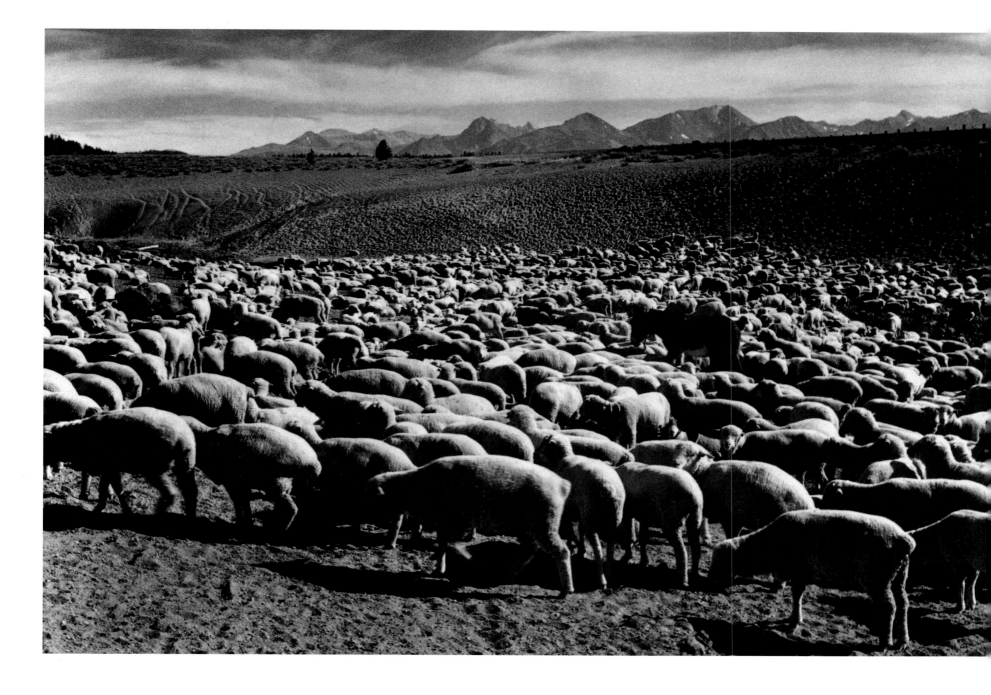

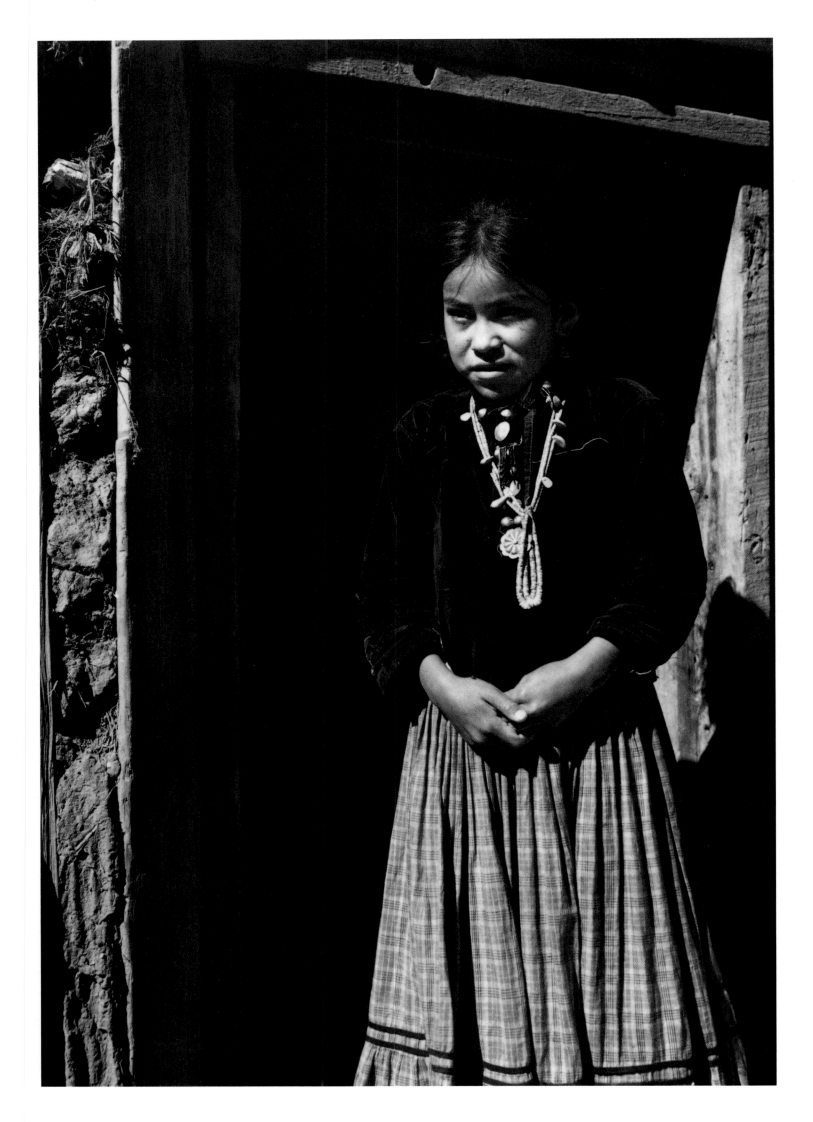

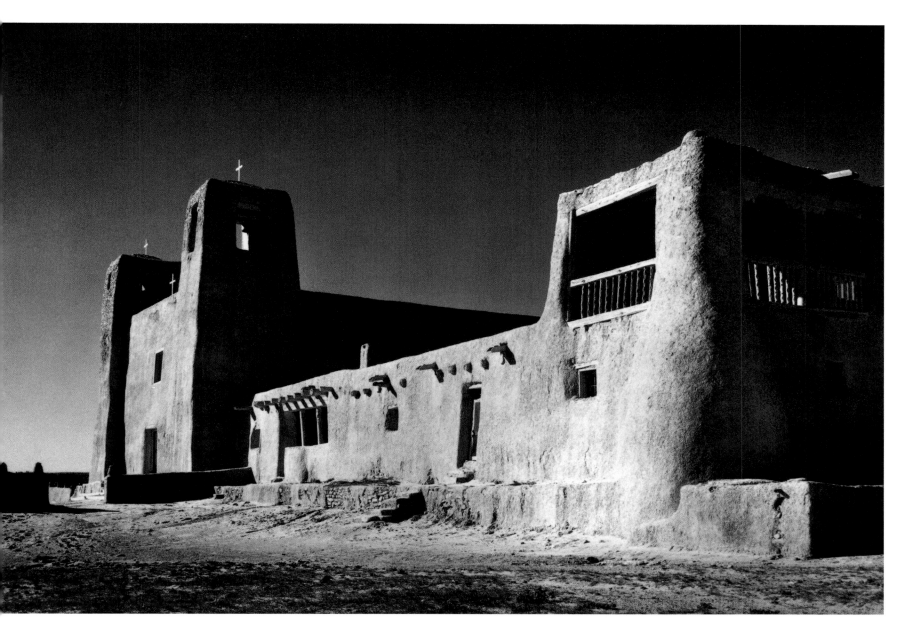

"Church, Acoma Pueblo"

"Navajo Girl, Canyon de Chelly, Arizona"

"Navajo Woman & Infant, Canyon de Chelly, Arizona"

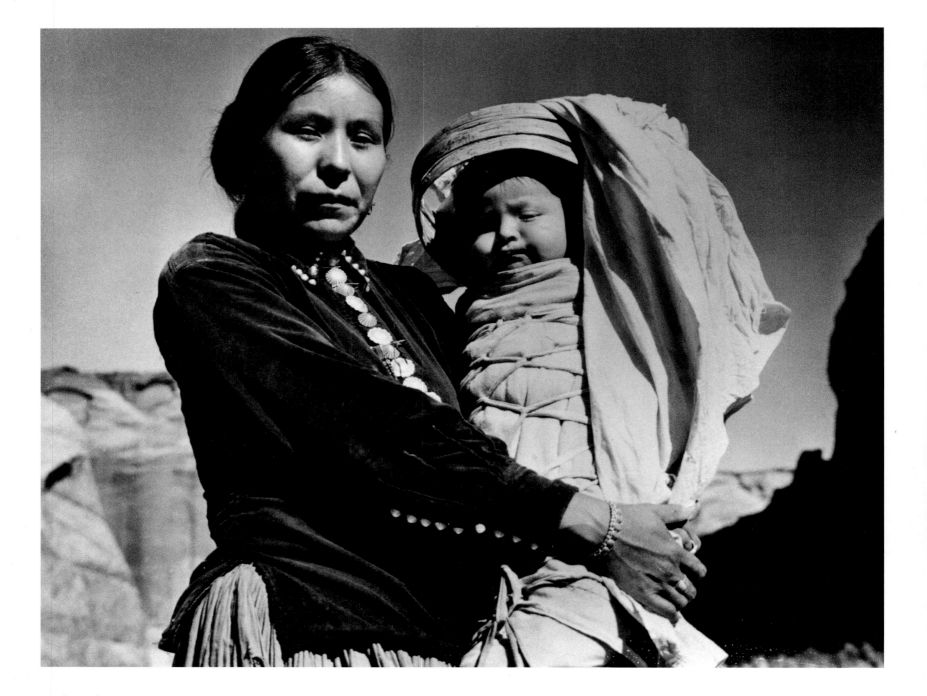

"In Zion National Park"

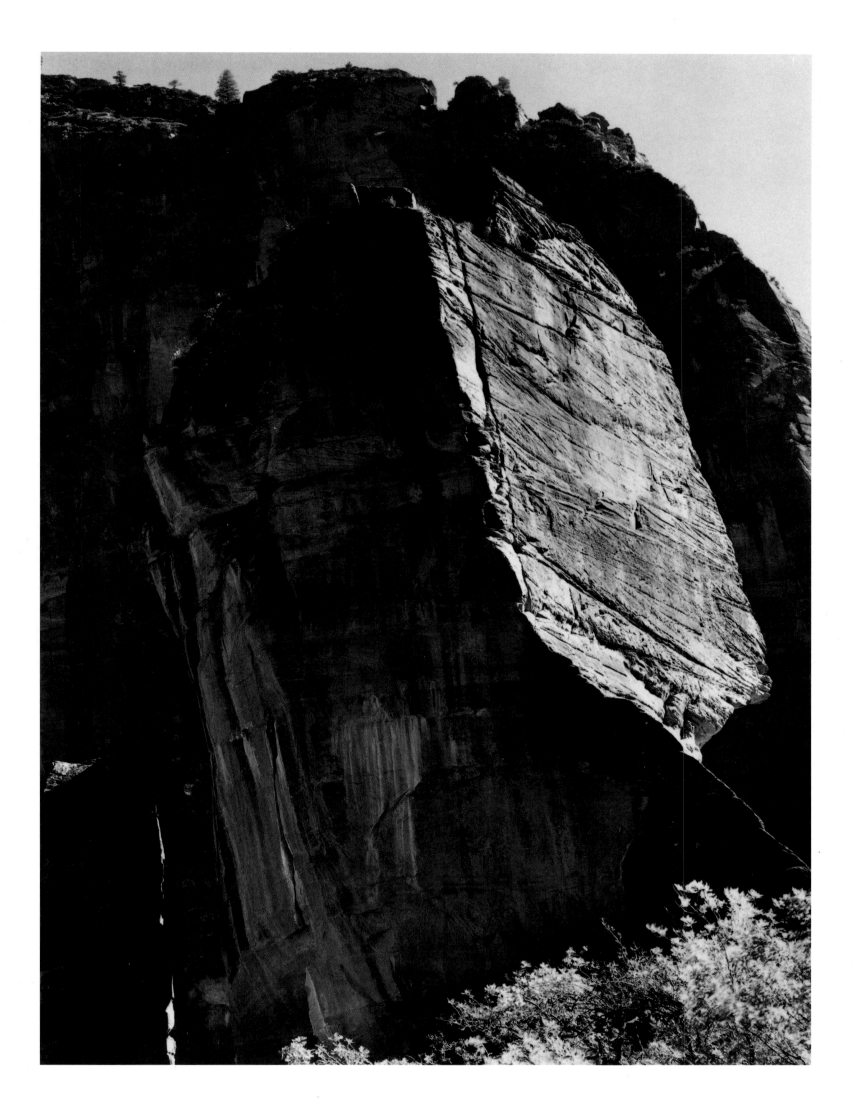

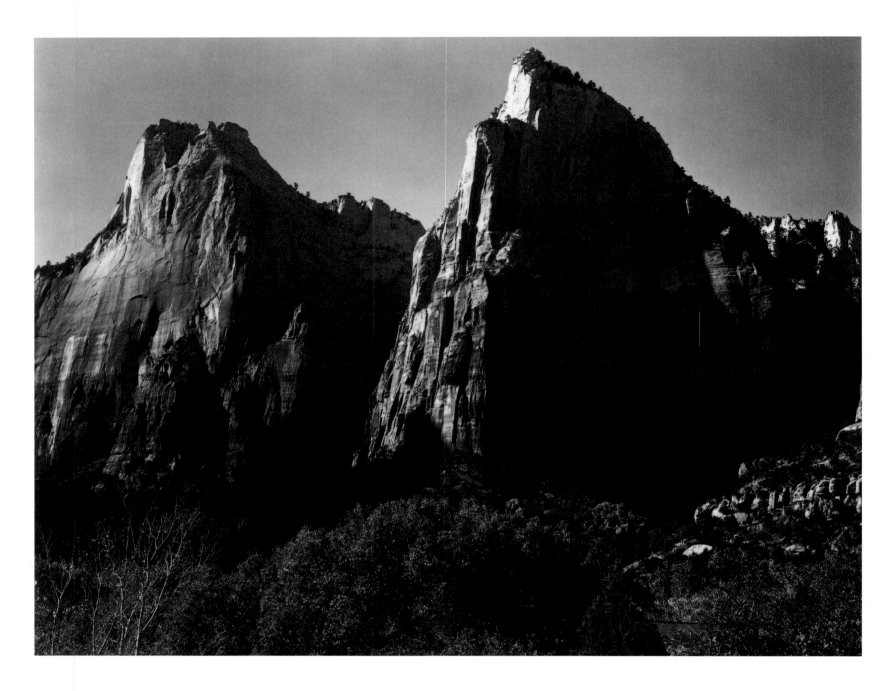

"Court of the Patriarchs, Zion National Park"

"From Long Pass, Glacier National Park"

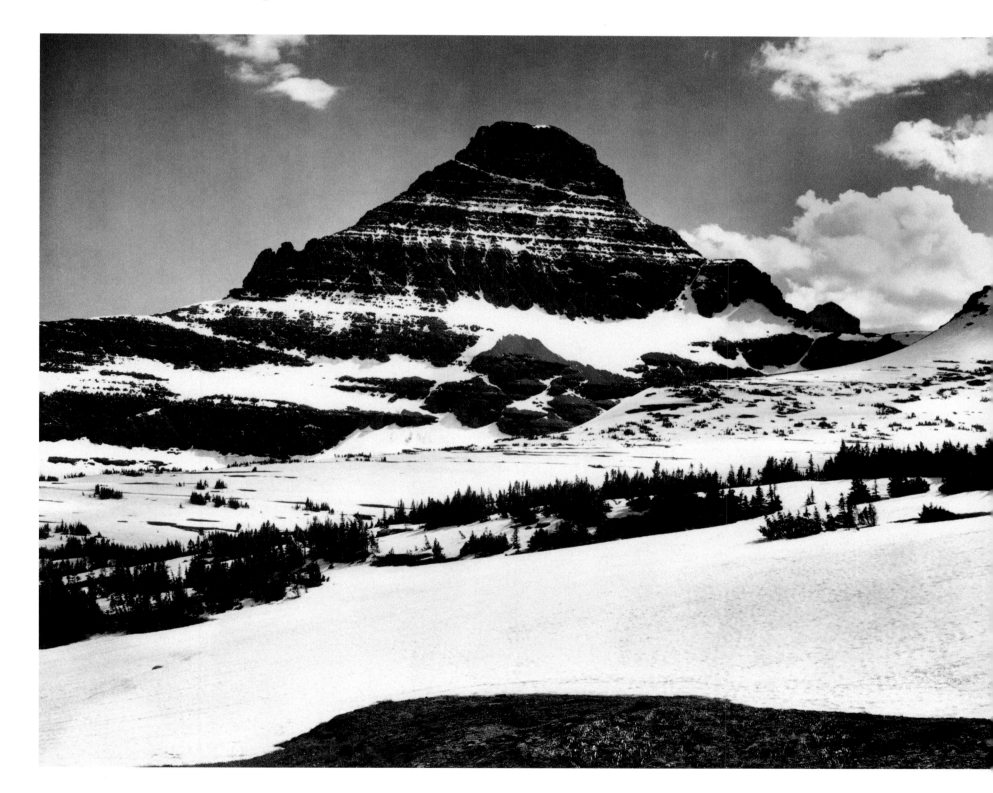

"Zion National Park"

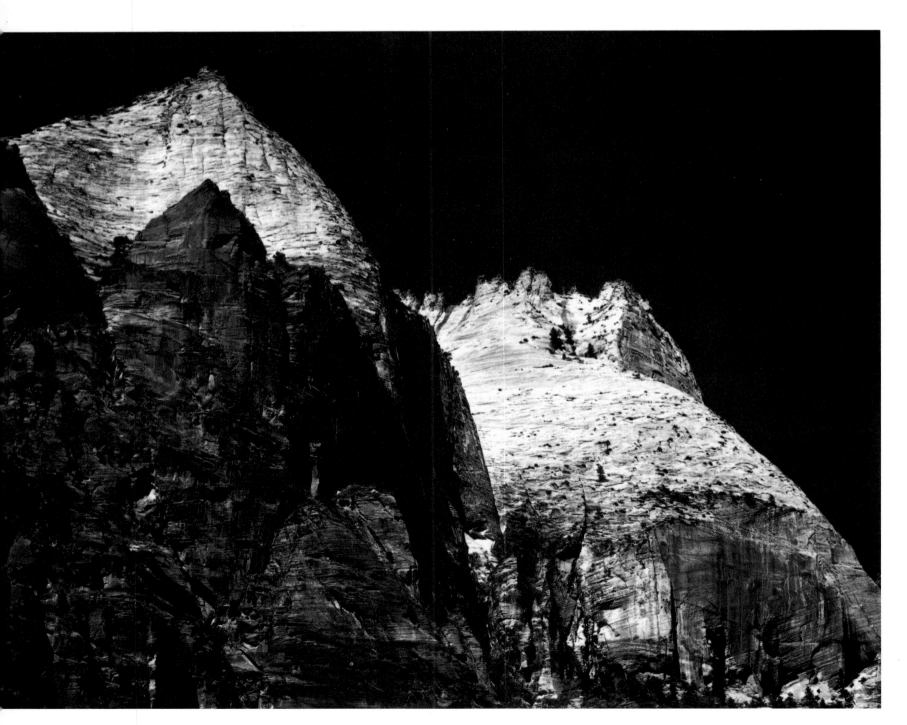

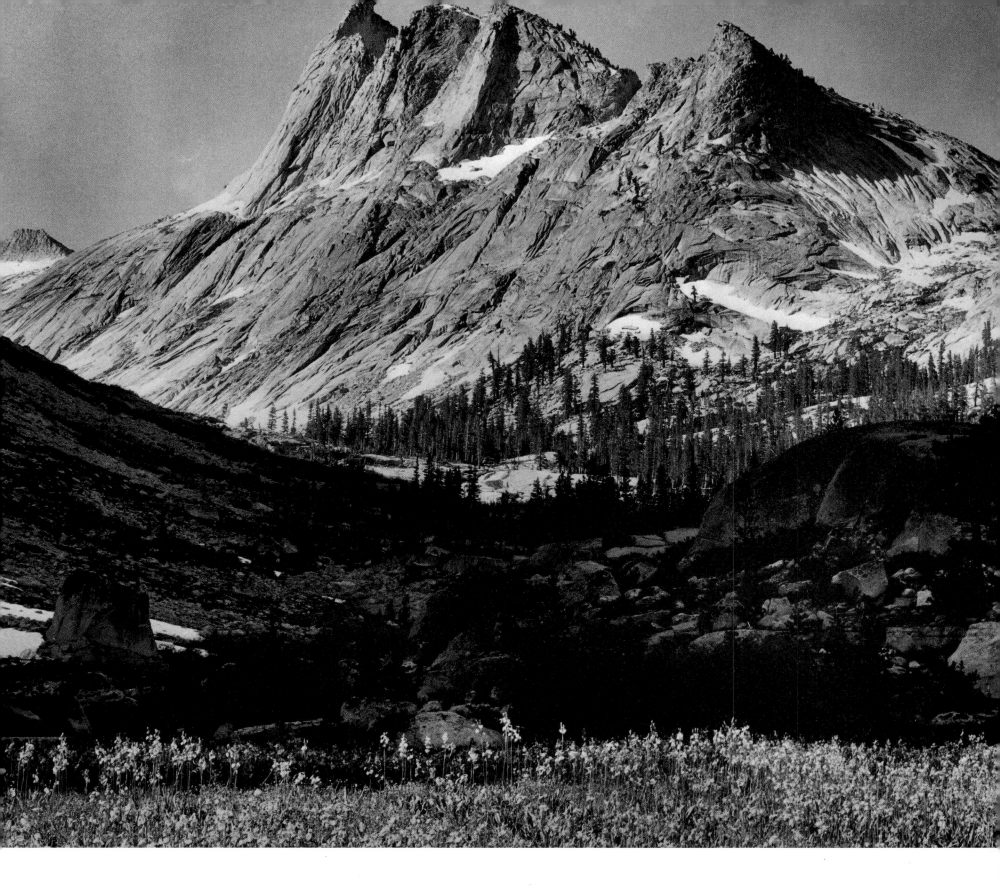

"Boaring River, Kings Region, Kings River Canyon"

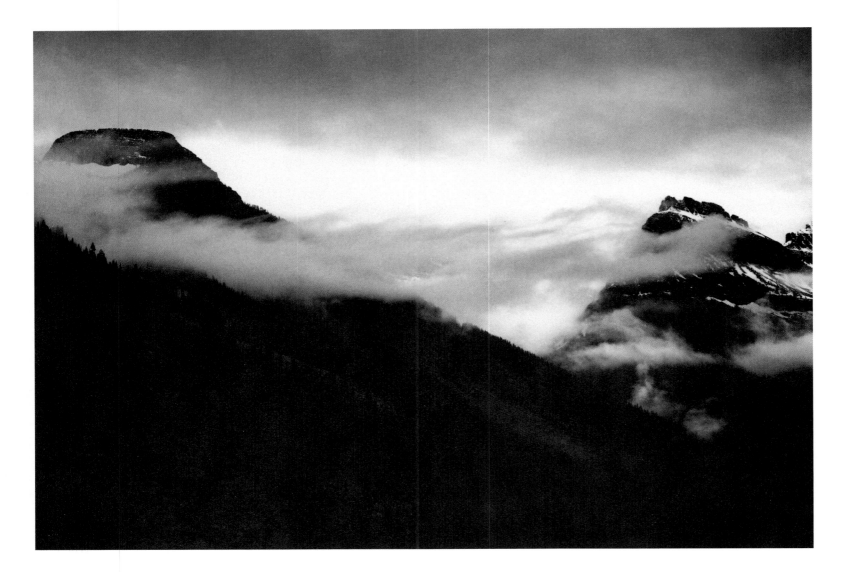

"In Glacier National Park"

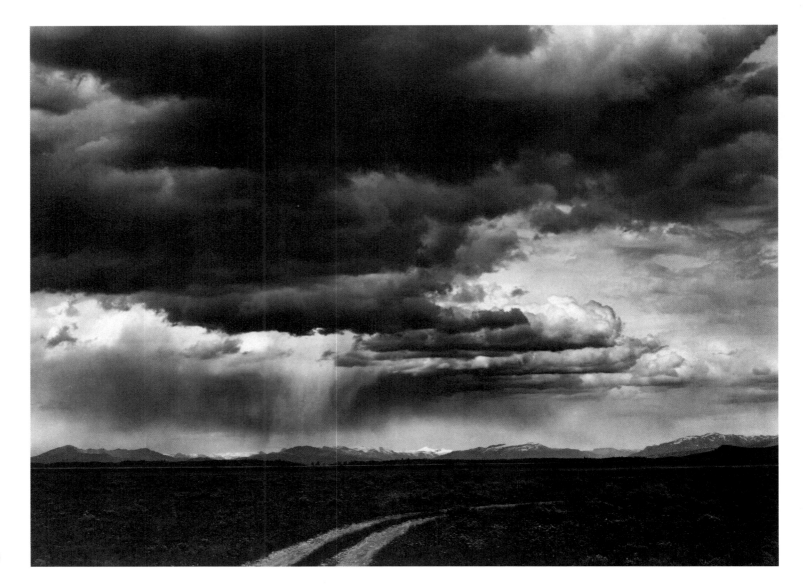

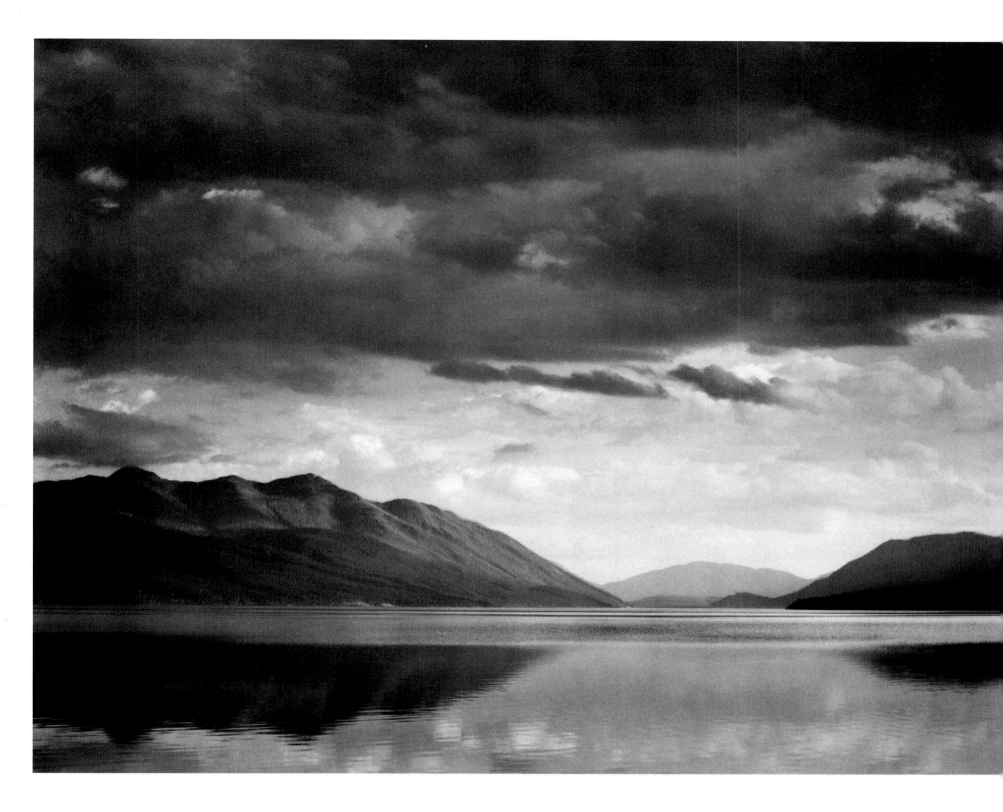

"Evening, McDonald Lake, Glacier National Park"

"Near Teton National Park"

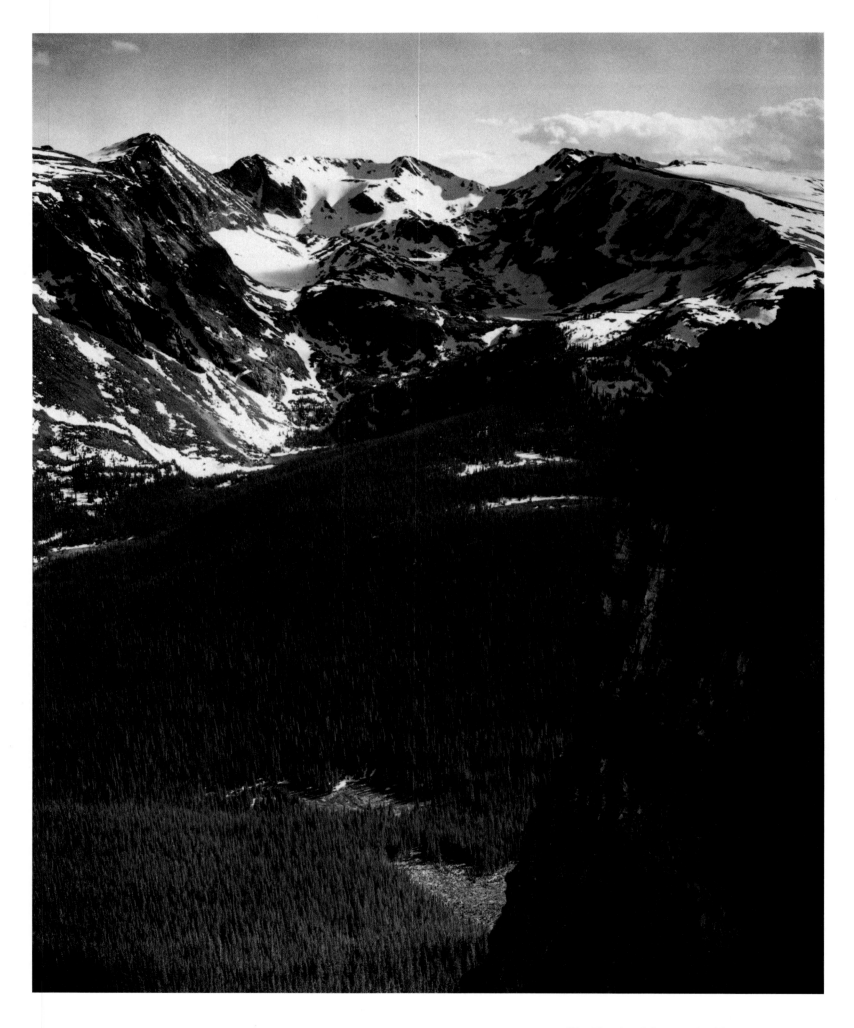

"In Rocky Mountain National Park"

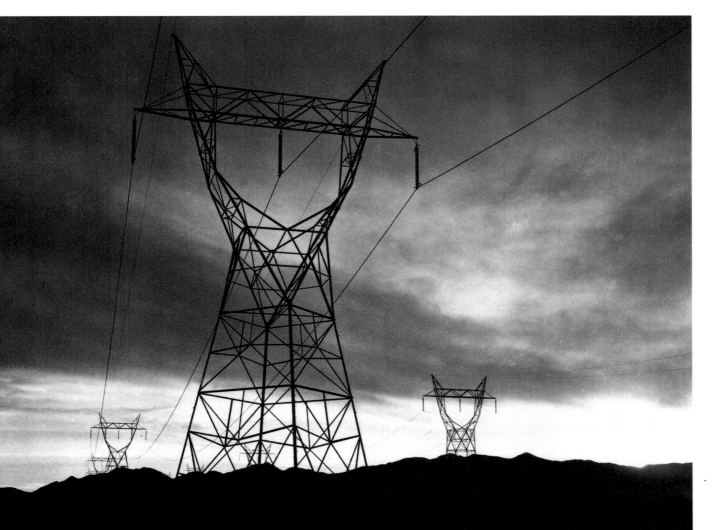

"Transmission Lines
in Mojave Desert"

"Boulder Dam, 1941"

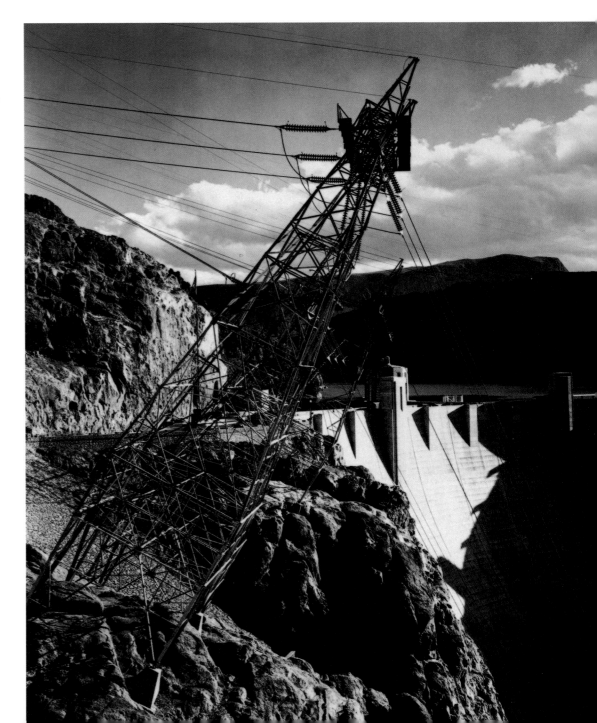

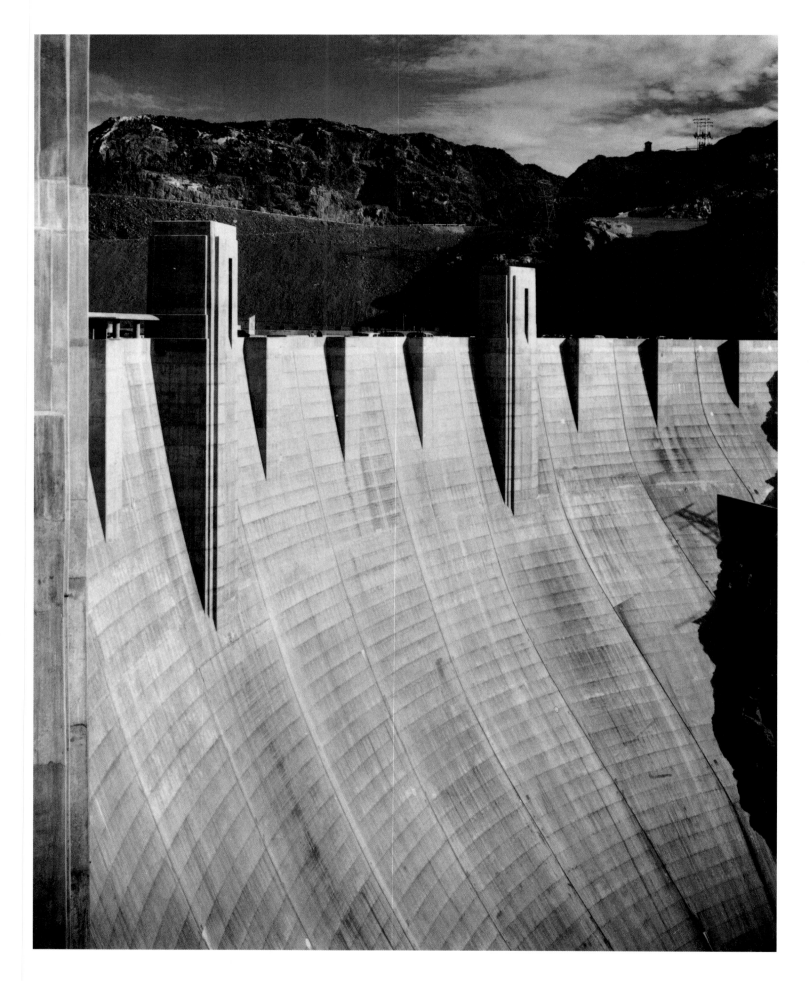

"Boulder Dam, 1941"

"Boulder Dam Power Units, 1941"

"Boulder Dam, 1941"

"Acoma Pueblo"

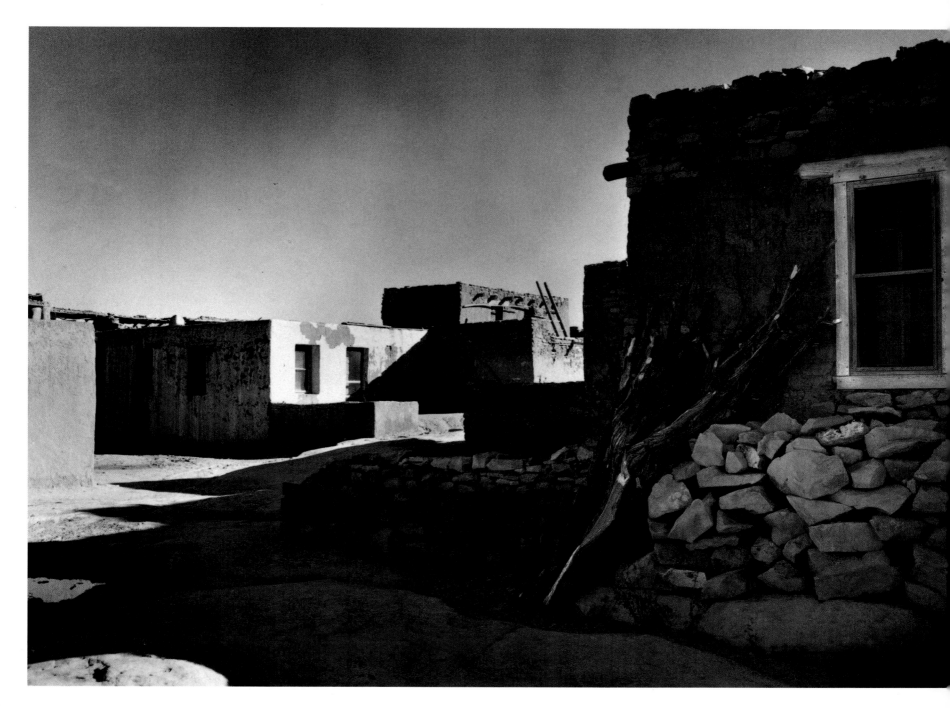

"Corn Field, Indian Farm Near Tuba City, Arizona, in Rain"

"At San Ildefonso Pueblo,
New Mexico, 1942"

"Acoma Pueblo"

"Dance, San Ildefonso Pueblo, New Mexico, 1942"

"Dance, San Ildefonso Pueblo, New Mexico, 1942"

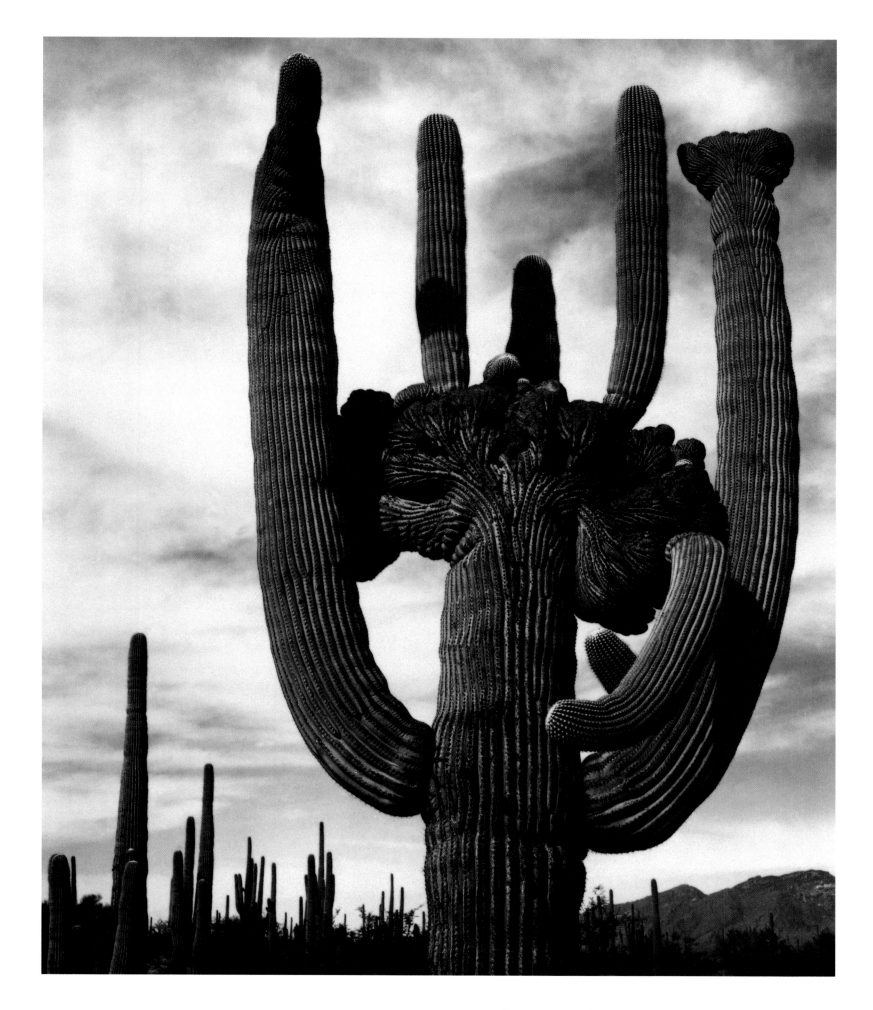

"Saguaros, Saguaro National Monument"

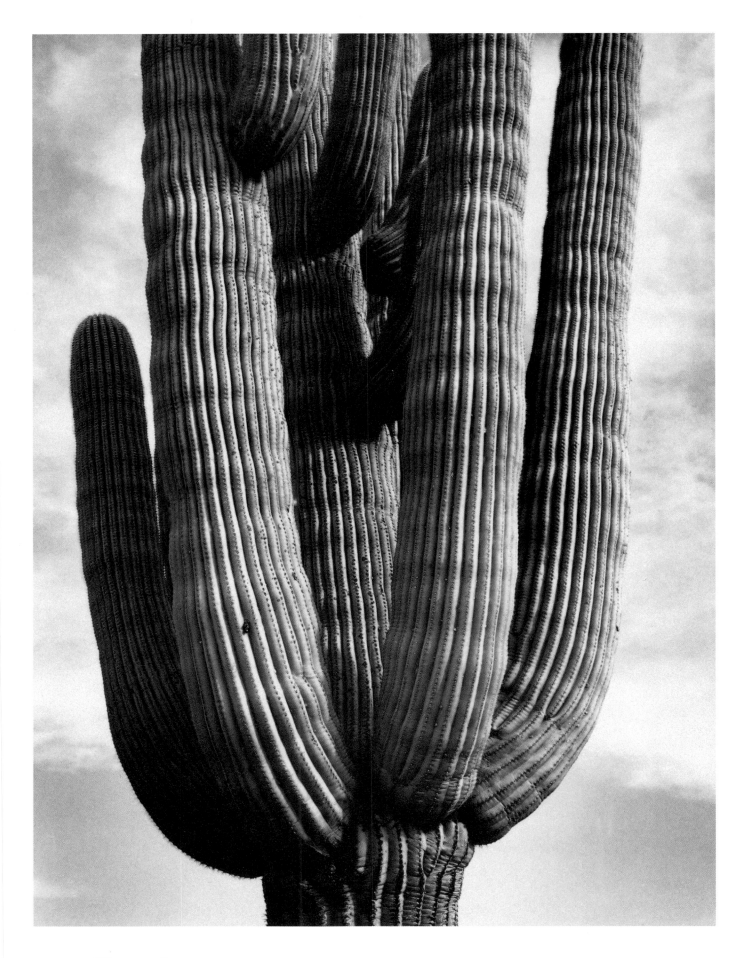

"Saguaro"

"In Saguaro National Monument"

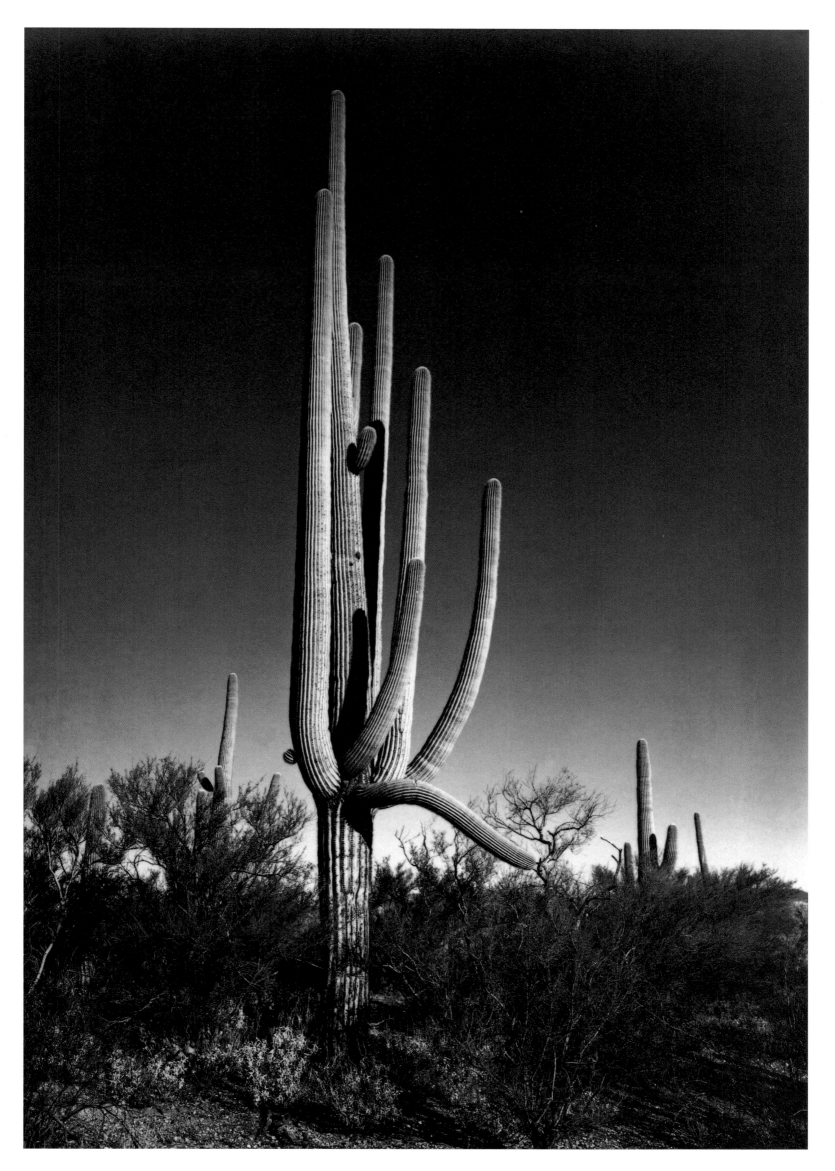

"Saguaro National Monument"

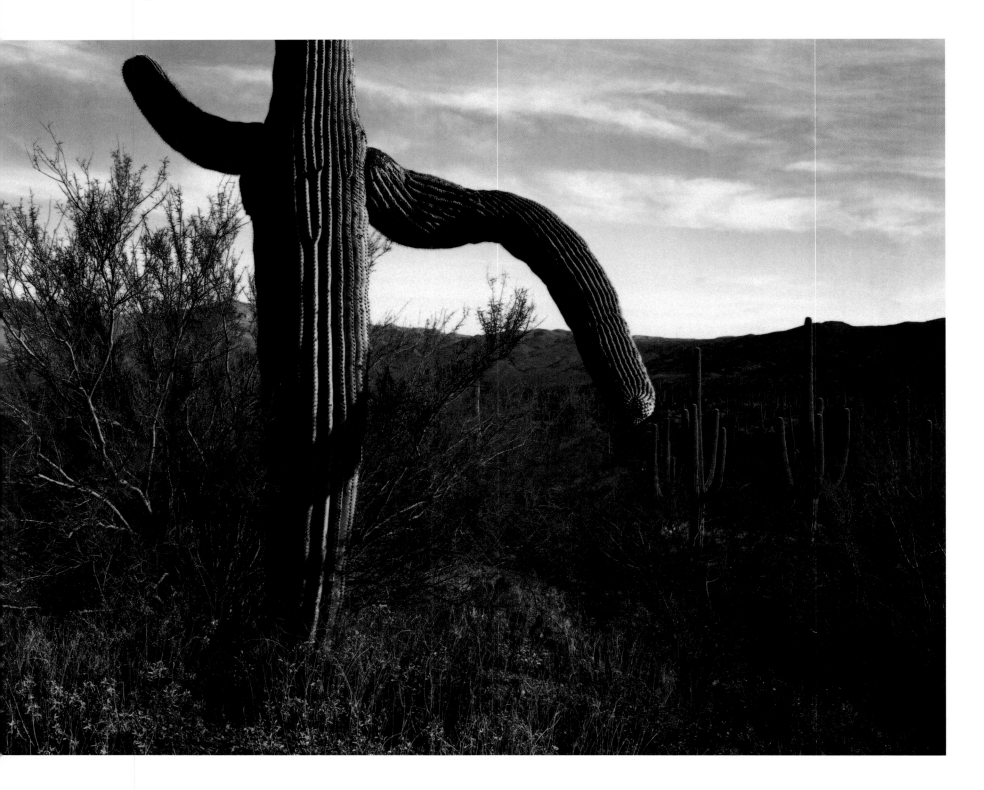

"Moraine, Rocky Mountain National Park"

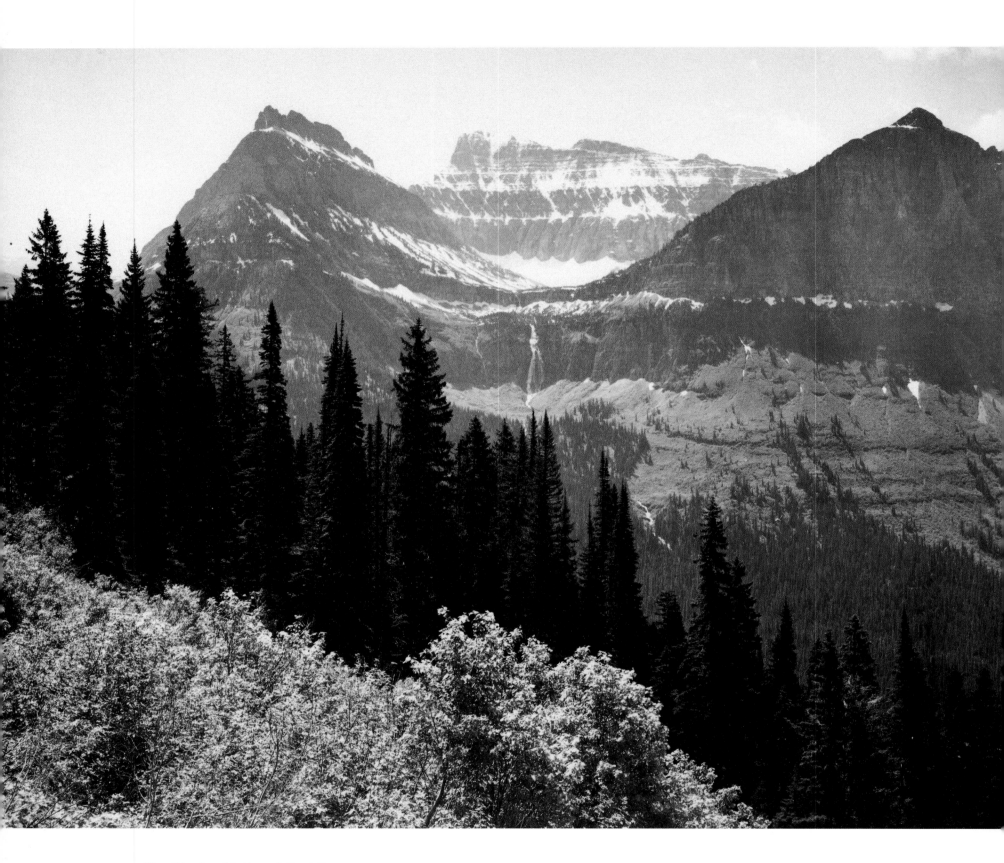

"In Glacier National Park"

"Long's Peak
from North,
Rocky Mountain
National Park"

"In Rocky Mountain
National Park"

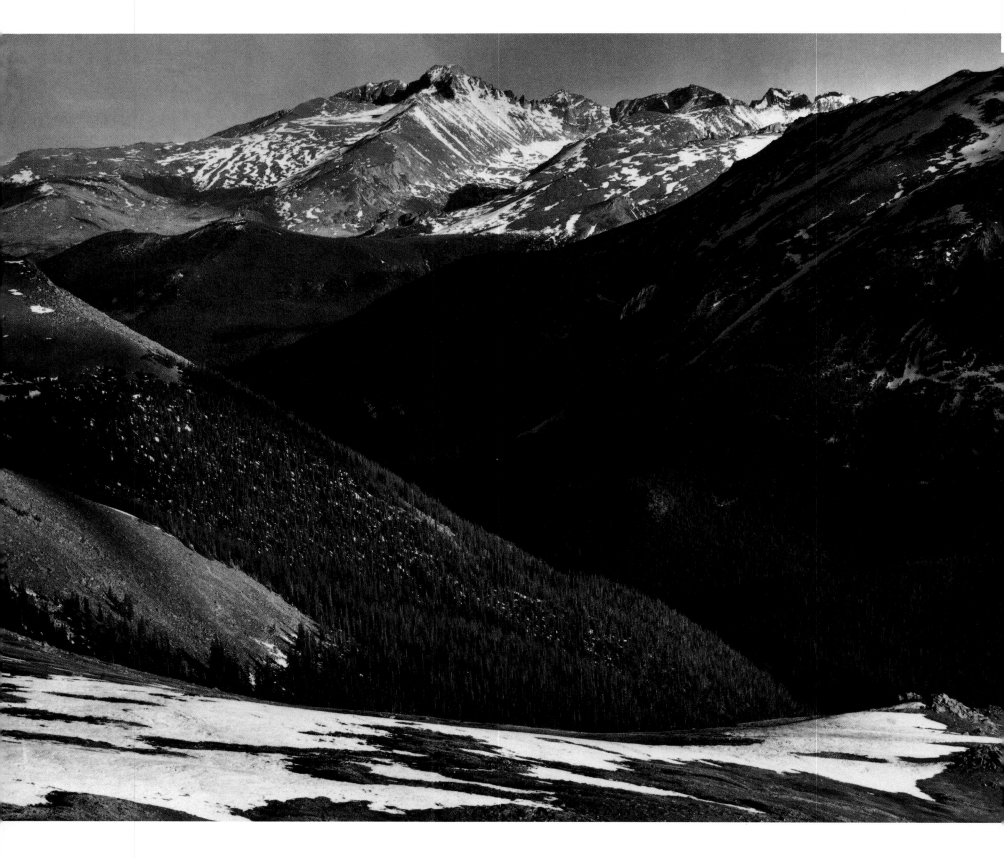

"Long's Peak, Rocky Mountain National Park"

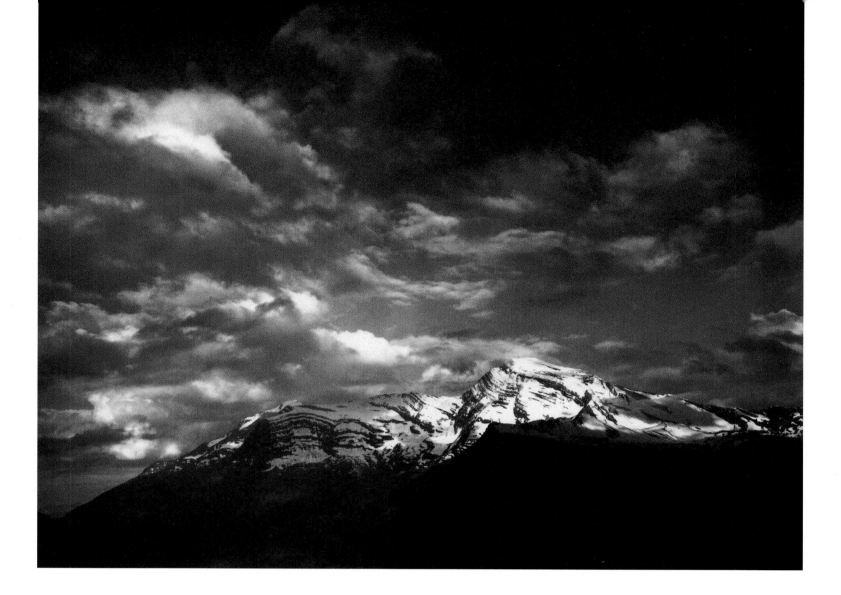

"Heaven's Peak, Glacier National Park"

"Lichen, Glacier National Park"

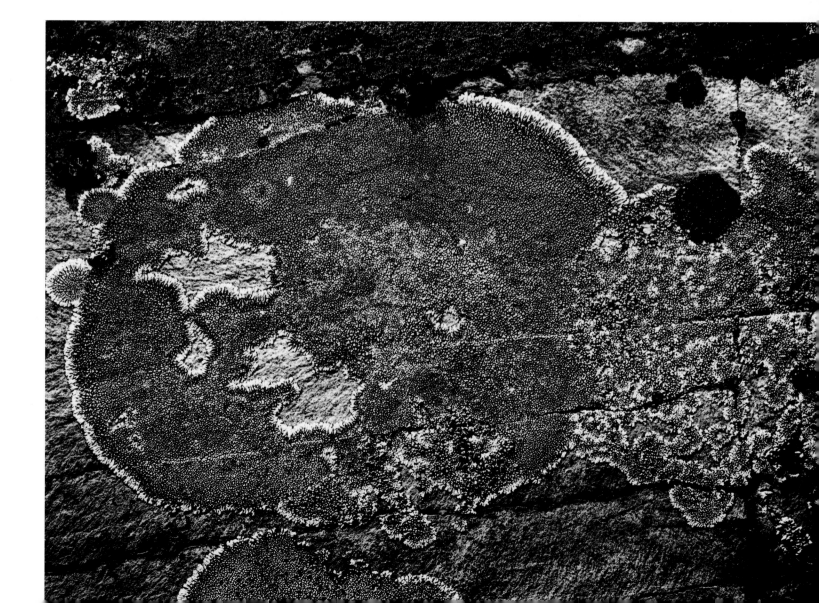

"In Glacier National Park"

"Carlsbad Caverns National Park"

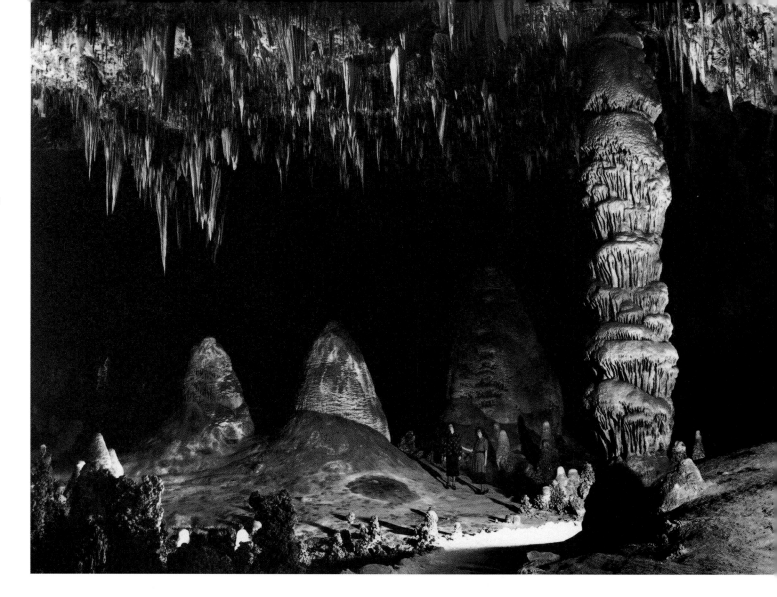

"Carlsbad Caverns
National Park"

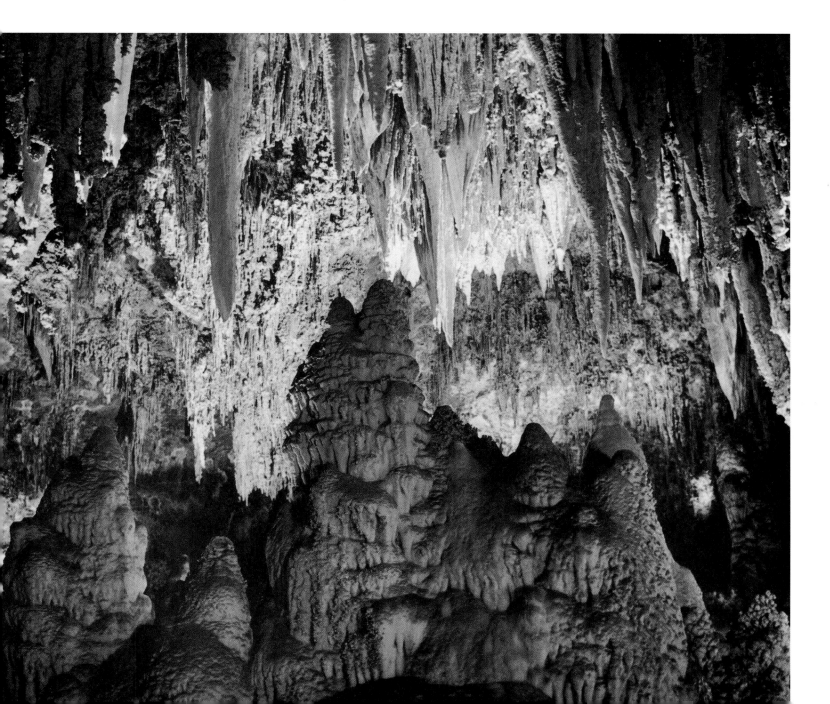

123

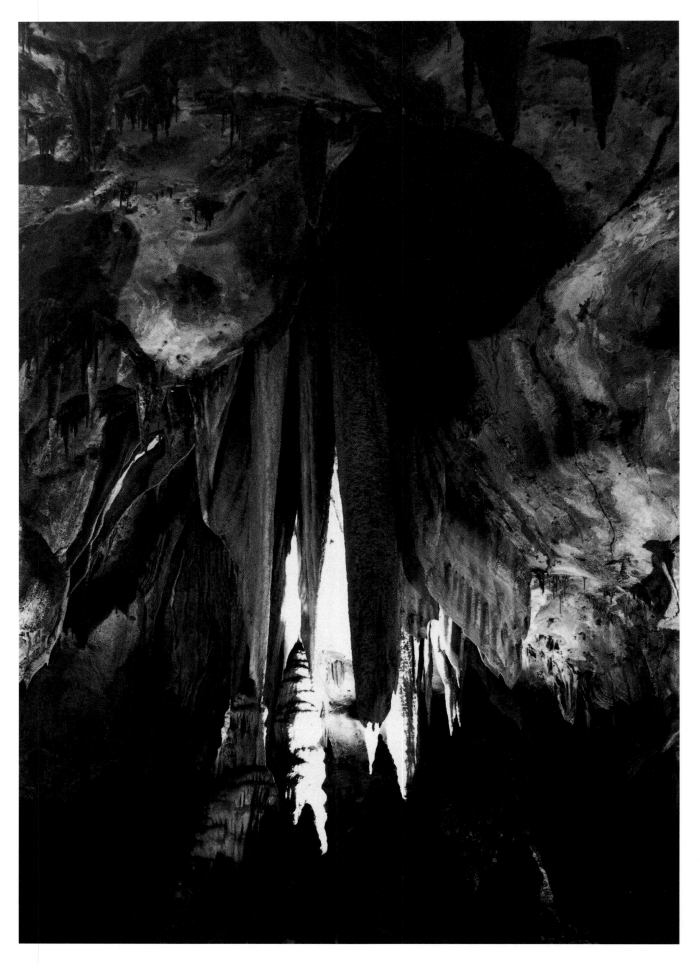

"Carlsbad Caverns
National Park"

"Carlsbad Caverns
National Park"

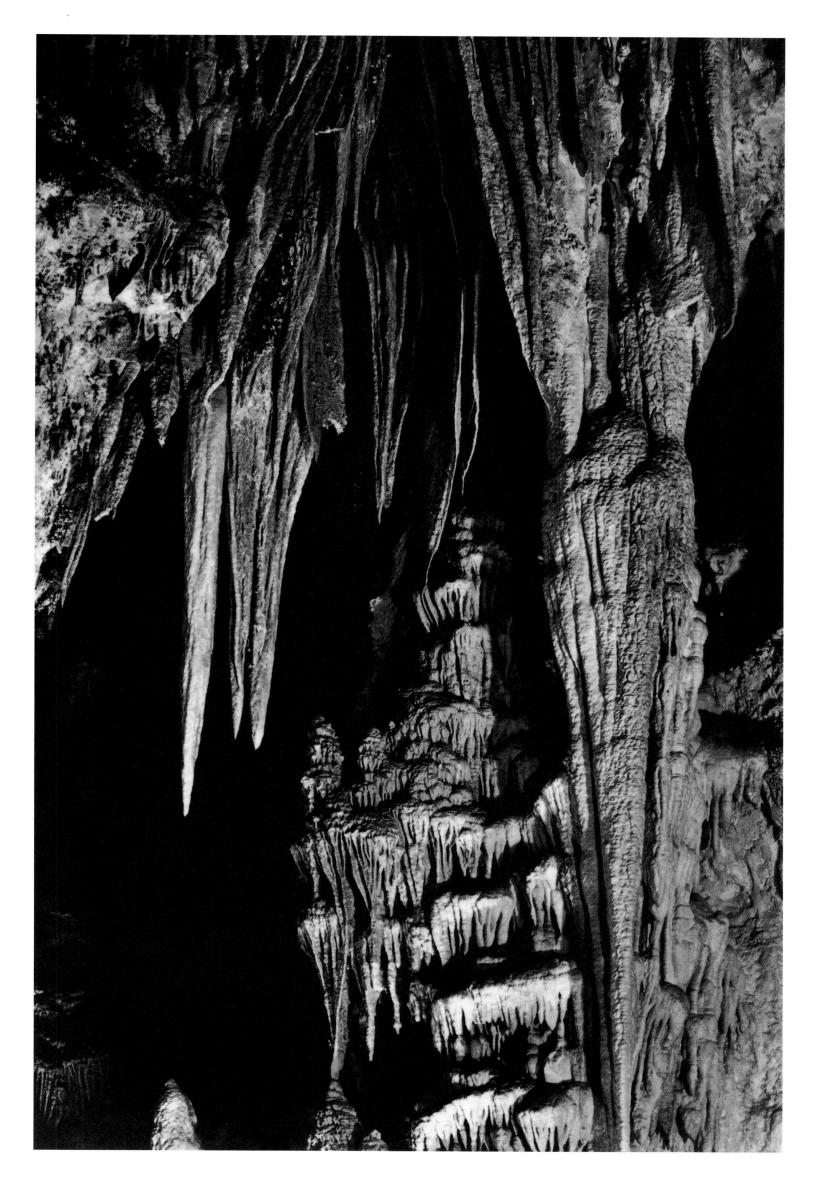

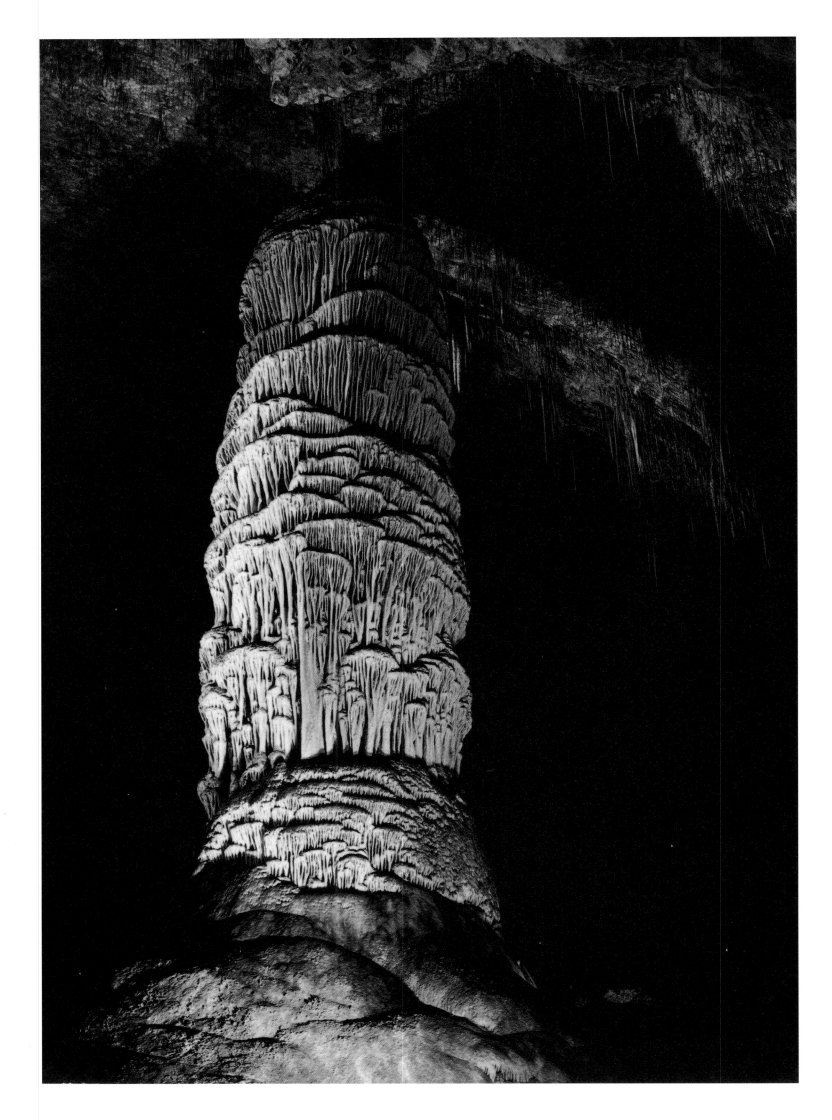

"Carlsbad Caverns
National Park"

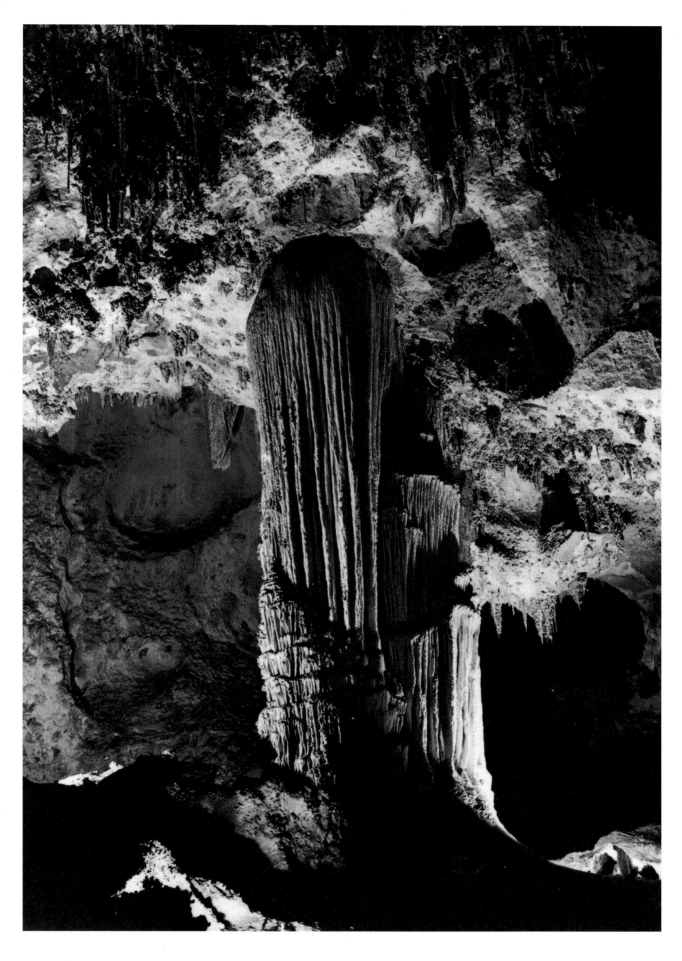

"Carlsbad Caverns
National Park"

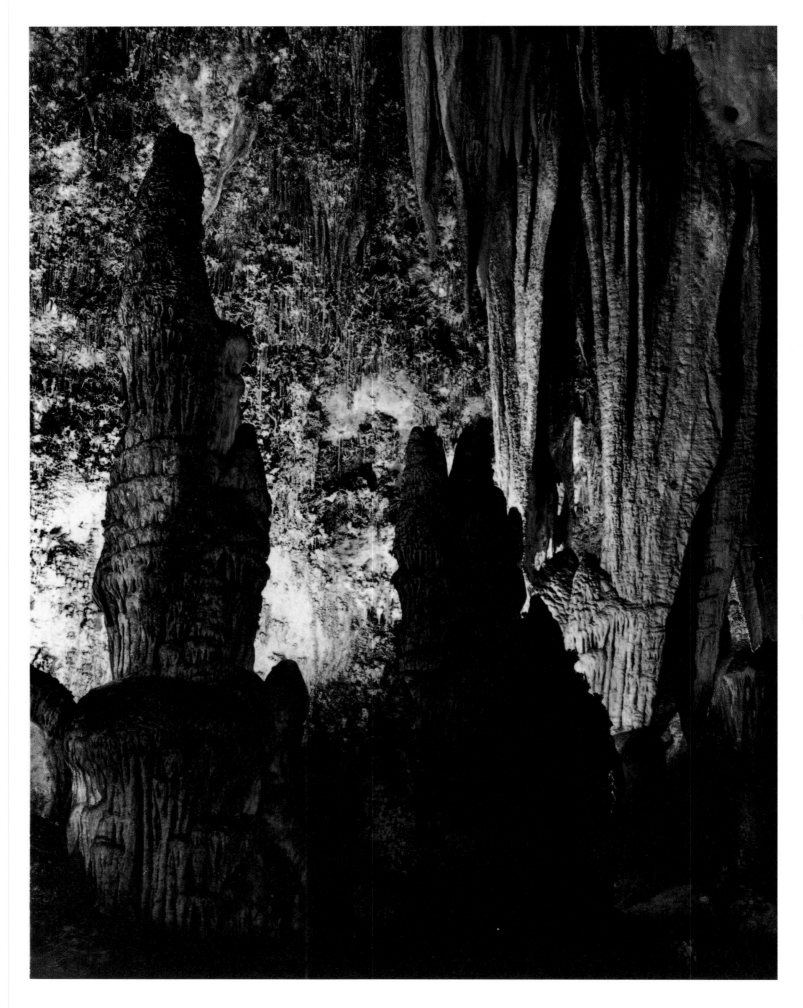

"Large Stalagmite Formations and Onyx Drapes above, in the King's Palace"

"Formations in the Big Room near the Temple of the Sun, detail"

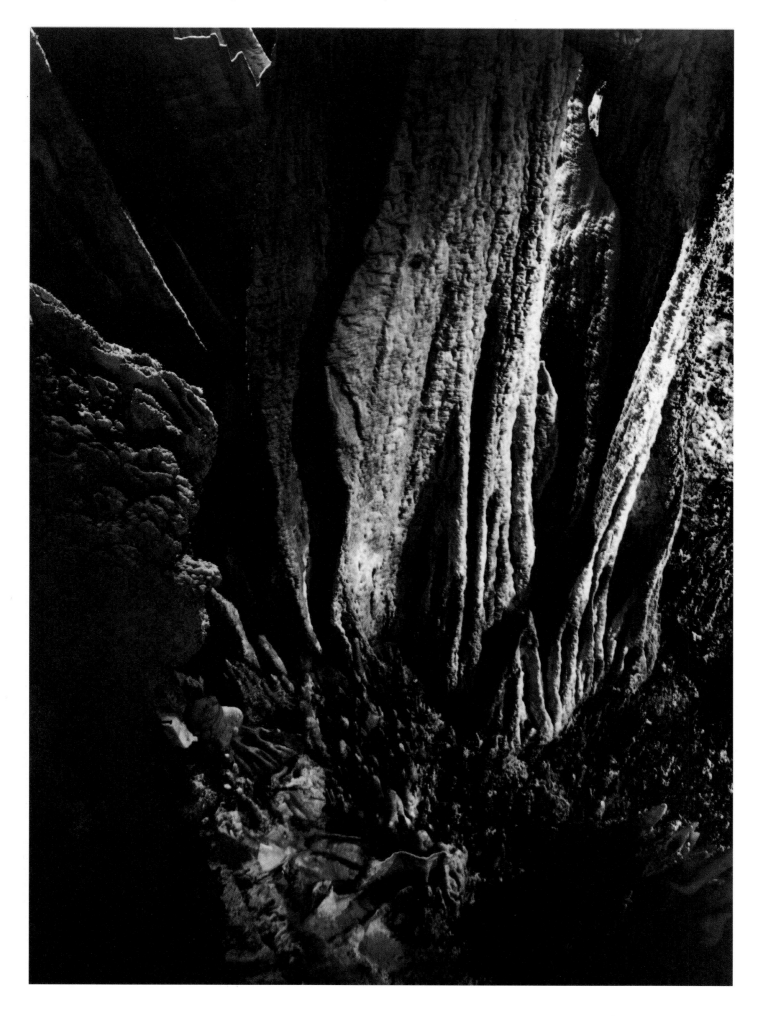

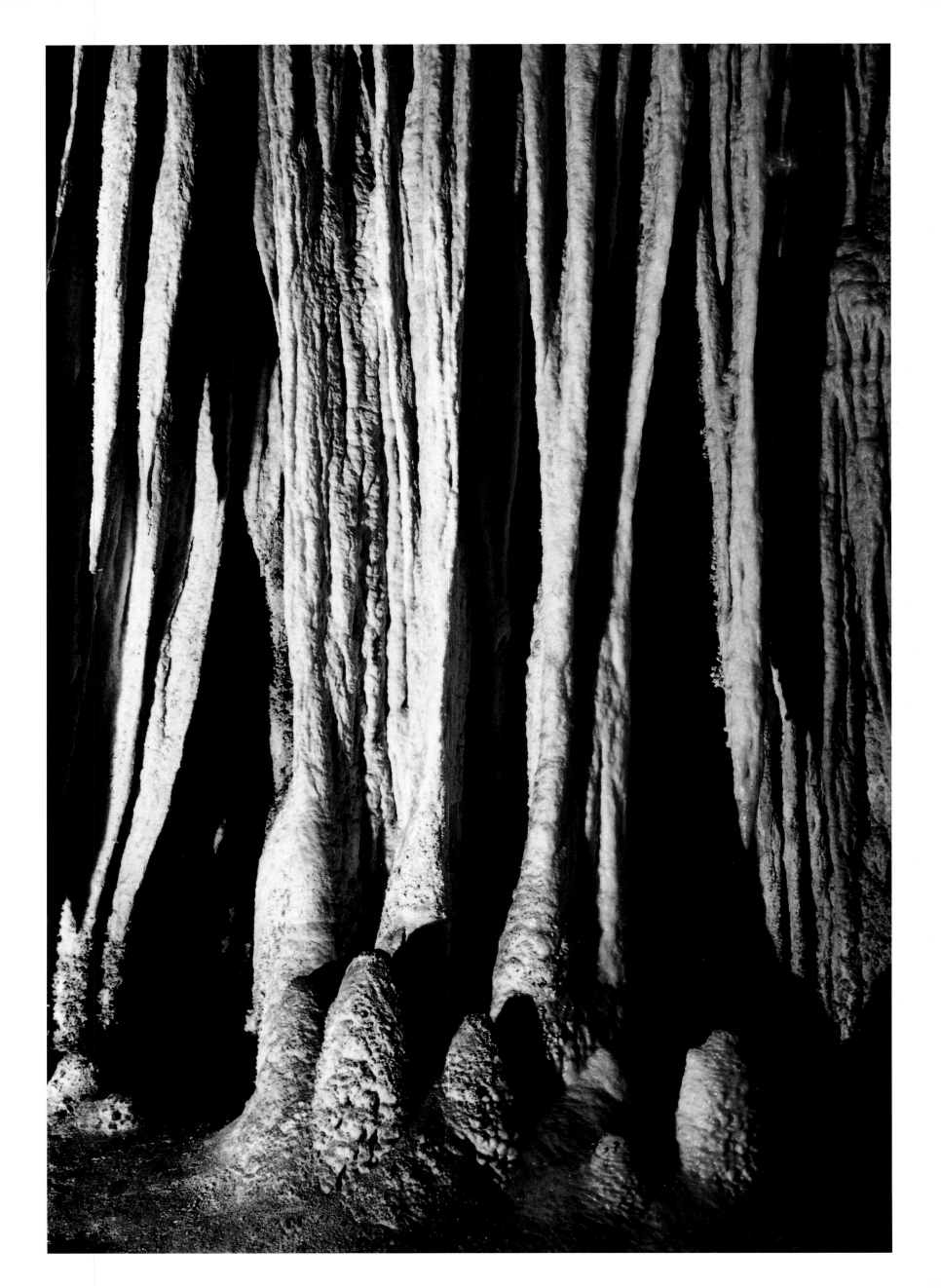

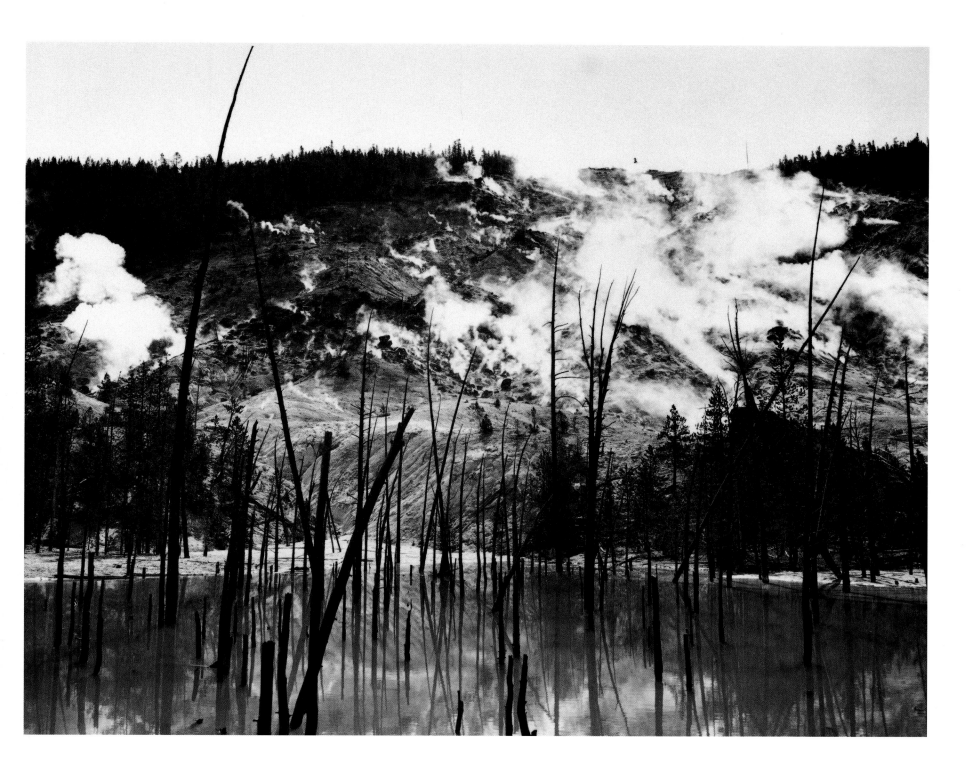

"Roaring Mountain, Yellowstone National Park"

"Formations along the Trail in the Big Ram, near the Temple of the Sun"

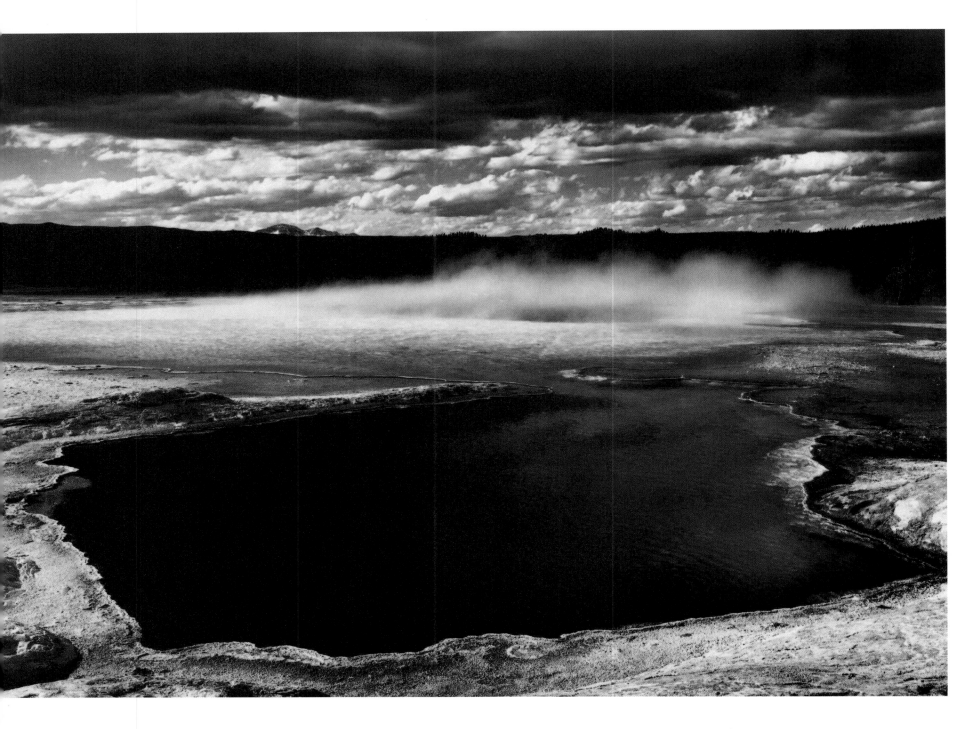

"Fountain Geyser Pool, Yellowstone National Park"

"Yellowstone Lake-Hot Springs Overflow, Yellowstone National Park"

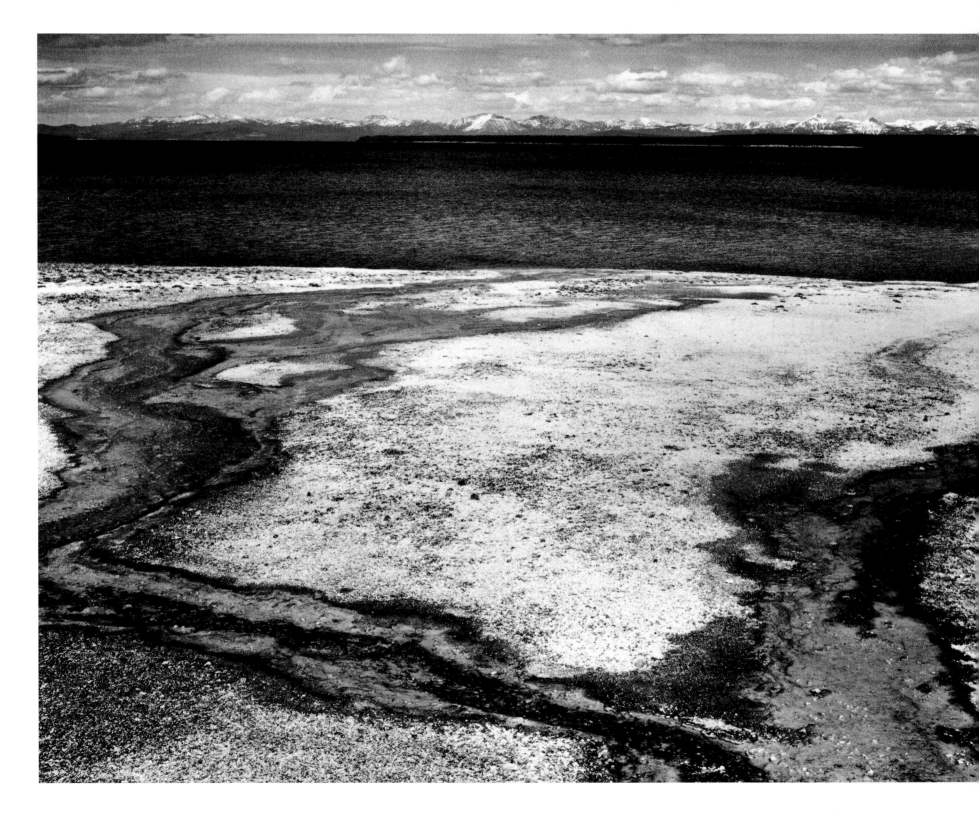

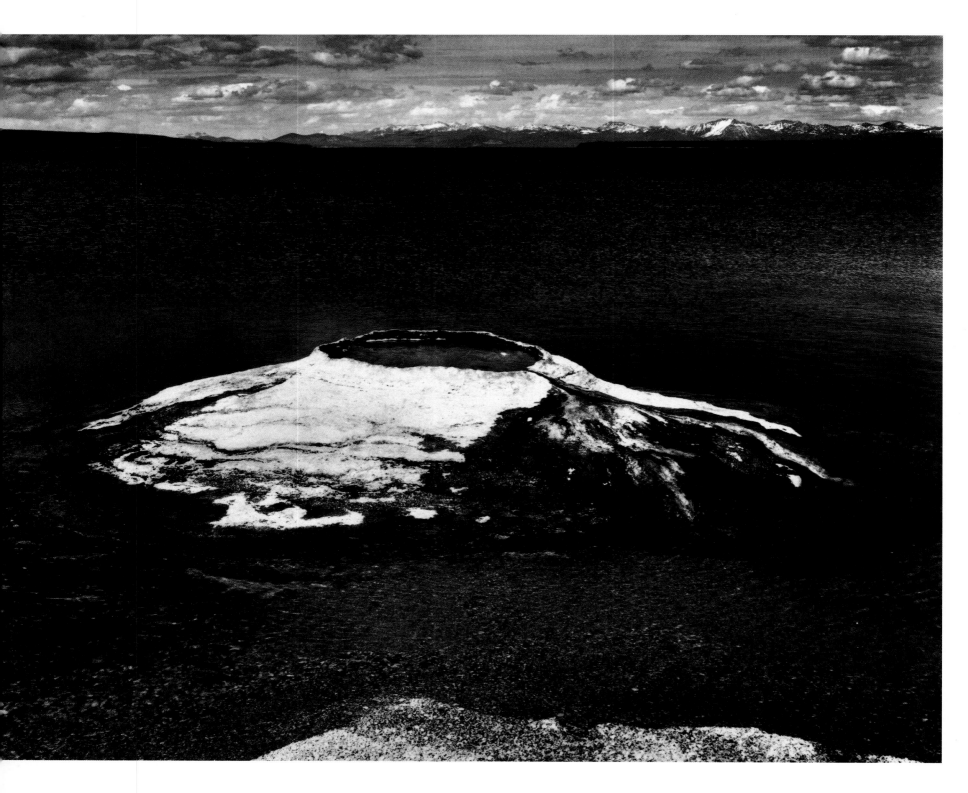

"The Fishing Cone—Yellowstone Lake, Yellowstone National Park"

"Firehold River, Yellowstone National Park"

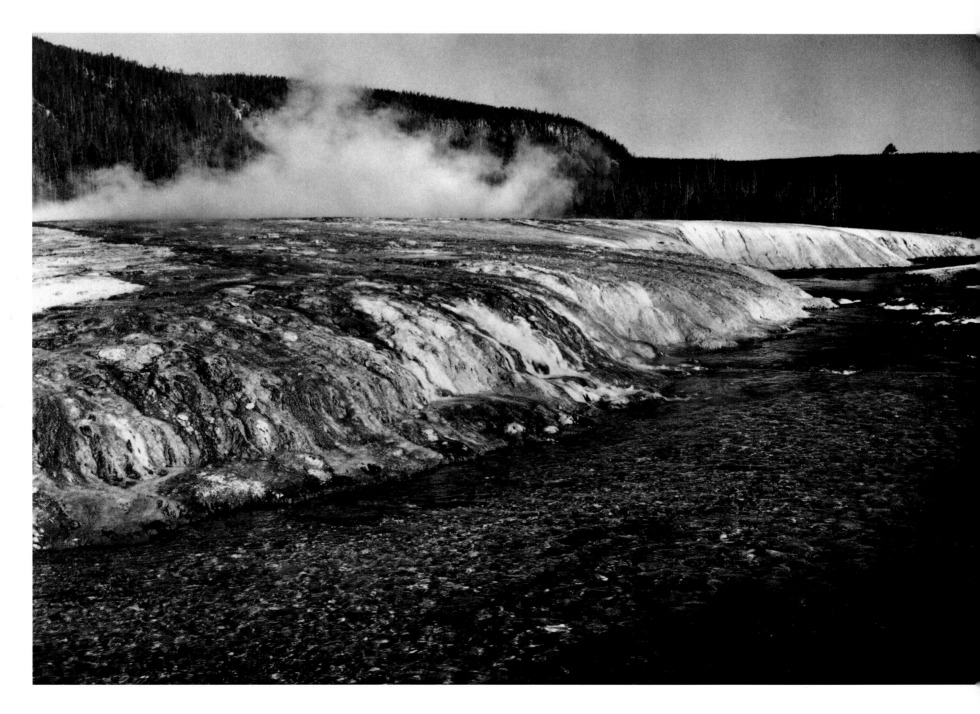

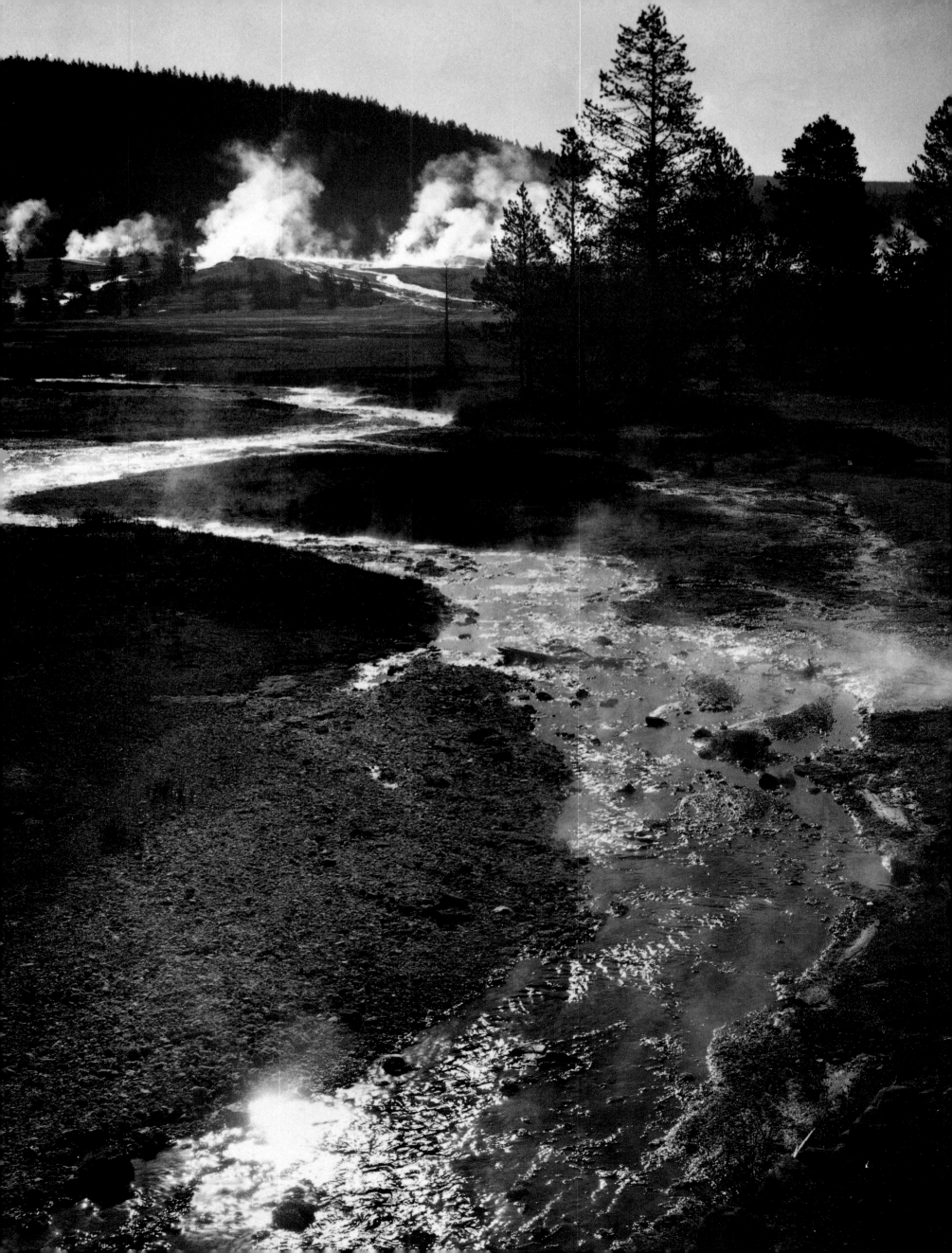

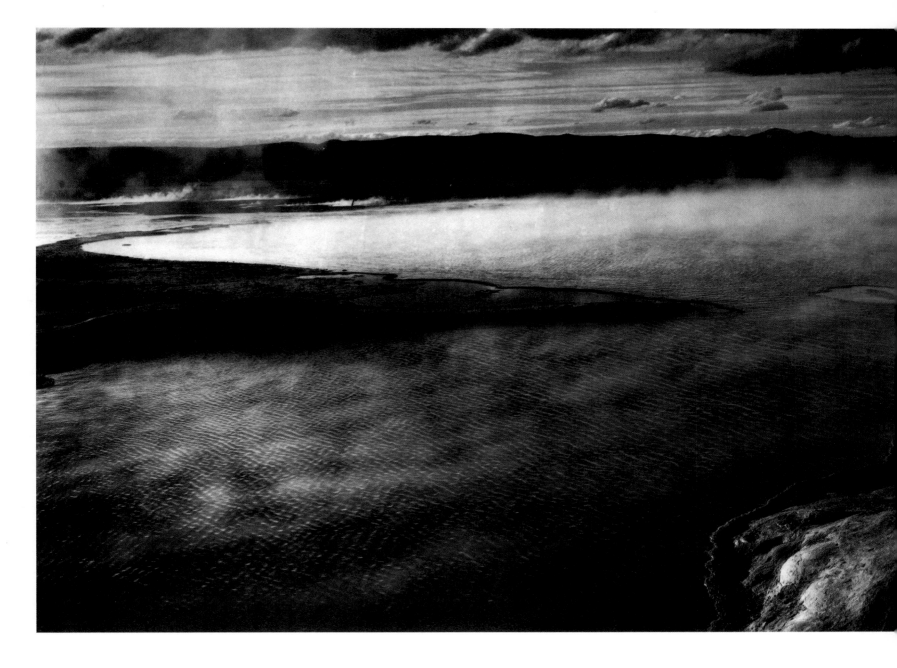

"Fountain Geyser Pool, Yellowstone National Park"

"Central Geyser Basin,
Yellowstone National Park"

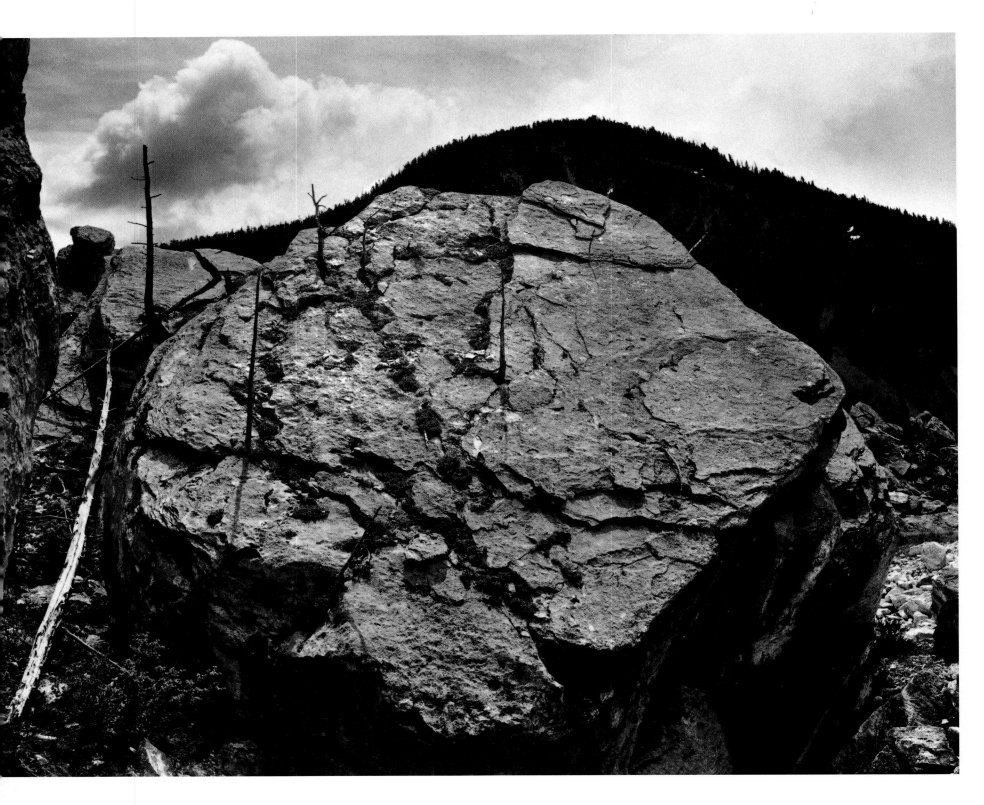

"Rocks at Silver Gale, Yellowstone National Park"

"Jupiter Terrace, Fountain Geyser Pool, Yellowstone National Park"

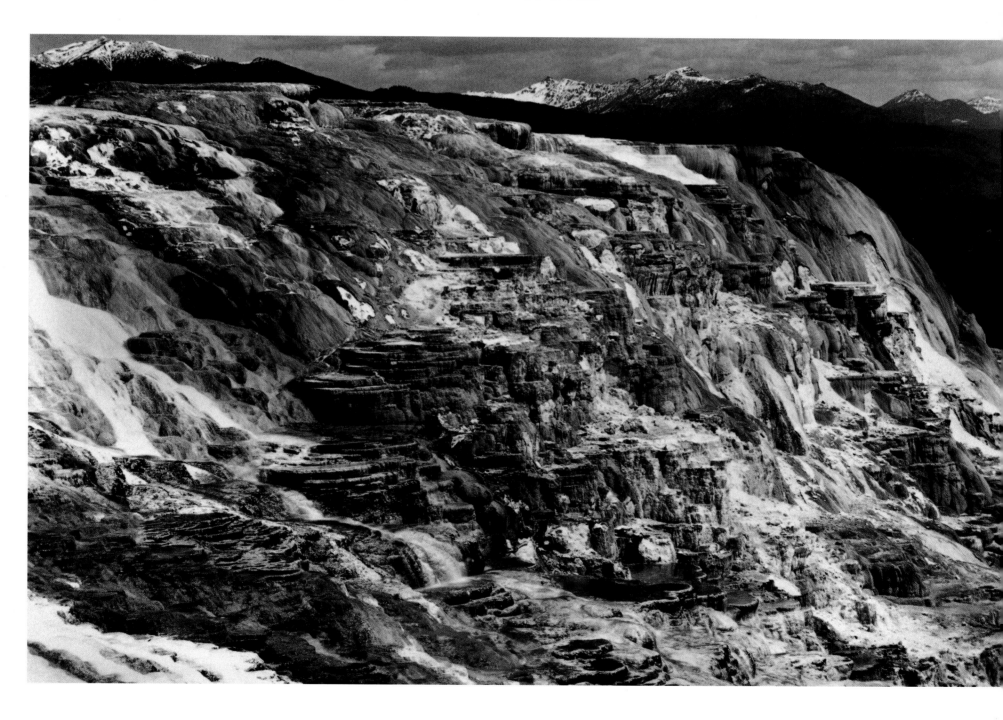

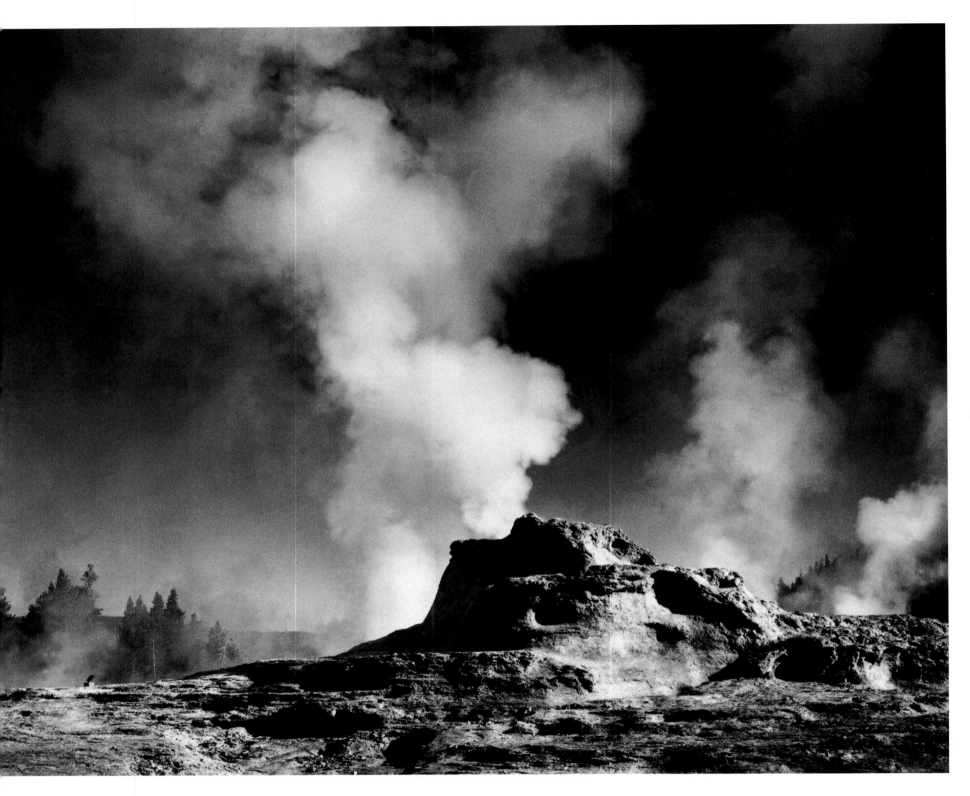

"Castle Geyser Cove, Yellowstone National Park"

"Old Faithful Geyser,
Yellowstone National Park"

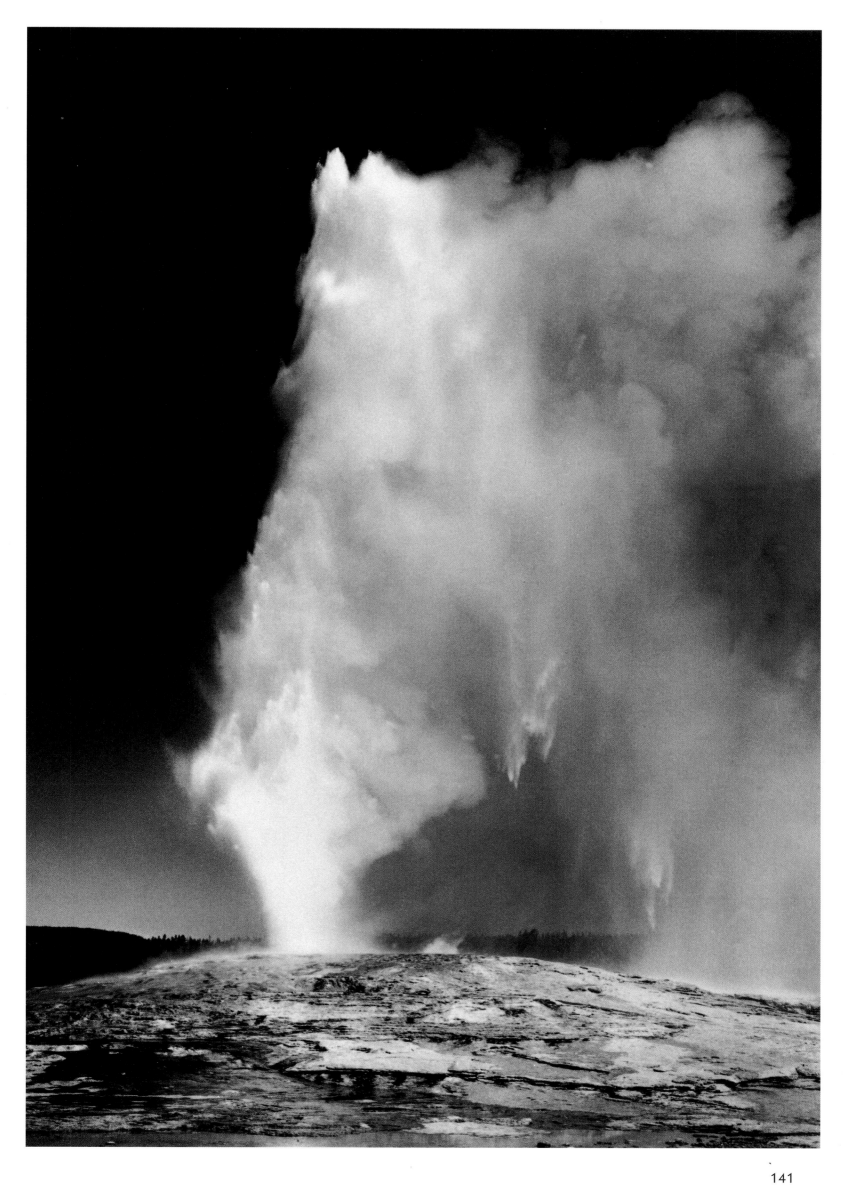

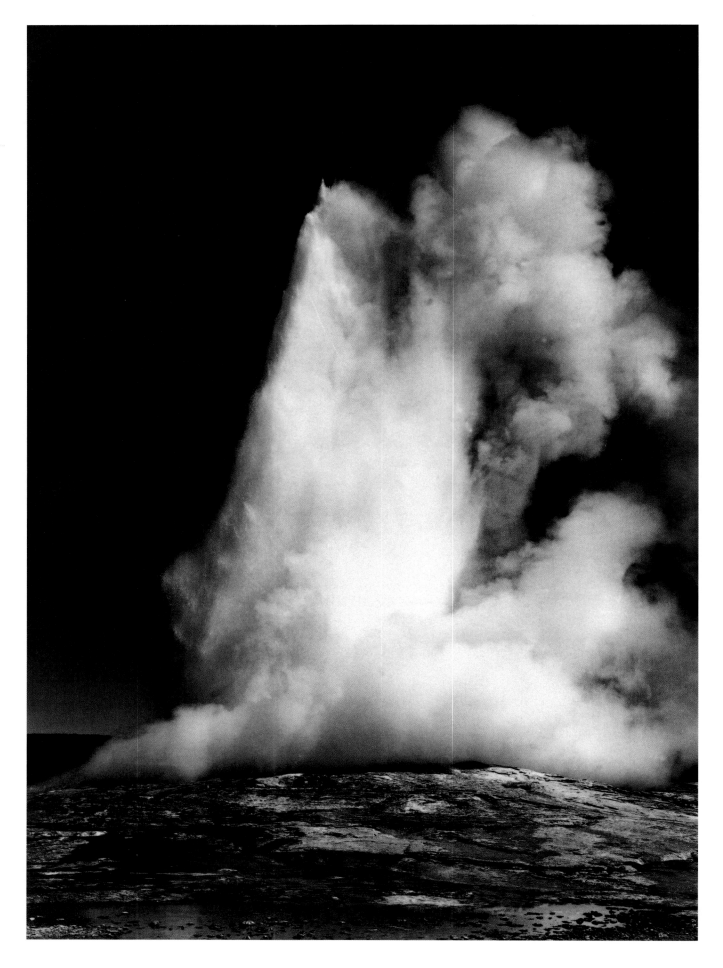

"Fountain Geyser Pool, Yellowstone National Park"

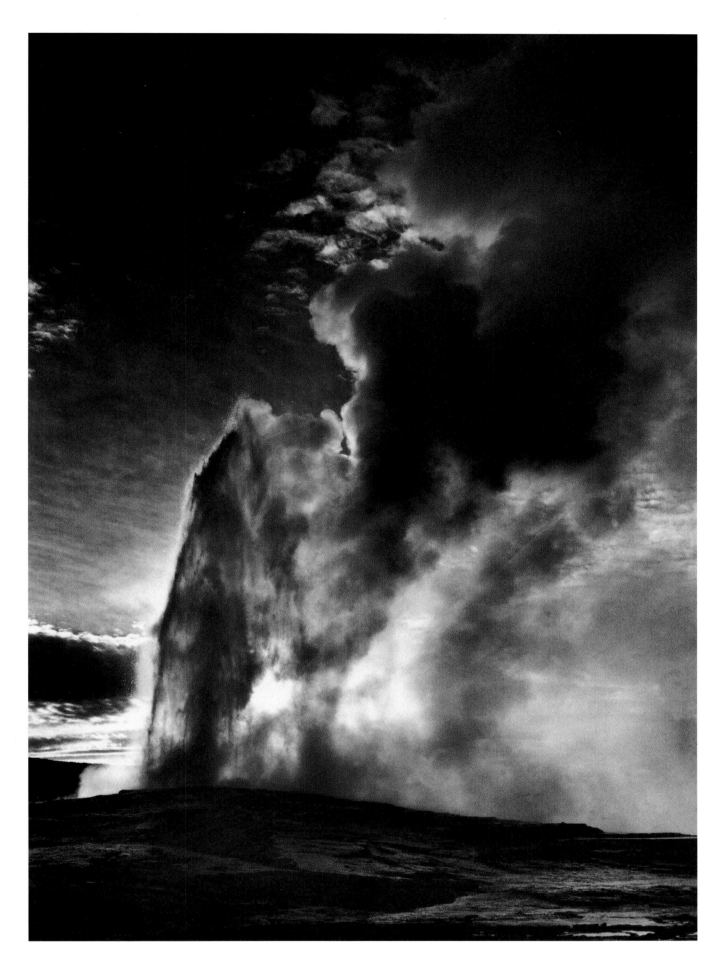

"Old Faithful Geyser, Yellowstone National Park"

Index

Page numbers in **boldface** indicate
picture captions.
Works for which no attribution is
given are by Ansel Adams.
Works with identical titles are listed
under a single heading.